AT THE WATER'S EDGE

EXHIBITION SCHEDULE

TAMPA MUSEUM OF ART
 Tampa, Florida
 December 9, 1989-March 4, 1990

CENTER FOR THE ARTS
 Vero Beach, Florida
 May 4, 1990-June 17, 1990

VIRGINIA BEACH CENTER FOR THE ARTS
 Virginia Beach, Virginia
 July 8, 1990-September 2, 1990

THE ARKANSAS ARTS CENTER
 Little Rock, Arkansas
 November 8, 1990-January 6, 1991

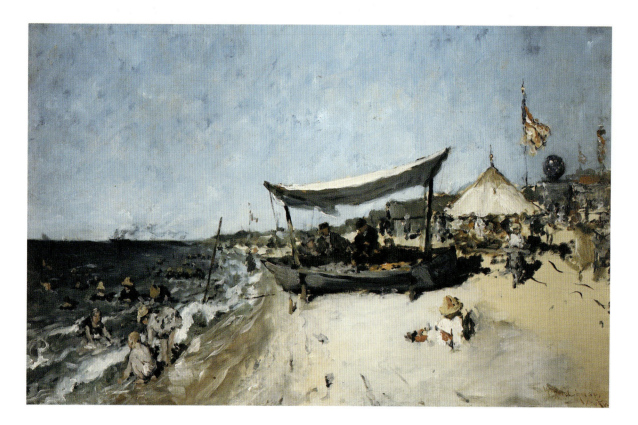

WILLIAM MERRITT CHASE (1849-1916)

By the Shore, c. 1886

oil on canvas, 21¼ x 34¼
The Pfeil Collection

AT THE WATER'S EDGE

19th and 20th Century
American
Beach Scenes

Organized by the
Tampa Museum of Art

Exhibition Sponsored by
OUTBOARD MARINE CORPORATION

Catalogue Underwritten by
AT&T FOUNDATION

Front Cover: SAMUEL S. CARR
 Beach Scene, c. 1879
 oil on canvas, 12 x 20 in.
 Collection of Smith College Museum of
 Art, Northampton, Massachusetts; Bequest
 of Mrs. Lewis Larned Coburn, 1934

Back Cover: HILO CHEN
 Beach 103, 1983
 watercolor, 26 x 39 in.
 Courtesy of Louis K. Meisel Gallery,
 New York

Catalogue design by Bob Hellier

Edited by Ann S. Olson

Typeset in Weiss by Hillsboro Typography

Printed by Promocom Printing

© 1989 The Tampa Museum of Art, Tampa, Florida

Catalogue by: Russell Lynes
 William H. Gerdts
 Donald B. Kuspit

Library of Congress Catalog Card Number 89-05176
ISBN 1-878293-03-6

Sponsored in part by the National Endowment for
the Arts and the State of Florida, Department of State,
Division of Cultural Affairs through the Florida
Arts Council.

Accredited by the
American Association
of Museums

CONTENTS

Lenders to the Exhibition

ACKLAND ART MUSEUM, THE UNIVERSITY OF NORTH CAROLINA AT CHAPEL HILL, CHAPEL HILL,
 NORTH CAROLINA
ALBRIGHT-KNOX ART GALLERY, BUFFALO, NEW YORK
BROOKE ALEXANDER, NEW YORK, NEW YORK
THE ARKANSAS ARTS CENTER, LITTLE ROCK, ARKANSAS
THE ART INSTITUTE OF CHICAGO, CHICAGO, ILLINOIS
THE ART MUSEUM, PRINCETON UNIVERSITY, PRINCETON, NEW JERSEY
GRACE BORGENICHT GALLERY, NEW YORK, NEW YORK
BOWDOIN COLLEGE MUSEUM OF ART, BRUNSWICK, MAINE
BP AMERICA, INC., CLEVELAND, OHIO
MATTHEW L. BULT, CALIFORNIA
CANAJOHARIE LIBRARY AND ART GALLERY, CANAJOHARIE, NEW YORK
CEDAR RAPIDS MUSEUM OF ART, CEDAR RAPIDS, IOWA
THE CHRYSLER MUSEUM, NORFOLK, VIRGINIA
CHILDS GALLERY, BOSTON, MASSACHUSETTS AND NEW YORK, NEW YORK
CHUCK KLEIN CO. CORP.
THE CLEVELAND MUSEUM OF ART, CLEVELAND, OHIO
COLBY COLLEGE MUSEUM OF ART, WATERVILLE, MAINE
COLUMBUS MUSEUM OF ART, COLUMBUS, OHIO
THE CORCORAN GALLERY OF ART, WASHINGTON, D.C.
THE GEORGE D. AND HARRIET W. CORNELL FINE ARTS MUSEUM AT ROLLINS COLLEGE,
 WINTER PARK, FLORIDA
CROCKER ART MUSEUM, SACRAMENTO, CALIFORNIA
THE CURRIER GALLERY OF ART, MANCHESTER, NEW HAMPSHIRE
DANFORTH MUSEUM OF ART, FRAMINGHAM, MASSACHUSETTS
FREDERICK K. W. DAY, CHICAGO, ILLINOIS
S. DAVID DEITCHER, NEW YORK
DELAWARE ART MUSEUM, WILMINGTON, DELAWARE
MR. AND MRS. WILLIAM DUPONT III
THE FINE ARTS MUSEUMS OF SAN FRANCISCO, SAN FRANCISCO, CALIFORNIA
FISCHBACH GALLERY, NEW YORK, NEW YORK
FLORENCE GRISWOLD MUSEUM, OLD LYME, CONNECTICUT
GEORGIA MUSEUM OF ART, THE UNIVERSITY OF GEORGIA, ATHENS, GEORGIA
GRAND RAPIDS ART MUSEUM, GRAND RAPIDS, MICHIGAN
MR. AND MRS. MERRILL J. GROSS
EVA AND WILLIAM GRUMAN
O.K. HARRIS WORKS OF ART, NEW YORK, NEW YORK
HEARST ART GALLERY, ST. MARY'S COLLEGE, MORAGA, CALIFORNIA
HERBERT W. PLIMPTON FAMILY FOUNDATION
HIGH MUSEUM OF ART, ATLANTA, GEORGIA
HIRSHHORN MUSEUM AND SCULPTURE GARDEN, SMITHSONIAN INSTITUTION, WASHINGTON, D.C.
NANCY HOFFMAN GALLERY, NEW YORK, NEW YORK
HUNTER MUSEUM OF ART, CHATTANOOGA, TENNESSEE
INDIANA UNIVERSITY ART MUSEUM, BLOOMINGTON, INDIANA
MRS. GEORGE WALTER JOHNSON
KENNEDY GALLERIES, INC., NEW YORK, NEW YORK
IRA AND NANCY KOGER
MR. AND MRS. R. A. LANGLEY, SAN FRANCISCO, CALIFORNIA
SAMUEL B. AND MARION W. LAWRENCE
LITTLEJOHN-SMITH GALLERY, NEW YORK, NEW YORK

LYMAN ALLYN ART MUSEUM, NEW LONDON, CONNECTICUT
MARION KOOGLER MCNAY ART MUSEUM, SAN ANTONIO, TEXAS
LOUIS K. MEISEL GALLERY, NEW YORK, NEW YORK
MEAD ART MUSEUM, AMHERST COLLEGE, AMHERST, MASSACHUSETTS
THE METROPOLITAN MUSEUM OF ART, NEW YORK, NEW YORK
MIDTOWN GALLERIES, NEW YORK, NEW YORK
MITCHELL MUSEUM, MT. VERNON, ILLINOIS
THE MONTCLAIR ART MUSEUM, MONTCLAIR, NEW JERSEY
MUNSON-WILLIAMS-PROCTOR INSTITUTE, MUSEUM OF ART, UTICA, NEW YORK
MUSEUM OF ART, FORT LAUDERDALE, FLORIDA
MUSEUM OF ART, RHODE ISLAND SCHOOL OF DESIGN, PROVIDENCE, RHODE ISLAND
THE MUSEUM OF CONTEMPORARY ART, LOS ANGELES, CALIFORNIA
MUSEUM OF FINE ARTS, BOSTON, MASSACHUSETTS
MUSEUM OF FINE ARTS, ST. PETERSBURG, FLORIDA
NATIONAL GALLERY OF ART, WASHINGTON, D.C.
THE NATIONAL MUSEUM OF WOMEN IN THE ARTS, WASHINGTON, D.C.
THE NELSON-ATKINS MUSEUM OF ART, KANSAS CITY, MISSOURI
NEWINGTON-CROPSEY FOUNDATION, HASTINGS-ON-HUDSON, NEW YORK
NEW JERSEY STATE MUSEUM, TRENTON, NEW JERSEY
NORTON GALLERY OF ART, WEST PALM BEACH, FLORIDA
THE OAKLAND MUSEUM, OAKLAND, CALIFORNIA
OIL AND STEEL GALLERY, LONG ISLAND CITY, NEW YORK
ORLANDO MUSEUM OF ART, ORLANDO, FLORIDA
PENNSYLVANIA ACADEMY OF THE FINE ARTS, PHILADELPHIA, PENNSYLVANIA
THE PFEIL COLLECTION
THE PHILLIPS COLLECTION, WASHINGTON, D.C.
PHOENIX ART MUSEUM, PHOENIX, ARIZONA
MR. AND MRS. MEYER P. POTAMKIN
ROSE ART MUSEUM, BRANDEIS UNIVERSITY, WALTHAM, MASSACHUSETTS
SAN FRANCISCO MUSEUM OF MODERN ART, SAN FRANCISCO, CALIFORNIA
SANTA BARBARA MUSEUM OF ART, SANTA BARBARA, CALIFORNIA
SEATTLE ART MUSEUM, SEATTLE, WASHINGTON
JOAN SEMMEL
SHELDON MEMORIAL ART GALLERY, UNIVERSITY OF NEBRASKA-LINCOLN, LINCOLN, NEBRASKA
SHELDON SWOPE ART MUSEUM, TERRE HAUTE, INDIANA
DRS. BEN AND A. JESS SHENSON
SMITH COLLEGE MUSEUM OF ART, NORTHAMPTON, MASSACHUSETTS
SORDONI ART GALLERY, WILKES COLLEGE, WILKES-BARRE, PENNSYLVANIA
STEIN GALLERY, TAMPA, FLORIDA
MRS. MIRIAM STERLING
TAMPA MUSEUM OF ART, TAMPA, FLORIDA
TERRA MUSEUM OF AMERICAN ART, CHICAGO, ILLINOIS
WALKER ART CENTER, MINNEAPOLIS, MINNESOTA
WEATHERSPOON ART GALLERY, THE UNIVERSITY OF NORTH CAROLINA AT GREENSBORO,
 GREENSBORO, NORTH CAROLINA
WHITNEY MUSEUM OF AMERICAN ART, NEW YORK, NEW YORK
THE WILLIAM BENTON MUSEUM OF ART, UNIVERSITY OF CONNECTICUT, STORRS, CONNECTICUT
WILLIAMS COLLEGE MUSEUM OF ART, WILLIAMSTOWN, MASSACHUSETTS
PRIVATE COLLECTORS

Foreword

More than one hundred years separate these two views of the narrow band of land surrounding the earth's oceans. Yet in each, the authors hold what we today call the "beach" in awe. Nature has not changed. Only man's perception of, and ability to confront, nature has changed.

This unique exhibition, *At the Water's Edge*, documents striking changes in public perception, from reverence and contemplation to mania and self-absorbtion. This fringe of land was once seen as wild, inhospitable and too isolated to be enjoyed. Today, whether it be rocky or placid sand, the beach is viewed as a place to go wild, to rest, to inhale the air for its curative powers, or to immolate oneself in pursuit of a tan. *At the Water's Edge*, in the works exhibited and the essays presented herein, traces artists' involvement with this constantly changing, often embattled, band between sea and mainland.

Tampa, nestled on a bay and adjacent to the Gulf of Mexico, is the appropriate locale to host such an exhibition, the first of its kind ever assembled. The Tampa Museum of Art is pleased to honor these artists, from Homer and Potthast to Fischl and Frankenthaler, for their interpretations of the "beach." After almost three years in development, the Museum is proud to present *At the Water's Edge* as a testament to art and to our collective fascination with the sand and surf. The Tampa Museum of Art brings you greetings from the beach.

R. Andrew Maass
Director

ACKNOWLEDGEMENTS

The undertaking of a project the magnitude of *At the Water's Edge* has been a daunting, yet pleasurable, task. That this Museum could request the assistance of, and draw upon the collections of, so many willing and generous individuals and institutions is truly a credit to the Museum and to the soundness of the exhibition's premise. Acknowledging everyone would be impossible but I must mention a few whose support and assistance have been invaluable.

That the expertise and technical know-how were available to accomplish any such project was a given. What were not givens were the origination of this particular exhibition premise and the funding capability to ensure its success. The germination of the idea for a "Beach" exhibition was presented to Museum staff early in 1987 by Linda Bassett, a documentary producer at Tampa's PBS television station WEDU, to coincide with her project "The Beach: Myth, Culture and Experience." Through the good offices of J. Reno Fender and Janice Baskin, the AT&T foundation signed on early as the sponsor of this documentary exhibition catalogue. The primary funding for the exhibition itself has been assured through a very generous grant from the Outboard Marine Cor-

poration facilitated by Laurin M. Baker, OMC's Director of Public Affairs. All of the exhibition's opening festivities and events, for which this Museum has become so well-known, have been underwritten by First Union National Bank headed in Tampa by Roy Whitehead. Without the inspiration, confidence and generosity of these individuals and corporations, the exhibition and catalogue would have remained just a great idea and not become a reality.

Once the concept was developed and the potential realized, a search began to identify the most appropriate scholars and art historians to expound upon the original theme. I believe the Museum found them and is indebted to the in-depth research and superlative discourses of Russell Lynes, Dr. William H. Gerdts and Dr. Donald B. Kuspit. Together, they have broken new ground in documenting the theme of the "beach" in American art. Their combined knowledge greatly assisted staff in identifying and locating works to be included. Additionally, this research was advanced by the aid of Elizabeth de Veer; Bennard B. Perlman; Ronald G. Pisano; Dr. Anthony F. Janson and John W. Coffey, North Carolina Museum of Art; Janice T. Driesbach, Crocker Art Museum; Doreen B. Burke, The Metropolitan Museum of Art; Sona Johnston, The Baltimore Museum of Art; Deborah Chotner, National Gallery of Art; Martha Oaks, Cape Ann Historical Association; Dr. Bruce Chambers, Berry-Hill Galleries, Inc.; and Franklin Riehlman, H. V. Allison Galleries.

Assembling more than one hundred twenty works from private collectors, galleries and museums across the country has been no mean feat. The Museum appreciates the willing cooperation of all these diverse and impressive lenders. Specifically, acknowledgement is extended to those whose efforts facilitated the arrangement of significant loans: Barry M. Heisler, Santa Barbara Museum of Art; Pamela Pack, San Francisco Museum of Modern Art; D. Scott Atkinson, Terra Museum of American Art; Deborah Lyons Levine, Anita Duquette, Joe Dugan and Nancy McGary, Whitney Museum of American Art; Debra Fillos, Florence Griswold Museum; Barbara Brady, Orlando Museum of Art; Nancy Mowll Mathews, Williams College Museum of Art; Elizabeth Wylie, Danforth Museum of Art; Pamela Parry, Norton Gallery of Art; Brian Shrum, the Koger Collection; Edward Lipowicz, Canajoharie Library and Art Gallery; Carolyn and Brooke Alexander; Nancy Hoffman and Sique Spence, Nancy Hoffman Gallery; William M. Chambers, III, Grace Borgenicht Gallery; and Patricia Koch, assistant to Roy Lichtenstein.

The Museum also acknowledges the interest and cooperation of the three institutions and their directors who have joined with Tampa in bringing this important exhibition to a wider audience: John B. Henry, III at the Center for the Arts, Vero Beach; Michael Marks and Sydney Jenkins at the Virginia Beach Center for the Arts; and Townsend Wolfe and William T. Henning at The Arkansas Arts Center.

In conclusion, it has been the staff of the Tampa Museum of Art who have painstakingly labored to bring this exhibition, *At the Water's Edge*, to fruition. While each department has had enormous tasks to perform, special mention must be made of Kay Morris, Annette Gordon, Ann Olson, Bob Hellier and Diane Broderick who have been intimately involved with all aspects of this exhibition. And in the end, it has been Valerie Leeds who has curated and guided *At the Water's Edge* from its infancy to joyous and stunning conclusion.

R.A.M.

List of Illustrations

†Indicates color illustration

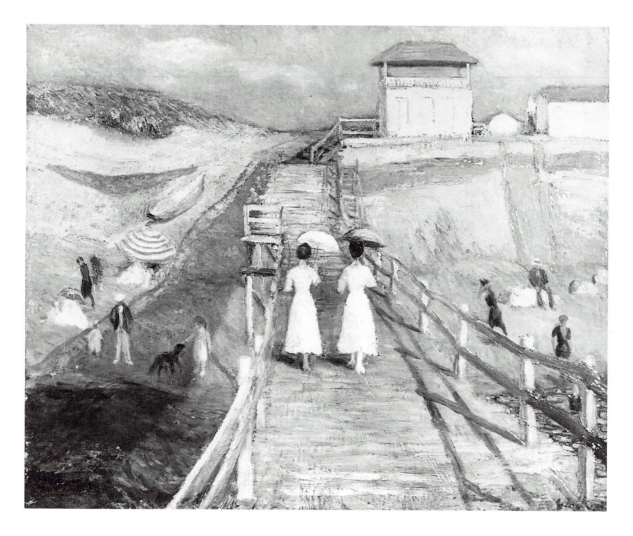

WILLIAM JAMES GLACKENS (1870-1938)

Cape Cod Pier, 1908

oil on canvas, 22¼ x 32
Collection of Museum of Art, Fort Lauderdale, Florida; Anonymous gift

Introduction

Throughout civilization, man's fascination with the beach has been recorded in literature and art. Works of art have projected changing attitudes about the beach for thousands of years; a stone relief from ancient Assyria documents swimming. However, the modern view of the beach, as a place for swimming, water sports, tanning and rejuvenation of the body as well as the spirit, is a relatively recent development.

The American beach resort is a legacy from eighteenth-century England but can be traced to the ancient spas of the Roman Empire. The English town of Bath was among several sites whose springs were frequented by the ancient Romans. It was actually in the 1730s that the first seaside resorts flourished in England at Brighton, Margate and Blackpool. But it was almost another century before ocean bathing became commonplace on the Continent and in America.

During the second half of the eighteenth century, Americans began to spend increasing amounts of leisure time at the beach. Newport, Rhode Island began the trend, followed soon afterward by the southern New Jersey shore towns of Cape May and Long Branch. As economies changed, other seacoast towns began a transition from fishing village to beach resort, reflecting similar changes which had occurred in Europe. American artists have illustrated the changes in society's habits, filtered through their artistic interpretations, over the last one hundred fifty years.

The tradition of painting landscapes originated with Dutch artists of the seventeenth century, but it was not until the emergence of the Hudson River School in the 1820s that beach scenes occurred with any frequency in American painting. Thomas Birch, with his interest in the grand American landscape, was a precursor of this style. Examples by John Frederick Kensett and Worthington Whittredge illustrate this movement's romanticized and aggrandized view of unspoiled American terrain, while still adhering to the prevailing artists' philosophy of being true to nature in their work. The works by William Sonntag and Jasper Cropsey are representative of the typically intimate scale of the first generation of the Hudson River School.

The first generation of the Hudson River School began exploring the northeastern coast, as scenes of this region began to appear in their work. Artists of the second generation also painted these same locations, but they experimented with effects produced by direct and reflected light on water. The artists who investigated light in a romantic but literal style of realism have become known as the Luminist painters. In this exhibition, Luminist effects can be seen in works by Francis Silva, William Trost Richards, Alfred Bricher and William Bradford.

Many beachscapes executed by members of this second generation, such as Worthington Whittredge and Albert Bierstadt, as well as the artists who worked apart from the Hudson River School such as Silva, Richards, Bricher, and Bradford, exemplify a lyrical interpretation seen in expansive panoramas which link landscape painting with Ralph Waldo Emerson and the Age of Transcendentalism.

Luminism came to its inevitable conclusion by the 1880s as ties between European and American art communities became stronger. Changes in taste were affected by French art trends introduced through American expatriate artists who traveled to Paris to further their art education. By the late 1880s Impressionism had become a strong force within the American art scene. While interest in light began with the Luminist painters, the Impressionists' works were characterized by an even brighter, more intensely saturated palette and the introduction of visible brushstrokes which had been purposely undetectable in the work of the Hudson River School and Luminist painters. The American Impressionists painted in direct glaring daylight. Although their work was derivative of French Impressionism, it sustained a uniquely American flavor.

With the beginning of outdoor painting in America, beach scenes had a strong presence in American painting. The Ten, a group of influential Impressionist artists, are well represented in this exhibition. These Impressionist scenes are populated with summer vacationers enjoying freedom from society's constraints. In them, we sense a harmonious synergy between the stylistic freedom and brightened palette of J. Alden Weir, John Henry Twachtman, William Merritt Chase and Edward Potthast.

During the first decade of the twentieth century, as the dominance of romanticized, pastel visions began to recede, a brash, more typically American style of painting emerged. The Eight, and other

artists who practiced a broader stylistic interpretation, became known as New York Realists or the Ashcan School and were responsible for the promotion of a new movement of American Realism. This new Realism, rich with social commentary, is evident in the beach scenes of Robert Henri, William Glackens and especially John Sloan. These works depict the leisure of diverse social and economic classes, as seen on beaches from Newport to Coney Island. The paintings by Glackens and Sloan are strong examples of a uniquely American genre. As the beaches became peopled by other than fishermen working for a livelihood, paintings began to mirror these social changes.

Another radically different path of Realism developed, quite apart from the New York Realists, in the work of Winslow Homer whose naturalistic beach scenes captured the essence of America's early beach resorts and unspoiled coastlines. The clarity and precision of his watercolors and oils strongly influenced a generation of artists including Edward Hopper and later Realists.

Maurice Prendergast, whose long career spanned a broad spectrum of artistic trends, heralds the transition to Post-Impressionist America. Although he was formally an exhibiting member of The Eight, Prendergast stylistically was never a realist. His later work was even more in synchrony with the general evolution toward a more abstract, expressive idiom characterized by Post-Impressionism. He uses such modernist elements as dramatic tonalities and flattened space and form. The beach scenes of American Modernists, Walt Kuhn, Alice Schille, and Abraham Walkowitz clearly indicate the influence of Cézanne, Matisse and the Fauves.

Artists of the next generation continued to visit the eastern seashores which had previously inspired the artists of the early nineteenth century. However, trends toward abstraction, initiated by the poetic and minimal watercolors of John Marin, continued with the paintings of Milton Avery. The movement towards abstraction became more pronounced in the 1950s as Abstract Expressionism displaced the reign of representational subject. Avery, a prolific artist who painted many beach scenes, was able to convey considerable meaning with a simplified and referential contour, which at times closely approached abstraction.

Broad diversification occurred in the subsequent decade, resulting in the stimulation of other streams in twentieth-century American art. While in earlier landscape paintings, man's depiction was clearly

subordinate to the grand scale of the landscape, in the twentieth century the figure has played an increasingly important role.

In the 1960s, a tide of reaction swept aside the predominance of Abstraction and Abstract Expressionism. Pop artists and Photorealists re-emphasized recognizable subjects and commercial images. The works of Red Grooms, Tom Wesselmann and Roy Lichtenstein epitomize irreverent wit and superficial topicality with their cartoon treatment of subjects, traits which characterize much of the work produced by the Pop movement. And Realists such as Wayne Thiebaud, Alfred Leslie and Hilo Chen also used aspects of American popular culture in their work. They often portrayed the zenith of the free and easy life that characterized the 1960s.

In the last two decades, illustrated by the most recent beach scenes in the exhibition, the statement made is less about society than about the artists' pursuit of originality. However, in pursuit of individuality, artists have continually looked back through art history, as may be seen in many current recycled and refashioned trends. The works of Judy Rifka, Richard Bosman and Eric Fischl are examples of Neo-Expressionism and New Realism, and indicate the pluralism in contemporary art. Their work presents powerful humanistic images which are infused with realistic drama and vivid narrative reinterpreted into a post-modern vernacular.

Works from certain art historical movements, such as Minimalism or Abstraction, have not always depicted representational subjects. Regardless of movement, however, the beach has been a recurring theme in the work of American artists. While it was once thought to be an unfit habitat, marketing and development have transformed it to a retreat from the pressure of the modern world. Changing trends in tourism, recreation and lifestyle, as well as art, have come to mirror these changes in social attitude. More recent works project the popularization of the beach, as seen in the increasing focus on the figure.

As landscape painting has evolved over this one hundred fifty years, beaches, and all virgin territory, have deteriorated under the pressures of civilization. As man's attraction to the beach has remained strong, as the edge between the land and sea has remained intact, so has the artist's interest in depicting this subject, which is, perhaps, a metaphor for the familiar bordering on the edge of the unknown.

Valerie Ann Leeds

REGINALD MARSH (1898-1954)

Coney Island Beach #2, 1938

tempera on composition board, 29⅜ x 39½
Collection of Rose Art Museum, Brandeis University, Waltham, Massachusetts;
Gift of the Honorable William Benton, New York

Most works discussed in the essays are illustrated in the catalogue.
Numbers in margins refer to pages on which those works are reproduced.

At the Water's Edge:
Changing Perspectives on the Beach

No two pairs of eyes see a beach in the same way or search for the same satisfactions, reflections or alarms in what they see. In this exhibition, eyes dwell on beaches with considerably more intensity than we who are not artists are likely or able to do, and what they see and set on canvas or paper tells us much about them and their times, something of the varied nature of beaches, and perhaps about ourselves as well. When we stand "at the water's edge," as the title of this exhibition invites us to do, we are asked to reflect as much on our own experience of beaches as on what is revealed for us by the artists who have stood to paint where they now place us.

To many of us, the beach is a single beach we know well, "my beach" where we have played, picnicked and soaked up the sun, salt and sand. To some others it is the sum of many beaches accumulated and recollected over years, places of temporary escape, of fleeting loves, impressions of sea and sky that overlap and so are edgeless and ill-defined. Beaches for others are a way of life: morning, noon and night, work and play, health and illness, anticipation and disappointment and achievement—home, in other words. For still others beaches are parentheses in which our nation is enclosed from sea to shining sea, from Atlantic to Pacific, a subordinate clause in a sentence that describes the world. As parentheses beaches are emblems of arrival and departure; they are shock-absorbers against the pummelings of oceans and invitations to exploration. They are welcome mats for mariners and cautionary reminders for adventurers that beyond them are threats of danger and even of terror, of sea monsters, as early map makers took pains to note. For generations we have sung for those in peril on the sea.

Beaches and resorts to many are synonymous: they are places where the serious business of life stops and the business of easy living begins. To the artists whose pictures are under scrutiny in the exhibition, a beach is many things. One thing it is to each of them is a starting place. It suggests a composition that may be abstract or literal. It may be the setting of a social situation, a composition that involves people and their interactions. It may be an opportunity to comment on natural phenomena, on peace or turbulence, or to speculate on pleasure or the imminence of disaster. Beaches have the charm of unpredictability, and it is the artist's pleasure to impose temporary order and discipline on them. In some respects beaches are robust and sturdy guardians of the land, especially when they are buttressed by rocks; in others they are fragile and subject to being resculptured by storms and altered by the depredations of human carelessness. The only beaches that are immune to future disasters, it increasingly seems, are those that have been made permanent by artists.

It was not until beaches became gathering places and assumed certain social functions that artists became interested in them except as pieces of foreground for expanses of sea, and even then, rocks served the foreground purpose better and far more dramatically than sand and dunes. Beaches as places for gatherings, for picnics and cook-outs and clambakes and sports, emerged only in societies prosperous enough to have plenty of time for leisure. Except for a thin crust blessed with wealth, few Americans enjoyed such leisure until well into the nineteenth century. Long before beaches, enlivened by people, became attractive subjects for painters, the sea was very much their quarry, not sea alone but oceans on which were ships in battle, ships in perilous storms, ships in full sail going about their business peacefully and with great dignity, a special dignity that no other conveyance could rival. The maritime tradition on canvas was not surprisingly of Dutch inspiration. The Netherlands, economically as well as spiritually and socially, floated on water, but the first American paintings of the sea were subsidiary to more immediate and important matters, the faces of the powerful.

In the late seventeenth century and early years of the eighteenth the first marine pictures in America were, in fact, portraits with glimpses of the sea in their backgrounds. The sea was there for purposes of iconography rather than for its own charms. Ship owners, admirals, ship builders, captains, men whose commerce was conducted and wealth amassed with the help of ships, liked to have their association with the sea proclaimed in their portraits. In some cases they were gratified with a view through a window of ships under full sail on a placid sea, sometimes there is a bit of shoreline with ships in the distance, sometimes to emphasize the nautical profession of the sitter he holds a spyglass. It is as though today's tycoons had their portraits painted with corporate skyscrapers in the background.

There are suggestions of shorelines, if not quite of beaches, in some of the early portraits of nautical gentlemen (and they were indeed gentlemen), but the edge of the sea was looked upon in a different way from the way in which the Hudson River School painters of the mid-nineteenth century began to observe it closely and record it meticulously. The edge of the sea in early marine paintings was frequently where the battered hulls and spars of ships blown on the rocks or split apart on off-shore reefs piled up. It was where shells of tragedy were beaten to splinters in angry surf and where the "finger biters" that Captain Frederick Marryat wrote about stole jewels from the victims of wrecks they had caused with false signal lights. The paintings in this exhibition are not of such catastrophies, once commonplace in nautical art, though the power of the sea as it beats against the shore is the subject

85, 24
75

of Frederick Waugh's *Green Wave*, Thomas Birch's *Seascape* (View of Maine Coast) and Julian Onderdonk's *Seascape*, but even these suggestions of power do not imply violence. Indeed in all the paintings in the exhibition the edge of the sea is a friendly, not a hostile place. However in many of the works its dignity invites respect rather than intimacy.

Playful intimacy with the beach as a friendly companion came slowly to America. The sea was business turf to mariners as the land was to farmers, to be worked not played with. The sea was for food and travel and commerce, oil for lamps, whalebone for stiffening corsets, ambergris for perfumes, and tea and coffee and chocolate for the table. It was the slow and dubious postal route to almost everybody's forebears. It was an arena for fighting, for piracy and slaving. It was a necessity, but it was not considered a friend. It was treacherous and unpredictable, to be challenged but not to be toyed with, at least not until the early years of the nineteenth century when we began to use its shores for respite and relaxation.

By the third decade of the nineteenth century the charms of seaside resorts proffered relief to city dwellers from the increasing discomfort of urban living; cities grew noisier, dirtier and more dangerous as they sprawled and left decay behind. Even the most committed urbanites found the city a place from which to escape, at least temporarily and especially in the heat of the summer. By the second half of the century during which seaside resorts flourished, a network of railroads made it possible to flee in a few hours to resorts that early in the century would have taken days to reach. Boats like those of the Fall River Line had, to be sure, transported vacationers from New York to the resorts of New England, an overnight trip on the quiet waters of Long Island Sound, but it was railroads, somewhat later supplemented by interurban trolley cars, that brought cities and resorts closer together and made beaches playpens for the modestly well-off as well as for the rich. It was steel rails that made Coney Island and Newport's Bailey's Beach recreational cousins if, to be sure, social antipathetics.

Vacationers, it seems, had just two choices: "the shore" and "the mountains." The mountains were often just gentle hills like the Berkshires in Western Massachusetts, but the shore to most people meant miles of unsullied beaches whose dunes were at intervals peppered with hotels and boarding houses, with bathhouses for "changing" and with shingled summer cottages with wide porches facing the sea. "The shore" ranged in elegance from socially (if not always morally) circumspect resorts like Newport to the rowdy beaches like Coney Island that were backed and arched over by amusement parks. For wealthy New Yorkers and Bostonians who lived in hubs of maritime commerce, resorts were less places to relax than they were to involve themselves with the most rigorous social and architectural competition. The very rich among them built vast houses that would have been suitable for princelings and their entourages and which, by a sort of reverse snobbism, they called "cottages." The most extravagant of the resorts was Newport, Rhode Island, and its most conspicuous "summer people" (in Maine they still call vacationers "summer complaints") were New Yorkers — Vanderbilts, Astors, Belmonts and other proprietors of vast fortunes, who employed the amiable and gifted architect, Richard Morris Hunt, to build their chateaux and palaces surrounded by small napkins of land and manicured gardens. (Mrs. "Willie" [W. K.] Vanderbilt's "Marble House" cost $2.5 million to erect in 1873 and another $7 million to furnish.) Well-born and prosperous Bostonians considered Newport to have been "vulgarized" by New Yorkers who enjoyed showing off their wealth.

Fashionable life at Newport included the beach, but it was a minor part of recreation. "As for the celebrated Bailey's Beach," a long-time resident of Newport wrote, "it would have been considered a shabby little joke by any pushing new summer resort. A small cramped cove, it was far from ideal for swimming—not in a class with the superb mile-long stretch of the (Newport) public beach. At Bailey's, one often had to wallow about in a thick ooze of seaweed through which tiny marine monsters scooted."[1] Newport matrons were too busy paying social calls and "dropping cards" on acquaintances and showing off their carriages and high-stepping teams and liveried grooms to bother much with the beach; they surely avoided the public beach where *hoi polloi* gathered for frolic and serious bathing. (Bailey's was an example of what pride would put up with for the sake of exclusivity.) Nonetheless some fashionable women "did actually venture into the ocean at Bailey's—well covered, to be sure, by full-skirted bathing suits and long black stockings. Mrs. O. H. P. Belmont even carried a green umbrella with her into the surf."[2]

Swimming, rather than just standing in the edge of the water and letting the waves break against one's prudently clad person, was generally regarded as a male prerogative, especially venturing beyond the ropes that were held up by floats to mark a small patch of ocean presided over by lifeguards. "Going out beyond the breakers" was looked upon as a very risky business, but there were always show-offs who challenged the breakers and beyond. Two young women at Newport early in this century shocked some and delighted others of their staid community by their defiance of polite custom and more particularly by their physical prowess. The famous Boston eccentric Eleanora Sears and her companion, Constance Warren, swam "from Bailey's to Easton's (the public beach) by moonlight—a distance of three and a half miles."[3]

Resorts could prosper only as leisure increased and more people had more time on their hands and more money with which to indulge themselves. What was true on a grand scale in fashionable resorts was just as true on a modest scale at less lavish places of escape. The resort hotels in which hundreds of women and children, and husbands on weekends, spent their vacations at the beach had their own social conventions that demanded to be rigidly observed. The ladies in flowered hats and gloves who rocked in armchairs on the endless porches could enjoy the beaches without the discomfort of sand in their shoes and feel the breezes from the sea without the ravages of the sun. They were just as engaged in social contests as the ladies who flaunted their wealth in victorias and barouches. But it was not only more leisure for more people that made the resorts spring up and prosper. Phenomena like Narragansett Pier, just across Narragansett Bay from Newport, Long Beach and Atlantic City on the "Jersey Shore," Coney Island, Brighton and Manhattan beaches on Long Island, and others all the way down the east coast to Palm Beach and St. Augustine were made possible and supported by the railroads just as were the resorts at San Diego and on the Monterey Peninsula at the other edge of the continent. These resorts were at the peak of their popularity, it is well to remember, long before what has come to be called our era of "mass leisure" was made possible by the thirty-five hour work week, month-long vacations and daylight savings time which profoundly affected our habits of play.

The great days of the beach resorts were very much alive at the time that many of the paintings in this exhibition were put on canvas or paper. It was at these resorts that beach life in America began to assume a character quite different from what it had been in the days when beaches were primarily the concern of mariners and fishermen and their families and of a few artists to whom they had a romantic appeal as an element in the grandeur and mystery of unharnessed and unspoiled nature. Those artists liked their beaches unpeopled and unsullied except by bits of shipwrecks that told of nature's relentless distaste for being challenged. By contrast, most of the artists represented in this exhibition looked on the beach as a place to play, a restorative, a free-for-all gymnasium and public bath, a place to rest, to let off steam, to show off, a place to advertise the extent of one's indolence (in itself a status symbol) by the depth of one's tan.

The great seaside resorts of the East Coast began to emerge almost simultaneously in the 1820s and '30s as though all at once the ocean and its shores had achieved social respectability in America.

(In England resorts like Brighton had attracted Londoners from the middle of the eighteenth century.) Atlantic City, now the home of gambling casinos in lavish hotels backed by urban decay, was in its early days conservative in nature. When it opened five brand new hotels on July 4th, 1854 its target was Philadelphians, not just the Society crowd, but the Quakers to whom Philadelphia was home. Atlantic City and its competitor at Cape May prospered but Atlantic City seems to have been the more ingenious in providing for its clientele's comfort and safety. In 1870 Atlantic City "invented" (if that is the word; laid might be better) the first boardwalk. It was not at first meant for the convenience of the vacationers; it was a railroad conductor named Boardman (suitably), infuriated by the amount of sand that passengers tracked into his cars, who suggested it. The original boardwalk was just a mile long and eight feet wide, but it was the progenitor of the splendid board esplanades with their rolling wicker wheelchairs propelled by flunkies that became an earmark of Atlantic City. Atlantic City was also the first resort to employ paid lifeguards, but that did not happen until 1892 and then only, I presume, because volunteer "rescue Life Guards," as they were called, were tired of being imposed on.

There were dozens of resort hotels built in the 1870s and '80s, none more conspicuous than the ones at Long Branch on the Jersey Shore and at Narragansett across the bay from Newport. Long Branch provided New Yorkers (who came by boat and carriage and train) not just with a wide expanse of beach but also with hotels that were regarded as the ultimate in luxury. The Ocean House, a four-story wooden building a city block long with tiers of balconies facing the sea, was not Long Branch's only caravansary, but it was probably its most respectable one. Mrs. Abraham Lincoln had stayed in Long Branch and spoken well of it, and President Grant said, "In all my travels I have never seen a place better suited for a summer residence than Long Branch."[4] Fancier and "faster," to use a word of the times, was the Chamberlain Club with its gilded turrets and colonnaded porches. It seems likely that two of the most notorious frequenters of Long Branch, the financier Jim Fiske (of whom some wit said, "There goes Jim Fiske with his hands in his own pockets for a change,") and Boss Tweed, the scandalous tyrant of Tammany Hall, stayed there.

Among the characteristic attractions of many of the beach resorts were (and in some cases still are) wooden or (later) steel piers that stretched out for several hundred yards into the sea, means of access to the full delights of salt breezes and uninterrupted views of the expanse of the ocean without getting one's feet wet or sand in one's shoes. Piers gave vacationers the impression of being both at sea and ashore: there were concerts and restaurants and deck chairs that approximated the sensation of being on an ocean liner without the discomforting movement of the sea underfoot. It was at the piers that sidewheelers bringing city folk to the shore tied up and disgorged the trunks and boxes filled with ball gowns and flannel bathing dresses and floppy hats and black stockings and lace-up swimming shoes. In the days of leg-o-mutton sleeves and bustles even simple dresses were bulky, and a variety of perky hats to perch on pompadors were *de rigeur*, though it was parasols not hats that protected the ladies from the sun. Ocean City, Atlantic City, Narragansett and Coney Island, New York's most immediate beach, all had their recreation piers. Every now and then, as though it were part of the planned drama of resorts, the piers would be destroyed or so badly damaged by hurricanes and towering seas that they had to be abandoned or rebuilt.

The first great resorts in Florida and California came into being decades after those in the northeast, and in both the southeast and the far west it was railroads that in a very real sense "created" them. In the 1880s Henry M. Flagler, who made his fortune as an associate of John D. Rockefeller in the oil business, saw Florida as worth his attention. He bought up a number of small railroads and put them together as the Florida East Coast Railway which he extended to Palm Beach and ultimately to Miami (not then yet on the map) and Key West. In 1897 *Harper's Weekly* reported that he had "converted Palm Beach into the most beautiful mile or two of waterfront on any sea . . . it has been called the American Riviera, but the Riviera has nothing compared to its gorgeous tropical setting." Flagler's first hotel in Palm Beach was the Royal Ponciana. It had a dining room that seated two thousand, and boasted six stories of luxurious suites. He had already built two hotels in St. Augustine, equally splendid, the Ponce

de Leon and the Alcatraz. No northerners took Florida seriously as a land suitable for lotus eating until Flagler worked his magic.

It was principally the Santa Fe Railroad that turned southern California into a land of beach resorts and made modest little fishing villages like San Diego into boom towns to which speculators and vacationers flocked from as far away as Missouri.

The most spectacular beach hotel in the area was the Hotel del Coronado, whose sprawling dunce-capped and dormered building of unidentifiable, capricious styles was a delightful setting (as many who have seen the film again and again will remember) for Marilyn Monroe's antic caper, "Some Like It Hot."

This exhibition's paintings contain few hints of the bold caravansaries to which people flocked in the nineteenth century in order to be near the beach nor, indeed, are there many pictures of crowds of people at the seaside. It may be that painting flimsy Victorian architecture and miscellaneous huddles of over-dressed people whose principal occupations were seeking satisfaction in being one of a crowd seemed scarcely worth bothering with . . . better left to magazine illustrators and picture postcards. There are, however, a few such beach pictures in the show. The Coney Island scene (called just "Beach Scene") by S. S. Carr is a charming, static evocation of beach life in the late 1870s. It depicts a number of typical seaside activities: a Punch and Judy show which seems to be as much enjoyed by adults as by their children, a tintype photographer posing two women and a child, several fully dressed children playing in the sand, but no one in this well populated canvas has gone so far as to get wet feet, and only one couple seems interested enough in the sea to look at it. By contrast there are two pictures by Reginald Marsh in which nearly naked bodies rub against one another in an orgy of sweat and public intimacy. *65*

16, 94

Coney Island, "the sandbar that became the world's largest playground,"[5] in many respects tells the story of all the vagaries through which beach resorts in America have passed during the last century and a half. It has been quiet and discreet, fashionable, gaudy, scandalous and honky-tonk. It cannot be said to be typical because in its long career it has been all things to all vacationers, to the rich, the poor and those between. It emerged as a watering place in the 1840s and its proximity to New York made it popular with fashionable families such as the Belmonts and the Vanderbilts and the Lorillards who put their heads and their hearts and their pocketbooks together and formed the Jockey Club in 1880 and raced their thoroughbreds at nearby Brighton Beach, Sheepshead Bay and Morris Park. But the fashionables, as they were called, excluded themselves from what Coney Island became and for which it is both famous and notorious. Anyone who could pay the fare could ride on the Iron Steamship Company's sidewheeler, and having been entertained *en route* by a small orchestra, could find something to everyone's taste. Seafood restaurants abounded, so did hot dogs and sideshows, the spice of gambling parlors and the scandalous existence of bawdy houses. (In the 1870s the local political boss, John Y. McKane, is said to have pronounced that "houses of prostitution are a necessity on Coney Island.")[6]

There were elegant hotels and fantasy ones. One famous fantasy (though not one of a kind, as several of them were built at Atlantic City in 1882) was in the shape of a tremendous elephant topped by a howdah, with rooms in its body and trunk and shops in its legs. But those who sought the luxury of carpeted halls and ballrooms and wide porches on which to take tea and watch the passing show found massive wooden hotels with flags flying from their turreted roofs. If they preferred, they could move further out on the sandbar to Manhattan Beach or Brighton where a more conventional and circumspect clientele spent its vacations more sedately.

There are pictures of typical resort beaches crowded with men and women and children in the enveloping costumes thought only decent in the last part of the nineteenth century, of the waves churning with waders and dippers and a few swimmers in hats (not yet bathing caps), but they are pictures made to illustrate magazine stories in publications like *Harper's Weekly* and *Leslie's;* they were not the sort of pictures that "serious" painters of the nineteenth century thought suitable either to their talents or to

the taste of the kinds of people to whom they hoped to sell their canvases. Beach scenes of the magazine sort were not pretty or uplifting or, like those of William Merritt Chase, Winslow Homer or Edward Potthast, suitably genteel (this was a time when gentility was regarded socially as very close to holiness); they were on the other hand excellent examples of pictorial reporting by very competent and now largely forgotten draughtsmen. They showed the crowds on nineteenth-century beaches somewhat differently from the ways John Sloan and Reginald Marsh showed them in the early years of this century, and, as you would expect, the history of the bathing suit (more accurately the bathing costume) is better seen in fashion plates from magazines like *Demorest's* and *Harper's Bazar* (as it was then spelled) than in the painting of the same period.

James Laver in his delightful brief history of clothes, *Modesty in Dress*, wrote, "The history of the bathing costume is very curious, for, after all, the only sensible costume for bathing is no costume at all. The Greeks and the Romans would have thought it madness to put on clothes in order to get them wet."[7]

In the century and a half spanned by the paintings in this exhibition, bathing costumes reached their most extreme manifestations of over-compensated Victorian modesty and twentieth-century lack of reticence. If the ladies who waded up to their calves in the surf at Bailey's Beach or Ocean City had worn their ballgowns to the beach they could scarcely have been less appropriately clad for swimming. (Their ball gowns, indeed, exposed more flesh than their bathing dresses.) But since most of them had no notion of getting wet above the knees, their costumes can be said to have been not only practical but quite pretty. Mme. Demorest, who edited a fashion magazine in the 1870s and sold dress patterns by the millions, suggested: ". . . for bathing dresses there is nothing better than twilled flannel, decently long and well cut . . . with a Garibaldi waist, not too full or baggy, gored skirt and full drawers gathered into an elastic. About ten yards of flannel are required."[8] On the beach, hats, preferably perky ones of straw with brims that were not too wide, were proper; so, of course were parasols. (The sun was considered an enemy not a friend.) Men's bathing costumes were meant for swimming, but when wet they might have taken all but the stoutest swimmers to the bottom. They were flannel with long drawers that clung to the thighs, and tops with sleeves, and as likely as not the men wore floppy, wide-brimmed cotton hats. The rubber bathing cap was not to appear for some years, and it was not until after the turn of the century that Annette Kellerman shocked and delighted the public by appearing in a one-piece, all-covering bathing suit. John Sloan noted in his diary in 1909 that he had been to Hammerstein's Victoria Roof Garden and seen "Annette Kellerman in diving acts, a handsome piece of healthy womanhood in black tight [sic] shining with the water."

We are inclined to think of the bikini, which is well represented in this exhibition, as a twentieth-century, post atom-bomb invention. In fact a two-piece bathing costume almost identical with today's bikini was evidently fashionable in about 400 A.D. with women who attended public baths. There is a mosaic of a slender young woman thus clad in the floor of a Sicilian bath. The bikini was bound to happen as the only nearly logical end in the drift from bathing dresses to swim suits. Men shed their tops in the 1920s and replaced their dark blue (usually) medium length flannel shorts held up by white cotton belts with brief trunks. Women in America have not, except in the seclusion of private pools, recaptured a kind of physical freedom enjoyed by the mothers of our civilization in ancient Egypt, Greece and Rome.

"What reduced bathing costumes to their present exiguous dimensions," Laver observed, "was not bathing, but sun bathing."[9] He suggests, moreover, that backless bathing suits inspired backless evening dresses, the influence of the beach on the ballroom, the reverse of what happened in the 1880s. The bikini looms small in a number of paintings in this exhibition, in Hilo Chen's *Beach 103*, in Alfred Leslie's *Casey Key* and in Ben Schonzeit's *Scott Cameron (Bridgehampton)*. In each of these the bikinied figures are prone and passive sun worshippers patiently waiting for a patina. In Wayne Thiebaud's *Bikini* the no-nonsense young woman who is his subject has done her job; she is browned to a turn and ready to be served.

111

109, 116

115

More concentrated effort seems to inspire the subjects of the sunbathing pictures in the show than the other beach scenes populated by women and children and an occasional man. (There are no men in the three charming beach scenes by Edward Potthast.) The sunbathers are working; the figures in 78, 79 the other pictures are having fun, the kinds of unorganized and disorganized fun that beaches are good for—wading, throwing stones, snoozing, playing in the sand, chatting (no serious conversation), enjoying the salt breezes, unwinding, contemplating whether to go in the water, speculating about what is beyond the horizon—Spain if you look east from New York, China if you look west from California. Beach people know what it means to be on the edge of the world, and those who do not see and feel this for themselves are taught to see it by artists.

Many things happen on beaches and to beaches that are not to be seen in this exhibition, many pleasant things that we take for granted, the perquisites of loving and living, many unpleasant things, the price of challenging or playing fast and loose with nature. The clean sweeps of sand that lie beyond Long Island dunes that William Merritt Chase painted with such brilliance and delight and peopled with pretty women and children, prettily dressed and parasoled, the crescents of sand that delighted Albert Bierstadt and William Bradford and Helen Frankenthaler, the rocks against which waves break in the canvases of Winslow Homer and Alfred Bricher and John Kensett—these sweeps and rocks and busy waves so recently cherished as incorruptible, if sometimes treacherous and unpredictable, we see being despoiled. Oil from offshore wells and severed tankers and the bilges of merchant ships defiles beaches from Alaska to Santa Barbara and far beyond. Garbage and medical waste wash up on the shores of New Jersey and Florida. Poisons from factories and power plants follow rivers into the sea and pollute our harbors and our shorelines. This exhibition does not remind us of these distasteful truths, but it most poignantly does remind us of what we have inherited and stand to lose.

It would be foolish to predict the demise of the beach as we have cherished it. For all its fragility, for all the depredations that we submit it to, for all our carelessness and greed, for all the temptations that leisure puts in our way (shorter work weeks, early retirements, faster travel), beaches are an indispensible part of our tradition. We will see to it that they survive, secluded beaches for those who relish privacy, thronged beaches for those who can enjoy themselves only in crowds, quiet beaches where one can read, beaches drenched with radio "rock" for those who are frightened of silence as children are frightened of the dark—all kinds of beaches for all kinds and ages of people with all manner of taste and tolerance and aspirations.

For the nostalgic among us who want to cling gently to the past but do not clutch it with frenzy, the beach will continue to be ours as long as the reminders, some sentimental, some playful, some satiric, some lyrical, some ominous, that make up this exhibition inhabit the same world that we do and their artists did.

FOOTNOTES

1. Richmond Barrett, *Good Old Summer Time*, 1952, p. 127

2. Ibid., p. 127

3. Ibid., p. 129

4. Leslie Dorsey and James Devine, *Fare Thee Well*, New York, 1964, p. 284

5. *New York City Guide, Federal Writers's Project*, New York, 1939, p. 471

6. "A Coney Island State of Mind," Susan Martin, Howard Greenberg Photofind Gallery, Woodstock, VT., 1987, unpaginated.

7. James Laver, *Modesty in Dress*, Boston, 1969, p. 145

8. Dorsey and Devine, p. 298

9. Laver, p. 147

THOMAS BIRCH (1779-1851)

Seascape (View of Maine Coast), 1826

oil on canvas, 30½ x 40
Collection of Ackland Art Museum, The University of North Carolina at Chapel Hill; the
W. W. Fuller Collection (bequest of Dr. Frederick M. Hanes) and the gift of
Katherine Pendleton Arrington, by exchange.

Surf and Shore
Nineteenth-Century Views of the Beach

The present exhibition, devoted to depictions of the shore, and primarily to scenes of beach activities, is, to my knowledge, the first historical and comprehensive treatment of this theme in American art. This seems surprising, given the popularity of the subject itself, both actual and pictorial. Allied themes of the coastal scene, the seascape, and marine painting have been treated in numerous books and exhibition catalogues, either devoted solely to American examples of the genre, or combining American and European renderings of such subjects.[1] But while occasional views of the beach, bathing, and the shore itself have figured in such examinations, no previous show has been devoted primarily to American representations of recreational activities on the shore.

It might seem specious to seek too insistently a distinction between "shore" and "coast." The two terms are generally used interchangeably, and yet one is aware of a subtle difference even in common parlance. Basically, the coast primarily denotes the line of demarcation between land and sea — we refer far more often to the "coastline" than to the "shoreline." The shore, on the other hand, more often brings to mind a broad band of land, less oriented to the water; one of the definitions of "shore" in *Webster's New International Dictionary* is "land as distinguished from the sea." "Coast" also might be so defined (though, in fact, it is not) and would seem more to imply an equivocal relationship to both realms.

The paintings in the present exhibition, then, are generally land-oriented, and portray nature in her more smiling moments, the shore utilized for human pleasure and relaxation. Absent here for the most part are scenes of the shore as a setting for toil and commerce — the transactions of fisherfolk and ship builders, painted in a romantic mode by such American artists in the early nineteenth century as Washington Allston; by mid-century Luminists such as Gloucester's Fitz Hugh Lane; and by such late nineteenth-century naturalists as John Singer Sargent. But present is that staple of romantic coastal drama, the shipwreck picture, illustrated by William Trost Richards's *Shipwreck*, a genre popular in late *56* eighteenth- and early nineteenth-century European painting. It was introduced into our art by English-born Thomas Birch, who worked in Philadelphia.

Such paintings constitute what are probably Birch's finest and most dramatic representations; his reputation as our first marine painter was established on his depictions of the naval actions of the War of 1812. In addition, Birch essayed all the other themes associated with the marine painter: ship portraiture, port and harbor scenes, and coastal views.[2] Historically, the present show begins with Birch's *Seascape* (View of Maine Coast), though, despite the existence of other paintings also designated as *24* Maine subjects, there seems to be no confirmation that Birch travelled that far up the coast. Nantucket would appear to be the most northern of his documented painting grounds.

It may be, too, that similar to his European coastal scenes, which range from Scotland to the Mediterranean, Birch depicted his subjects, and assigned titles, on a conceptual rather than an empirical basis, as there is no evidence that he travelled abroad. In any case, his *Seascape* conforms to the criteria of early nineteenth-century romantic art. Nature here is still inimical. While the wilderness had recently been pushed back sufficiently for Americans to find pleasure in views of wild, untamed scenery, the sea remained a realm of constant (and very real) peril. Though Birch's scene is not a threatening one, the two figures in the middle ground, who would seem to be designated as sailors, one of them holding a harpoon, appear dwarfed by the great rock formation looming above them, and their spindly forms are no match for the restless force of the infinite sea. More to the point, they stand on a bit of shore, but the waves appear to be making inroads on their limited "turf," and the picture is quite properly oriented ocean-ward. The concept of "beach" seems far in the distance.

Yet, by mid-century, and especially among that group of painters who have, in recent decades, been designated "Luminists," both the vigor and the threat of Nature appear more tamed. A quintessential example of such coastal painting is John F. Kensett's *The Seashore*. Though the composition is remarkably *53* similar to the earlier work by Birch — tiny figures on a stretch of shore at the left, looming rocks above, and active, restless waters — there are also significant differences. In addition to introducing a much more precise rendering of landscape forms, based upon careful, exact observation, Kensett's band of seashore on the left swells outward, rather than yielding to the encroachment of the sea. The waves

25

retreat in measured cadence, inviting both the viewer and the tiny figures on shore to accept the entire foreground as flat terra firma. Indeed, the low horizon and the evenness of the luminous sky—so very different from the threatening dark clouds of Birch's scene—draw our eye simultaneously from side to side and from foreground to background.

We are not quite yet in the realm of seaside bathing, but the figures here would appear to be enjoying recreational boating, rather than involved, as are Birch's sailors, in the very serious vocation of whale hunting. The orientation here, as in many of Kensett's Newport and Massachusetts North Shore pictures, is on the ocean coast, and with the appearance of morning light coming from the right, the figures commence pleasureable activities. And despite the turbulence of the water, with the waves cresting to sharp peaks, the expanding carpet of shoreline would seem to promise an enjoyable experience.[3]

57

Another artist working in a Luminist mode was Alfred Bricher. Though the composition and the mood of serenity of his *Low Tide, Manomet, Massachusetts* are similar to Kensett's *Seashore*, Bricher seldom introduces figures into his oil paintings, the human presence being suggested only by the small boat anchored along the shore and the sailing vessels seen on the distant horizon. Figures are often to be found, however, in Bricher's watercolors, which have only more recently been accorded recognition.

66

In *Baby is King*, a large group of women, garbed in voluminous dresses in the latest fashion, are enjoying the sun and seashore, while compositionally they surround and enframe the tiny figure of the title, who is also emphasized by the bright blue pattern of its parasol shade and blanket. The subject and color scheme recall the near-contemporary work painted on the French coast by Eugène Boudin, perhaps the most famous of all the Continental masters of the recreational shore scene, though Bricher maintained a specificity which Boudin deliberately shunned. In addition to the baby, several women in Bricher's watercolor hold parasols, sun shields which affirm the warmth and glow of the light reflecting off the broad plane of sand in the foreground. Despite the formality of the women's costumes, this natural warmth adds to the expression of ease and relaxation which is projected by the poses of the figures, and is picked up also in the carefully detailed accessories, the pail and shovel at the left and the book right of center, which further suggest leisure activities of children and adults alike.[4]

In Albert Bierstadt's *Cove with Beach*, the artist creates a "plateau landscape", situating the spectator on high ground, among the dark colored dunes in the foreground, and precipitously drops us down upon the wide swath of clear bright sand, an inviting environment complemented by the glistening emerald green of the cove. A single figure is silhouetted against the sand, but the activity and purpose is undefined. In William Bradford's *Lynn Beach*, figures are promenading along the broad expanse of shoreline, and two ride horses, thus doubling recreational pleasure. The shore was thus a situation for quite fashionable outings, a place to see and be seen and, as the Brooklyn, New York artist Samuel S. Carr reminds us in his many beach views, a place to be photographed and documented against the exhilarating background of limitless sea and sky.[5] His *Beach Scene* probably records such activity at Coney Island, from which Carr often drew his subject matter beginning about 1879, and which from 1875 had become increasingly fashionable. The Luminist landscape painter Francis Silva, who specialized in both marine subjects and coastal scenes, whose work *Sunrise: Marine View* is included in the exhibition, was another artist who responded to the Coney Island shore, where he was active from 1871.

50

65

57

Seaside promenading and coastal resort life were phenomena of the nineteenth century. Ocean bathing began earlier, about 1750, with Brighton, England, established as probably the earliest coastal spa, but this development was involved primarily with health and a belief in the therapeutic powers of the sea. Sea bathing for restorative purposes spread to Germany and Russia, gradually developed into a recreational pursuit by about 1815 in England, and some years later gained popularity across the Channel on the French coast. Similar developments took place in America in the first half of the nineteenth century.[6] Not surprisingly, while beach pictures are recorded as early as 1813, when Thomas Birch exhibited such a work at the Pennsylvania Academy of the Fine Arts, sea bathing began to be extensively pictured only when it was associated with pleasurable pursuits.

Actually, Benjamin Franklin wrote directions concerning the art of swimming in the eighteenth century, primarily to insure protection against drowning; Franklin's advice, in fact, was reprinted in an English periodical in 1832.[7] In this country, a surprisingly early recognition of pleasure bathing was published in the *New England Magazine* in 1832,[8] but in general, matters of health generated most of the literature on the subject until about 1860, and these early discussions were as much concerned with public and private urban baths and with spas as with seaside bathing.[9] Articles on the art of swimming, however, abound in American and British periodicals from 1860 on, and in turn generated further literature on the nature of suitable and proper swimming costumes, and caricatures of such activity.[10] By the late 1870s, the literature on the subject began to include American accounts of European, particularly French, bathing resort life, as well.[11]

As the earlier works in the present show document, beaches and sea bathing developed along the New England, New York and Middle Atlantic coasts, with Newport, Rhode Island, becoming the most noted beach resort by the middle of the nineteenth century.[12] Beginning in the mid-1850s, a good many painters followed in the wake of the summer migration to Newport. John F. Kensett is probably the painter most associated with the depiction of Newport beach scenes; in addition, he also appears to have explored and depicted views of beaches such as those at Beverly, Lynn, Manchester, Salem, Swampscott, and elsewhere along the North Shore of Massachusetts more than any other artist. South Shore beaches also attracted numerous artist-visitors; Nantasket, near Plymouth, was painted by Arthur Quartley, Frank Rehn and, as seen in the present exhibition, Frank Shapleigh.

Many other artists including James Suydam, Casimir Griswold, Worthington Whittredge, and Martin Johnson Heade frequently painted beach scenes and coastal views in and around Newport. Among Worthington Whittredge's Newport paintings are exhilarating beach scenes and an extensive series of works seen from a hilltop and looking down upon comfortable rural homes, beyond which the glistening expanse of shore is viewed as an extension and culmination of the land mass, and separated from the sky by the thin, dark band of ocean waters no longer seen as a formidable realm. In his beach scenes, such as his *Second Beach Newport*, Whittredge responded to changing atmospheric conditions, employing a freer, more painterly style than Kensett and his Luminist colleagues; and, relatively unusual for Newport subject matter of the period, Whittredge actually situates figures in the offshore waters.[13]

In the cold waters of New England, however, bathing and swimming scenes are rare, especially in the nineteenth century. Rather, the earliest paintings of such activities are in the warmer waters of the Long Island and New Jersey coasts, where a number of communities such as Atlantic City developed as summer resorts. Philadelphia artists, particularly, including George Bonfield, Edward Moran and, beginning in the 1870s, William Trost Richards, frequented the beaches of New Jersey such as Atlantic City, Absecon, and Cape May. The marine specialist James Hamilton was probably the most prolific painter of such beach scenes (though he also painted views of Rockaway Beach on Long Island), and his sketch of *Atlantic City Beach and Bathers* (last known location, James McClelland, Philadelphia), painted in August of 1868, is one of the earliest American paintings actually documenting bathing and swimming recreation.[14]

Probably the best-known nineteenth-century American picture of such a subject was painted the following year, Winslow Homer's *Long Branch, New Jersey* (Museum of Fine Arts, Boston), (fig. 1) of 1869. Even here, the primary subject is the promenading of stylish ladies, with parasols and pet dogs, rather than bathing in the sea and surf, for only a small segment of beach can be seen, far in the distance at the left, and while a number of figures appear settled upon and walking along the beach, none appear to be in the water; swimming is rather most prominently indicated in the bathing costumes left out to dry along the railing next to the bath house. Despite the elegance of the principal figures in Homer's painting, Long Branch was a more popular and earthy resort, less refined than Newport, which is not apparent from Homer's fashionable strollers. The atmosphere of leisure and pleasure, in fact, is as fully established by the warm glowing sunlight and the sense of breezy airiness that pervades the scene as it is by the figural activities and the bath house on the cliff.[15]

52

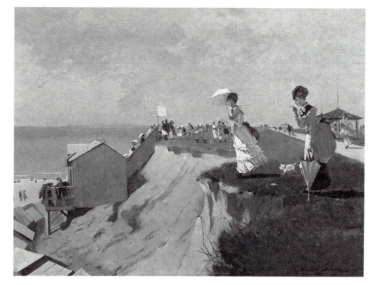

WINSLOW HOMER
(1836-1910)
Long Branch, New Jersey, 1869
oil on canvas, 16 x 21¾ in.
Courtesy of Museum of Fine
Arts, Boston; The Hayden
Collection

Nevertheless, Homer did draw and paint bathers at Long Branch, as records of several now unlocated paintings, and wood engravings which appeared in *Appleton's Journal* and *Harper's Weekly*, attest; in the engraving *The Beach at Long Branch,* which was published in *Appleton's* on August 21, 1869, the more raucous and democratic nature of the Long Branch beach crowds is evident, though the gentleman and damsels in the foreground, promenading on the sands, are still quite elegant. By the time Homer painted at Long Branch, it had become renowned as a summer resort, a reputation which went back to the first decade of the nineteenth century, with one of the earliest resort hotels in the country. But the pleasures of the shore were marred by the frequency of shipwrecks in the region, such as the *New Era* which sank off the coast at Long Branch in 1854 with the loss of two hundred and forty people. Long Branch's real fame was established in the 1860s, beginning with the visit of Mrs. Abraham Lincoln in 1861. Its supremacy among Jersey shore resorts was assured when President Ulysses S. Grant stayed there in the summer of 1869 and established a "summer White House" on Ocean Avenue in adjacent Elberon; this, in turn, must have occasioned Homer's sojourn.[16]

Homer continued to paint beach and bathing pictures during the 1870s; one such oil, while not nearly as ambitious as his *Long Branch,* is *On the Beach* of 1870, a composition daring for its time. Here a group of young women, some with skirts hoisted, wade in toward the waves at the far left. Homer's asymmetrical arrangement, crowding the figures at the edge of the composition, with the long rolling breakers dominating the rest of the scene, appears almost oriental in design, and while there is no sense of the ominous in this airy, light-filled depiction, the majesty of watery Nature is romantically contrasted with the tiny figures. They, in turn, establish a rhythmic cadence in the repetition of similar long-brimmed hats, tilted at different angles, and the voyeurism inherent in such bathing pictures takes on an added dimension in the superbly rendered reflections of their legs and skirts in the wet sand.

On the Beach was most likely painted at Manchester, Massachusetts, another of the North Shore resorts. Four years later, Homer painted beach scenes both at East Hampton, Long Island, and at Marshfield, Massachusetts, on the South Shore, the site of *On the Beach, Marshfield* (the work must actually have been done at a nearby coastal spot, since Marshfield itself is about three miles from the coast). This work is a watercolor, a medium that Homer began to investigate only the year before, in 1873. There is no suggestion here of bathing activities; the work is rather a "promenade" beach scene, dominated by the single figure in black, looking out, toward the distant tiny ship on the horizon, thereby establishing a visual tension between the figure and the ship.

After returning to this country in 1882 from his two-year sojourn on the North Sea coast of England, Homer settled at Prout's Neck, Maine, but his response to the coast and the sea was expressed in monumental and dramatic terms far different from the charming seaside pictures he had created previously. Indeed, Homer began a tradition of coastal paintings involving the elemental confrontation of pounding surf and rocky shoreline carried on by such prominent early twentieth-century artists as Paul Dougherty and, in this exhibition, Frederick J. Waugh in his *Green Wave*. Such scenes were often painted on the Maine island of Monhegan, which attracted a great number of artists. Rockwell Kent was one of these; he first visited Monhegan in 1905. Kent's work reached its maturation in 1907-09, with impressive paintings such as *Headlands, Monhegan*, in which the pounding sea of Homer and Waugh was replaced by a majestic stillness over the vast stoney terrain. Figures seldom appear in these coastal scenes by Homer, Waugh and Kent; these artists found on the Maine coast a last frontier of natural wilderness.

Still, once the bathing and swimming subject was introduced into American art in the late 1860s, it increasingly gained adherents among both painters and patrons. This was due in part, of course, to the growing popularity of this form of recreation, complete with its support system of protected beaches, resort hotels, and ever-more-convenient transportation to seaside communities from the urban centers of population. But an additional factor was the changing nature of our art. The late nineteenth and early twentieth centuries witnessed the growing adherence to plein-air painting, that is, painting done not in the studio from drawings and notations created in the field, but directly from nature. The artists, therefore, became more and more involved with attempting to record their immediate impressions of light, color and atmosphere, rather than the more solid and enduring elements of the landscape, as had been their primary concern earlier, and the seashore offered an especially suitable setting. Moreover, they increasingly sought out, not untamed wilderness scenery, but more pleasant and relaxed surroundings, where they could enjoy the amenities of civilization, the artists often congregating together and establishing summer art colonies which were almost always on an ocean coast. And, as their works were often finished on the spot, they might even have the opportunities to find a clientele "in situ," rather than depend exclusively upon exhibitions held back in New York and Boston in commercial galleries or at annual shows of art academies and societies held in large urban communities.[17]

A further development, in fact, was the establishment of a tradition of art exhibitions in these summer art colonies, and the concomitant establishment of a permanent gallery or exhibit hall to house annual exhibitions of the artists' summer work. The institution of such well-organized, on-site annual shows at the art colony in Old Lyme, Connecticut, in 1902 appears to have been innovative in this regard, but it was soon followed at other summer art centers such as those at Provincetown, Gloucester, and Rockport, Massachusetts, and elsewhere in the nation.[18]

An even earlier development which indirectly led to increased painting of shore scene and bathing pictures was the summer art school movement. Once the artists had regularly located themselves for the summers in attractive and comfortable surroundings, they began to realize that these would allow them a double advantage. Not only could such coastal situations become the site of their own work, but they offered an ideal setting at which to establish classes or a school for part or all of the season. From tyros to talented amateurs, young would-be painters (the great majority of them women) flocked from as far away as the Midwest and Texas to take such summer courses under established masters of plein-air painting, and these students in turn usually chose to paint subjects readily at hand and similar to those of their teachers—again often shore and beach scenes.[19]

John Twachtman had an outdoor painting class in Newport in the summer of 1889, and the following summer there was a spate of classes held on Cape Ann, Massachusetts: Frank Duveneck taught oil painting and Rhoda Holmes Nicholls watercolor in East Gloucester, and Joseph DeCamp held a class for twenty women at Annisquam. Probably in 1891, Twachtman, having settled in Greenwich, Connecticut, inaugurated a summer school at the Holley House in nearby Cos Cob, and that same summer the most famous of all summer schools of the period was established by William Merritt Chase at Shinnecock on Long Island's South Shore. Robert Henri taught a summer class at Avalon, New Jersey,

in 1893, and Walter Satterlee set up classes at Bellport, Long Island, in 1895. The marine specialist Charles Woodbury had first painted in Ogunquit, Maine, in 1888, and ten years later he built a home there and began two decades of summer teaching. Charles Hawthorne, who studied with Chase at Shinnecock in the summer of 1896 and became the master's assistant the following year, established his own summer school at Provincetown on Cape Cod in 1899. The summer classes held by the painter Joseph Boston, in affiliation with the Brooklyn Art School, were held in a different place every year. In 1902 Frank Du Mond established a summer school of New York's Art Students League in Old Lyme, Connecticut eight years after Boston had first taught there.

The works produced in the various coastal art colonies and at these summer schools did not, of course, necessarily involve the painting of views along the shore; Satterlee's own art and his teaching, in fact, were concerned with picturesque figure work and exotic genre. Likewise, although Old Lyme is situated near the mouth of the Connecticut River and only a few miles from Long Island Sound, the painting of scenes of the several adjacent beaches was seldom a concern for the many artists active in that long-lived art colony. William Chadwick, an early member of the community who began summering there in 1902 and is represented here with a sparkling Impressionist view of Griswold Beach, constitutes a relatively rare exception. When Old Lyme painters did undertake beach and coastal scenes, they often did them elsewhere in New England, or in Bermuda where a number of them wintered, or abroad in Europe. Edmund Greacen's 1914 *Beach Scene at Watch Hill* was painted in the pale, somewhat blurred mode for which he was noted; the picture was not created at Old Lyme, which community Greacen joined a year after his return from Europe in 1909, but at the popular summer resort situated on Rhode Island's most westerly projection. Still, the majority of the painters working in the turn-of-the-century art colonies in the northeast and, in turn, most of their students, adopted the increasingly prevalent Impressionist aesthetic of vivid brushwork and a fascination for colored light, and they often found that the seashore offered them an ideal setting in which to explore and teach these concerns. Even Robert Henri, not usually associated either with themes of seaside leisure or with the light and color of Impressionism, investigated the subject briefly during the time he taught at Avalon, New Jersey. Henri's *Beach at Atlantic City* and other pictures of this period, 1892-93, are among his most colorful and light-filled, though they are also characterized by a certain melancholy and emptiness, here particularly noticeable in the broad foreground expanse of empty sand, occupied only by the vacant beach chair.[20]

Indeed, some of the artist-teachers themselves were specialists in paintings of the sea and shore; this was true of William Merritt Chase during his years at Shinnecock in the 1890s and of Charles Woodbury throughout his long career. Chase's own Shinnecock pictures, such as his 1897 *Morning at Breakwater, Shinnecock*, represent his finest response to the contemporary concerns of outdoor light and color. Some of these emphasize the rolling dunes and glistening, spiky bayberry bushes of the southern Long Island landscape; others, such as the present work, concentrate upon the unbroken coastline, and the broad expanse of beach, glowing in bright sunlight. While Chase did paint pure landscapes at Shinnecock, most of his summer work included figures of mothers with their children, playing in the dunes or, as here, frolicking on the beach. These, which include representations of his own wife and children, project a casual enjoyment of nature which echoes Chase's own satisfaction and contentment in the merging of his dual vocations. As one of the many writers on his summer school noted: "His summer vacation is his busiest and happiest time, and upon the work then done he not infrequently finds his inspiration for the remainder of the year."[21]

During these summers, Chase spent several days a week offering criticism to his students at Shinnecock, who would themselves be out on the dunes and the beach painting en plein air, and this would be a practice that most of them, at least, would continue throughout their careers and some, in turn, would pass on to their own students. Mabel Woodward, who made the beach scene her specialty, and Alice Schille were roommates when studying with Chase at Shinnecock in the summer of 1899. Schille became one of the outstanding American watercolor masters in the early twentieth century. Though

86

72

she lived and taught in Columbus, Ohio, Schille found her pictorial subject matter elsewhere in this country, and in Europe and in Mexico, during her summer travels. World War I necessarily kept Schille in this country, and a number of her summers during the war years were spent at Gloucester, Massachusetts, long a favorite painting ground for American artists as well as a tourist bathing resort. By that time, her earlier, more delicate Impressionist style was reinvigorated by a greater chromatic intensity derived from more modernist European artistic currents, which found expression in bright bathing costumes and beach umbrellas.[22] One of the most eminent of Chase's Shinnecock pupils was Julian Onderdonk, who went on to become the best-known Texas artist of the early twentieth century. But while Onderdonk is especially remembered for his vivid paintings of fields of Texas wildflowers, he continued to divide his time between New York and San Antonio throughout the first decade of the present century; the small *Seascape* exhibited here may well date from the productive summer he spent 75 studying with Chase at Shinnecock during the school's last session in 1901.[23]

Many of the students at Charles Woodbury's summer school in Ogunquit, Maine, also followed their teacher, not only in espousing vivid brush work and high colorism allied to Impressionism, but also in exploring the subject matter of shore and sea. Perhaps the most talented of those represented here was Gertrude Fiske; like many of the American Impressionists, Fiske's oeuvre is divided between dark 83 and dramatic interior figures, and portraits and outdoor scenes filled with light and color. These are sometimes close-up renderings of the figure in a landscape, but Fiske also successfully attempted panoramas of casual bathers at the Ongunquit beach, the figures rendered in a summary manner and the landscape simplified and abstracted beyond the more traditional, naturalistic manner of her teacher.[24] Beatrice Whitney, later Beatrice Whitney Van Ness, was another pupil of Woodbury, studying with him in the middle 1910s; her work was included along with Fiske's in a three-artist exhibition in Boston in 1914. Van Ness painted colorful beach scenes similar to Fiske's, though she later employed slashing brushwork and a vivid, almost strident colorism in close-up views depicting bathers on the beach, such as *Summer Sunlight*, reminiscent in aesthetic of the work of the European Fauves.[25] 83

Actually, though the painting of beach and coastal scenes flourished in this country especially during the heyday of Impressionism, only Chase and Childe Hassam among the leaders of the movement, who banded together in 1897 to found The Ten American Painters, were themselves especially drawn to such themes. Chase was actually the eleventh member of "The Ten," replacing John Twachtman several years after the latter's demise in 1902. The Boston contingent of The Ten, Frank W. Benson, Edmund Tarbell and Joseph DeCamp, was not particularly known for this subject matter, although all three were major art teachers in Boston for many years, the first two long active at the Boston Museum Art School from 1889 on. Both Gertrude Fiske and Beatrice Whitney Van Ness studied there. The latter formed a close relationship with Benson, and joined him in summering on the island of North Haven, Maine; her home there at Barlett's Harbor was just north of Benson's, who had purchased an old farm at Wooster Cove in 1901. It was on the island that many of Van Ness's major works were painted from the 1920s on, while the great majority of Benson's landscapes, and his outdoor scenes of children and young women, were painted on North Haven.[26]

J. Alden Weir and his close friend and colleague, John Twachtman, also members of The Ten, were important Impressionist painter-teachers, but coast and shore scenes, as those in the present exhibition, are quite rare among their work, this despite the fact that a number of Twachtman's students at his art school at Cos Cob in coastal Connecticut investigated such subjects. Twachtman's *Sea Scene*, an unu- 73 sually dramatic work for him, partakes of the dynamics of elemental natural confrontation more often associated with Winslow Homer, and is antithetical to the colorful, casual beach scenes especially associated with Impressionism. His *Beach at Squam* (Annisquam), is probably a later work, most likely 74 done during his first summer spent at nearby Gloucester, in 1900; Twachtman had earlier illustrated scenes of American and European beaches including several near Gloucester, but whether these were based upon photographs and written descriptions or on his actual experience is not known.[27] While Gloucester had evolved into the major summer resort and artists' colony of Cape Ann during the 1890s,

Annisquam, further North on the Cape, had developed a separate identity and its own contingent of summer painters even earlier. Though Twachtman's depiction of *Beach at Squam* is quieter than his earlier *Sea Scene*, the artist still eschews the leisure activity implicit in such a subject, concentrating rather upon its desolate grandeur.

Emil Carlsen, a close friend of J. Alden Weir, was an artist whose landscapes share many characteristics of that artist's approach to Impressionism. Though Carlsen is best-known for his superb still lifes, in the later years of his career he turned increasingly to landscape painting, creating large, panoramic views featuring an abundance of cloud-filled sky. He was a great admirer and a friend of Charles Woodbury and also of Frederick Waugh and, like them, painted on the Maine coast. Some of Carlsen's scenic pictures, such as *Summer Clouds* of 1913, are shore scenes and marines, generally unpopulated, though here the artist includes a boat, beached upon the broad expanse of sand. However, unlike those of Woodbury and Winslow Homer, Carlsen's landscapes and coastal pictures often exude a mood of great tranquility, combined with the suggestion of infinite space.

There is a superficial similarity between Carlsen's *Summer Clouds* and Childe Hassam's *Fishing Skiffs, Nantucket*, painted about three decades earlier, though Hassam's work is, in fact, a small watercolor, and Carlsen's oil is quite large. Both works feature a boat beached upon a broad expanse of sandy shore, with a wedge of ocean in the distance. Hassam's beach scene, probably painted on a visit to Nantucket in 1882, is a very early example of his work, one of the series of watercolors that first brought him to public attention in Boston. Here, the dominant artistic mode is the "glare" aesthetic, a flat plane reflecting brilliant sunlight, where the artist is thus able to maintain tight and careful drawing, especially in his small boats, an artistic approach that gave way to the broader and more colorful aesthetic of Impressionism after Hassam spent three years in France from 1886-89. The beached boat upon the sands was a not infrequent motif in late nineteenth-century Nantucket art. Though most landscapes painted on Nantucket island were necessarily coastal scenes, it was not until well into the twentieth century that scenes of bathing on the beach appeared there.[28]

Of all the major American Impressionists, Childe Hassam was most consistently concerned with shore scenes and marines. He explored the entire New England coast, but no region so consistently attracted his attention as the island of Appledore, among the Isles of Shoals off the coast of New Hampshire and Maine. He visited the islands even before 1886, and after his return from Europe he began to go there regularly in 1890, attracted by the informal salon organized on Appledore during the summer time by his close friend, the poet, essayist and gardener Celia Thaxter. It was from 1890 to 1894 that Hassam painted some of his finest works depicting the garden and shore configuration of the island. After Thaxter's death in 1894, Hassam's visits were somewhat more sporadic, but he continued to explore the rocky coast of Appledore into the middle of the second decade of the twentieth century, as in his *Seascape—Isle of Shoals*, typical of Hassam's many reductive views of the surf-pounded rocks. The basic components and the compositions are derived from Winslow Homer, but as an Impressionist, Hassam ameliorates the potential drama with high-key color, not only the bright blue of sea and sky, but the vivid reds and blues that define the rocky coast.[29]

Though Hassam began to include ideal nudes among the rocks of some of his later Appledore pictures, he was only occasionally a painter of beach scenes featuring leisure activity. In part, the colder climate of Appledore where most of his coastal pictures were painted was not conducive to such a theme, but even when he painted in art colonies further south—as he did often at Gloucester, Provincetown, Newport, Cos Cob and Old Lyme—it was rather the towns, the activities therein, and the surrounding landscape that interested him, not the pictorial potential of their coastal situation. Once Hassam acquired a permanent summer home in 1919 in another long-established art center, East Hampton, Long Island, he was drawn more to the broad expanse of ocean coast, though even so, some of the coastal pictures he did there depicted allegorical and classical figures incongruously roaming the Long Island dunes. The same summer that he settled in East Hampton, Hassam also spent a good deal of time painting on Cape Ann, including such a traditional bathing scene as *Little Good Harbor Beach*, a rarity in his oeuvre.

77

70

69

70

Hassam's classical allegories on the Long Island coast were anomalies in American shore and beach painting; such work was necessarily naturalistic, however different the particular stylistic approach of the artists. The principal exceptions to this, in addition to Hassam's late work, are the idealized landscapes populated by nymphs, often nude, painted by Arthur B. Davies in the early years of this century, some of which are situated along the shore, and the even earlier and more raucous and colorful work of Charles Walter Stetson painted at the turn of the century, such as his *Water Play* of 1895-96. This *71* painting was done during the artist's second and longer stay in Pasadena, California, and then was acquired by Isaac Bates, the leading art patron in Stetson's home town of Providence, Rhode Island. Rare in American art of the time, the sense of restless abandon among the lightly clad, dancing young women on the shore is expressive not of Stetson's empirical observation, but of the artist's own sensual temperament, a romantic and synaesthetic fantasy.[30]

The first decade of the twentieth century witnessed several developments which gave further impetus and variation to the painting of shore and bathing pictures. One was the infusion into our art of a new and vibrant urban realism, associated particularly with the artists of The Eight, who painted and exhibited together under the leadership of Robert Henri. The work of these painters and those contemporaries with similar pictorial perceptions, later dubbed The Ashcan School, represents a reaction to the more aesthetic concerns and the light-hearted subject matter of the Impressionists, replacing a philosophy of "Art for Art's Sake" with one of "Art for Life's Sake."

While one associates their work particularly with gritty street scenes and vivid lower class figure painting, the leisure activities of the masses did not escape their attention, and this, of course, included beach scenes. While Henri himself does not seem to have tackled this subject after his earlier excursion on the Jersey coast while he was briefly involved with the Impressionist aesthetic, John Sloan's *South Beach Bathers*, painted in 1908, the year of the group's historic show held at the Macbeth Gallery in *89* New York, can be identified as the quintessential bathing scene of this new artistic mode. Here, on a Staten Island beach, most of the figures, many in bathing costumes, are informally arranged to focus around the voluptuous young woman standing at the left, who attracts the casual attention of her female companions in the foreground, and more serious interest among the male bathers spread over the beach. This woman (while working on the picture, Sloan identified it with the alternate title of *South Beach Belle*) appears to be preening with an elegant hat—hardly a bathing cap!—which echoes that of the little girl at the right, who is being dressed or undressed by her far more elegantly garbed mother. The playful sensuality of the scene is reinforced by the two women in the foreground, who both rest their arms upon the body of a reclining male bather. The democratic nature of South Beach is emphasized in the contrast of the standing lower class woman in dark bathing costume (which Sloan considered very chic at the time) with the mother, dressed in white and seated on the sand. But the generally plebeian character is defined by the angular poses, the shirtsleeved man seated on the sand, the male figure in the foreground with a cigarette in his mouth, and the picnic fare of hotdogs being enjoyed by the principal group.[31]

Such a subject was rare for Sloan, but a very popular one with his fellow member of The Eight, William Glackens. *Cape Cod Pier*, also painted in 1908, initiated a sequence of beach paintings by Glackens *12* which include a series of works painted at Bellport and Blue Point on Long Island's South Shore in the early and middle years of the 1910s, and those done at Annisquam and Gloucester on Cape Ann in 1919, all of them infused with a casual joyfulness. In these later works, the impact of Renoir's art is fully evident; already here, in the earlier *Cape Cod Pier*, Glackens has abandoned the dramatic chiaroscuro seen in his previous "dark" period garden and park pictures, which he had derived from Manet, substituting a rich, vibrant colorism, totally appropriate to a summer beach scene. But the forms of figures, buildings and landscape are sharply demarcated, the artist having not yet adopted the feathery touch that would characterize his painting of the following decade. Unlike the great majority of Glackens's beach paintings, this earliest example is a "promenade" picture rather than a bathing scene.[32]

The impetus to turn to such a theme may have come to Glackens from his friend and colleague among The Eight, Maurice Prendergast, with whom Glackens was in touch when he was on Cape

90, 91 Cod that summer of 1908. Prendergast was living in Boston, and had been painting beach scenes as early as 1891 at Dieppe, on the French Channel coast, during the time that he was studying in Paris. Back in America in 1894, Prendergast first became associated with the watercolor medium, painting brightly colored scenes of women and children at Revere Beach; these, again, are promenade pictures, concentrating upon the pageantry of figures strolling on the shore, rather than bathing. Only late in his career, and rather in the oil medium, would figures substantially appear actually in the water, and these were fantasies solely of women, nude and clothed. Revere Beach remained a favorite painting ground for Prendergast, though he also attempted similar subjects at Ogunquit, Maine and at Marblehead, Massachusetts. Although scenes of women promenading in parks along the shore would gradually replace Prendergast's dominant concern for beach subjects, particularly in his oils, the artist never completely abandoned the latter interest. But whether watercolors or oils, beaches or parks, in New England or New York City, an underlying theme in Prendergast's work was a pleasure ground for common leisure purpose.

100, 101 Abraham Walkowitz was probably the closest artistic heir to Prendergast among painters of beach scenes, though certainly not a follower or imitator. Rather, it was early European Modernism, particularly the bathing pictures of Henri Matisse and Paul Cézanne, which influenced him. Growing out of that style was the American Modernism of which Walkowitz was a part; it constitutes a second significant artistic development in this country during the century's first decade. It is known that Walkowitz attended the 1907 Cézanne Memorial Exhibition at the Salon d'Automne in Paris where studies for the French artist's monumental *Bather* series were on view. Walkowitz may well have recognized the power of the bathing theme to convey concepts of Modernism. Yet for the most part he eschewed Cézanne's structural clarity, but retained, especially in his watercolors, the virtuoso handling and transparent colors of the medium, the clear, concise drawing, and the use of areas of unpainted paper, all characteristics of Cézanne's art. The brilliant unmodulated color and curvilinear rhythms in Walkowitz's many bathing pictures are closer to Matisse, but the general gaiety of the scene, the friezelike, unfocused arrangement of many of his compositions, and the anonymity of the figures suggest a kinship with the work of Prendergast. Walkowitz painted bathers, both upon the shore and actually immersed in the waters, for almost four decades beginning in the late 1900s, but these have generally been overlooked in favor of his Modernist urban imagery and especially his literally thousands of drawings of the dancer Isadora Duncan.[33]

Early twentieth-century European Modernism impacted on the work of Walkowitz and a number of other Americans such as Max Weber, who painted beach scenes, but the vivid realism of The Eight had an obviously greater influence on painters of the period who were involved with such basically representational images. One of these painters was Gifford Beal, who in the second decade of this century abandoned his earlier dramatic and lonely images of the tempestuous ocean, quiet Maine coves, and dramatic Palisades cliffs, for colorful circus subjects, garden scenes and lawn fetes. These are painted with the bravura handling of Sloan and his colleagues, but they describe a more upper-class existence, and this also characterized many of his beach and bathing scenes, such as his relatively late *Garden*

93 *Beach* of the 1940s, probably painted at Rockport, Massachusetts, with the art colony of which Beal began a long association in 1921. Here, the costumes of several of the foreground figures identify them as anything but plebeian.

A friend and associate of Beal's, and another member of the Rockport community, was Max Kuehne, who had previously studied with both William Merritt Chase and Robert Henri. In his early picture,

76 *The Green Hotel, Martha's Vineyard*, of 1911, Kuehne's painting still reflects something of the light and sparkle of Impressionism. The beaches of Martha's Vineyard never attracted as many artists as Cape Ann or even the neighboring island of Nantucket, but Kuehne's visit in 1911 coincides with the growth of art activities on the island, the sculptor, Enid Yandell, having established the Branstock School, a summer art school, at Edgartown in 1908.

Also in the first decade of this century, a more direct European influence than that of the European Modernists upon both the nature and the popularity of the beach and bathing picture in this country

was that of the Spanish painter Joaquin Sorolla. By 1899, Sorolla had begun to move away from Social Realist themes to indigenous Spanish subjects in which brilliant sunlight was featured and which were situated on the Spanish Mediterranean coast. These included depictions of fishermen and fishing vessels, especially of figures promenading upon the beach and others, especially young children, swimming naked in the waters. Sorolla's incredible virtuoso brushwork and brilliant colorism, infused with sunlight, was related to and yet distinct from Impressionism; "Sorollismo" was internationally acclaimed, even before the artist was honored in 1909 with a gigantic exhibition of 350 paintings at New York City's Hispanic Society of America, one of the largest and best-attended one-man shows ever held in this country.

Sorolla's paintings were admired by such diverse American masters as Childe Hassam and John Singer Sargent, while William Merritt Chase, another admirer of the Spanish master, brought his summer class to visit Sorolla's home and studio in Madrid when they were abroad in 1905. A number of American artists studied in Spain with Sorolla. The most prominent of those was probably Jane Peterson, who joined the painter in Madrid in the summer of 1909 on the advice of a colleague, F. Hopkinson Smith.[34] Though Peterson absorbed both Sorolla's attraction to joyous subjects and his colorful, sun-filled method, her need to manifest careful structure and her concern for drawing, often evident in strongly outlined forms, prevented her from realizing his vivacious freedom. Peterson travelled and painted all over Europe and North Africa, as well as at beaches and harbors along the Atlantic coast from New England to Florida (including Edgartown, Martha's Vineyard, a few years after Kuehne's visit), until she settled in a summer home at Ipswich, Massachusetts after her marriage in 1925. Her *Beach at Spring Lake*, a resort some miles south of Long Branch, records a New Jersey bathing scene.[35]

84

The American painter who would seem most fully to reflect the impact of Sorolla, however, was Edward Potthast. A Cincinnati artist, Potthast had been introduced to Impressionist color while painting at Grez in France in 1889; he brought this then-innovative aesthetic back to his home town, but moved to New York City in 1896. Potthast appears to have begun to specialize in bright, colorful beach scenes only during the 1910s, quite likely due to the tremendous popularity evidenced by the Sorolla exhibition of 1909. Many of Potthast's beach paintings were probably done at Rockaway Beach and Coney Island, and their bright colors, broad brushwork, and generally anonymous, often featureless figures afford effective aesthetic contrast to the earlier work done there by Samuel S. Carr. Indeed, strong color accents of bright bathing costumes and vivid blue water, frequently found repeated in the rounded forms of balloons, bathing caps and/or beach umbrellas, often unify the artist's otherwise very casual compositions, reflecting his basic theme, the enjoyment of popular leisure at the seashore.[36]

78, 79

While the great majority of American coastal and beach pictures painted during the nineteenth and early twentieth centuries were done in the northeast, where not only most of the popular resorts but also the majority of artists' colonies were situated, artists were often attracted to virgin pictorial territory precisely because it was previously unexplored, as well as for unusual features of topography and vegetation. Florida began to develop as a resort area only in the 1880s, but northern artists began to visit there and to paint as early as 1859; the area around St. Augustine and along the St. Johns River was the first area frequented by painters. Thomas Moran was one of the earliest of these, staying in Florida at St. Augustine on an assignment from *Scribner's Monthly* in 1877, and illustrating and subsequently painting a number of coastal scenes of Fort George Island which feature a broad expanse of beach dominated by palm trees and tropical foliage. The world of resorts and tourism seems deceptively far in the distance.[37]

59

Beach and leisure scenes along the coast of the Gulf of Mexico, stretching from Florida to Texas, would appear to be extremely rare, though several such works by the New Orleans portraitist John Genin are known from the 1870s and '80s. They include a bathing subject at Grand Isle at the mouth of the bayou country, and also a shore scene on Lake Pontchartrain. Although the midwest is, by definition, an interior region, many states border upon the Great Lakes and artists occasionally painted scenes along the waters there. One who was a specialist in the painting of the Indiana dune country

81

on Lake Michigan in the early twentieth century was the Chicago artist Frank Dudley, who first visited the region in 1912. Nine years later, Dudley built a cabin in the dunes, and became an agent for the preservation of the region, which had begun to attract conservationists and naturalists. He earned the title of "The Painter of the Dunes," and in 1923, Indiana declared the dunes a State Park, at which time Dudley made an arrangement to keep his cottage in exchange for rent of one painting a year. Dudley's paintings are glowing, light-filled renditions, contrasting the beige sands and blue waters, and though they occasionally include buildings—presumably his own studio—the dunes are otherwise unoccupied.[38]

While relatively few artists painted the coast and beaches of the Gulf Coast, the Pacific shoreline was the subject of a good deal of activity in the late nineteenth and early twentieth centuries. Except for the activity of another Indiana artist, Theodore Steele, who became fascinated with the Oregon coast during visits in the summers of 1902 and '03, resulting in a good many beach and shore scenes, few professional painters appear to have chosen to paint the coastlines of the northwestern states, but the very active art communities in both northern and southern California became as committed to investigating the pictorial potential of that coast as did their eastern contemporaries.

In the San Francisco area, where an active art community got started soon after the Gold Rush of 1848, the early genre painters became involved especially with mining and other subjects indigenous to the region, while the increasingly strong landscape school that developed turned for much of the last half of the nineteenth century to the spectacular scenery of the Sierra Nevadas, Yosemite, the redwood forests and more northern California natural wonders such as Mount Shasta. This was true of the best-known San Francisco landscapists of the period, Thomas Hill and William Keith, though late in 1881, Keith was attracted to a new subject, the sand hills of Lone Mountain on the western edge

63

of San Francisco. In the paintings and watercolors he painted there, such as *The Lone Pine*, Keith emphasized the bleak emptiness of the scene, almost devoid of trees and grasses, and barren of figures.[39] Charles Dorman Robinson was another San Francisco artist who specialized in views of Yosemite, even maintaining a studio there, but having begun his professional career as a marine artist, he also painted

60

shore and dune scenes such as *The Wet Sand*, both in Marin County and also south of San Francisco, at Monterey. In addition to Robinson and other marine specialists active in San Francisco, probably the finest painter to specialize in coastal scenes was Raymond Dabb Yelland, who settled in the bay area in 1874. Some of Yelland's outstanding pictures are in the Luminist mode, and bear similarities to the shore scenes of John F. Kensett, but they concentrate upon the juxtaposition of rock formations and sea, and are not beach scenes, as such.

A new theme that attracted the attention of a number of California artists shortly after the turn of the century was the wild flowers of the state, often painted near the ocean coast. This became a specialty of John Marshall Gamble, in the Monterey-Point Lobos region, and of Theodore Wores around San Francisco's seashore, working from Lake Merced to the Golden Gate, his pictures painted directly on the scene. Wores, who was earlier known first for his Chinatown genre and then for his exotic subjects painted in Japan and Hawaii, continued to depict these colorful coastal scenes, greatly enlivened by the growing flora of lupines and poppies, for much of his remaining career. An example is

81

Ocean Shore of San Francisco, Lime Point Seascape, of 1927.[40] Figural beach scenes, however, such as those by Lee Fritz Randolph and *On the Beach* by the portraitist, Caroline Rixford, are relatively rare in the work of San Francisco painters.

Such work is understandably more common in the oeuvre of painters of southern California, where the more felicitous climate is extremely inviting to bathing and to general leisure along the beaches. Clarence Hinkle and William Alexander Griffith, associated with the art colony at Laguna Beach south of Los Angeles, painted colorful scenes of figures on the seashore under bright beach umbrellas, but the finest southern California artist of beach scenes was Alson S. Clark. Clark settled in Pasadena in 1919, after an extremely peripatetic career which had included some time in Monet's home town of Giverny. Clark had also painted beach scenes in Normandy, France, and brought with him to California a vivid color sense and a painterly manner, manifested in his views painted at Mission Beach, San Diego,

with tiny beach tents and umbrellas, and even more diminutive figures, situated on the edge of a vast 80
open landscape, and shown against a bright, cloud-filled sky which occupies most of the painting.[41]
Clark also painted beach scenes nearby at La Jolla, where the most active local painter of such subjects
was the San Diego resident Arthur Mitchell. Even the work of Clark and Mitchell, however, appears
strangely vacant and, except for the paintings of Hinkle and a few others, California beach scenes
seldom depict the varied human activities on the beaches favored by Eastern artists from Winslow
Homer on.

The first hundred years of American pictorial involvement with the shore and beach produced
remarkable changes and growth. The initial perception of that narrow band between land and sea as
an intimation of vastness and danger began to evolve into a perception of dialogue between man and
nature, as well as a staging ground for human intercourse on increasingly diverse levels of activity and
social interaction. The terrors of the sea, of course, had appreciably lessened with the advent of steam-
ships, while sea bathing, at first regarded as strictly therapeutic, quickly became a social diversion.
This was spurred by the commercial development of seaside resorts, which provided a vast array of
pleasures, from the refinements of upper class living to the honkey-tonk activities we associate with
the modern boardwalk. Overall, there is also man's never-ceasing fascination with the aquatic expe-
rience, with the literal immersion into an environment so totally distant from the norm. The sandy or
rocky shore constitutes a transitional platform between the regular and familiar surfaces of dirt, grass,
brick, and concrete, leading to the mysteries of the waters. And then there is the sea itself, offering
exhilaration, coolness and comfort, the thrill of moderate danger, and even the titillation of a bare arm
and ankle and wet, clinging garments. Our artists captured it all in their pictorial evocations of the
allure of sea and shore.

FOOTNOTES

1. The bibliography on American marine and seascape
painting is quite lengthy. For a partial listing, see Archives
of American Art, Smithsonian Institution, *Arts in America
A Bibliography*, 4 Volumes, Washington, D.C., 1979, 2, 1-
211-1-228. The most pertinent publication related to
the present show is: Museum of Art, Carnegie Institute,
The Seashore: Paintings of the Nineteenth and Twentieth Centuries,
exhibition catalogue. Introduction by Gustave von
Groschwitz, Pittsburgh, 1965. In 1959, the Davis Gal-
leries in New York City presented an exhibit of *The Beach
Scene and American Tradition*, which included a good many
of the same artists shown in the present exhibition; the
published catalogue consisted of a checklist with three
illustrations.

2. For Birch, see Doris Jean Creer, "Thomas Birch: A Study
of the Condition of Painting and the Artist's Position in
Federal America," unpublished Master's thesis, University
of Delaware, 1958; Philadelphia Maritime Museum, *Thomas
Birch 1779-1851*, exhibition catalogue, essay by William H.
Gerdts, Philadelphia, 1966.

3. The most recent study of Kensett's art, with bibliography,
is Worcester Art Museum, *John Frederick Kensett An American
Master*, exhibition catalogue, essays by John Paul Driscoll
and John K. Howat, Worcester, Massachusetts, 1985.

4. For Bricher, see Indianapolis Museum of Art, *Alfred Thomp-
son Bricher 1837-1908*, exhibition catalogue, essay by Jef-
frey R. Brown, Indianapolis, 1973.

5. Smith College Museum of Art, *S. S. Carr (American, 1837-
1908)*, exhibition catalogue, essay by Deborah Chotner,
Northampton, Massachusetts, 1976.

6. Von Groschwitz in: Museum of Art, Carnegie Institute,
The Seashore, passim.

7. "Art of Swimming. (Written by Dr. Franklin to a Friend.),"
The Penny Magazine, Fig. 1, July 7, 1982, pp. 143-144.

8. "Swimming. A Dialogue Between Philonao and Colym-
bao," *New England Magazine*, 2, June, 1832, pp. 506-512.

9. "Bathing and Swimming," *The Penny Magazine*, 4, Septem-
ber 12, 1835, pp. 354-355; Sir Julius Cutwater, "The Fine
and Froggy Art of Swimming," *Fraser's Magazine of Town &
Country*, 26, October, 1842, pp. 477-486; "Aids in Swim-
ming," *Chamber's Edinburgh Journal*, 8, July 31, 1847, pp. 73-
74; "A Swim Extraordinary," *Chamber's Edinburgh Journal*, 18,
October 9, 1852, pp. 225-229; "Bathing—Its Use and
Abuse," *The National Magazine*, 3, July-December, 1853, pp.
152-154; Harriet Martineau, "How to Learn to Swim," *Once
a Week*, Fig. 1, October 15, 1859, pp. 327-328.

10. See, for example: "The Art of Swimming," *Godey's Lady's Book and Magazine*, 60, June, 1860, pp. 493-497; "The Art of Swimming," *Eclectic Magazine*, 54, September, 1861, pp. 58-62; "Bathing Abroad and at Home," *(Littel's) Living Age*, 23, October-December, 1863, pp. 67-69; "Ladies' Bathing Dresses," *Godey's Lady's Book and Magazine*, 83, July, 1871, pp. 43-45; "Sea-Side Sketches," *Harper's Weekly*, 28, August 29, 1874, p. 712; Duffield Osborne, "Surf and Surf-Bathing," *Scribner's Magazine*, 8, July, 1890, pp. 110-112; Francis H. Hardy, "Seaside Life In America," *Cornhill Magazine*, 74, November, 1896, pp. 605-619; Sylvester Baxter, "Seaside Pleasure-Grounds for Cities," *Scribner's Magazine*, 23, June, 1898, pp. 676-687.

11. "French Watering-Places," *Harper's Weekly*, 23, August 16, 1879, pp. 657-658; M. G. Loring, "By the Sea in Normandy," *Scribner's Monthly*, 22, November, 1881, pp. 513-527; Julian Ralph, "At Trouville," *Harper's Weekly*, 34, November 1, 1890, pp. 848-851.

12. The literature on Newport is, not surprisingly, very extensive. For some of the early accounts of the town and its role as a resort, see: George William Curtis, *Lotus-Eating: A Summer Book*, New York, 1852, pp. 163-206; "Newport—Historical and Social," *Harper's New Monthly Magazine*, 51, August, 1854, pp. 289-317; George C. Mason, *Newport Illustrated, in a series of Pen and Pencil Sketches*, Newport, 1854; H(enry) T. Tuckerman, "Newport out of Season," *The Knickerbocker*, 52, July, 1858, pp. 24-35; "Newport," *The Knickerbocker*, 54. October, 1859, pp.337-352.

13. The principal study of Whittredge is: Anthony Frederick Janson, "The Paintings of Worthington Whittredge," Ph.D. dissertation, Harvard University, 1975; for Whittredge at Newport, see: Sadayoshi Omoto, "Berkeley and Whittredge at Newport," *The Art Quarterly*, 27, 1, 1964, pp. 43-56.

14. The Brooklyn Museum, *James Hamilton 1819-1878 American Marine Painter*, exhibition catalogue, essay by Arlene Jacobowitz, Brooklyn, 1966, esp. pp. 57, 61, 62.

15. Article in *Every Saturday*, August 26, 1871, quoted in Gordon Hendricks, *The Life and Works of Winslow Homer*, New York, 1979, p. 81.

16. Richmond Barrett, *Good Old Summer Days*, D. Appleton-Century Company, New York, London, 1941, pp. 235-248.

17. For changing artistic attitudes toward the landscape in the late nineteenth century in America, and the growth of plein-air painting, see the essays by Bruce Weber and William H. Gerdts in: The Norton Gallery of Art, *In Nature's Way: American Landscape Painting of the Late Nineteenth Century*, exhibition catalogue, West Palm Beach, 1987.

18. Karal Ann Marling, "The Art Colonial Movement," in: Vassar College Art Gallery, *Woodstock An American Art Colony 1902-1977*, exhibition catalogue, Poughkeepsie, 1977, unpaginated.

19. William H. Gerdts, "The Teaching of Out-of-Doors Painting in America in the Late Nineteenth Century," in: Norton Gallery of Art, *In Nature's Ways, op. cit.*, pp. 25-40.

20. Henri's few located works of this period have long attracted admiration but they have not been subjected to scholarly scrutiny; see: William Inness Homer, *Robert Henri and his Circle*, Ithaca, New York, 1969, p. 213; and, especially, Metropolitan Museum of Art, *American Impressionist and Realist Paintings and Drawings from the Collection of Mr. and Mrs. Raymond Horowitz*, exhibition catalogue, catalogue entries by Dianne H. Pilgrim, New York, 1973, p. 124.

21. John Gilmer Speed, "An Artist's Summer Vacation," *Harper's New Monthly Magazine*, 87, June, 1893, p. 3. This is one of many accounts of Chase's school and his teaching at Shinnecock; for additional references, see Gerdts, "The Teaching of Painting Out-of-Doors. . . ," Norton Gallery of Art, *op. cit.*, p. 39. For Chase's own painting there, see: Ronald G. Pisano, *A Leading Spirit in American Art, William Merritt Chase 1849-1916*, Seattle, 1983, pp. 121-135.

22. See: Columbus Museum of Art, *Lyrical Colorist Alice Schille 1869-1955*, exhibition catalogue, essay by Ronald G. Pisano, Columbus, Ohio, 1988; Keny and Johnson Gallery, *Alice Schille The New England Years 1915-1918*, exhibition catalogue, essay by Gary Wells, Columbus, Ohio, 1989.

23. Cecilia Steinfeldt, *The Onderdonks: A Family of Texas Painters*, San Antonio, 1976, pp. 89-168.

24. Columbia Museum of Art, *Gertrude Fiske: American Impressionist 1878-1961*, exhibition catalogue, Columbia, South Carolina, 1975; Vose Galleries of Boston, Inc., *Gertrude Fiske (1878-1961)*, exhibition catalogue, essay by Carol Walker Aten, 1987.

25. Canton Art Institute, *Beatrice Whitney Van Ness 1888-1981*, exhibition catalogue (exhibition organized by Childs Gallery of Boston and New York), essay by Elizabeth M. Stahl, Canton, Ohio, 1987.

26. Spanierman Gallery, *Frank W. Benson The Impressionist Years*, essays by John Wilmerding, Sheila Dugan, and William H. Gerdts, New York, 1988.

27. N. S. Shaler, "Sea-Beaches," *Scribner's Magazine*, 11, June, 1892, pp. 758-775.

28. My gratitude to Kathleen Burnside for her assistance in providing information on the several paintings by Childe Hassam in this exhibition.

29. For Hassam, see: Adeline Adams, *Childe Hassam*, New York, 1938; Donelson Hoopes, *Childe Hassam*, New York, 1979. For Hassam on Appledore, see: William H. Gerdts, *American Impressionism*, New York, 1984, pp. 99-102. An exhibition of Hassam's work on Appledore will be presented by the Yale University Art Gallery in 1990.

30. See: Museum of Art, Rhode Island School of Design, *Selection VII: American Paintings from the Museum's Collection, c. 1800-1930*, exhibition catalogue, Providence, 1977, p. 185; Spencer Museum of Art, University of Kansas, *Charles Walter Stetson Color and Fantasy*, exhibition catalogue, essay by Charles C. Eldredge, Lawrence, Kansas, 1983, pp. 71-77.

31. Bruce St. John, editor, *John Sloan's New York Scene*, New York, 1965, pp. 138, 167, 223-237.

32. See: Richard J. Wattenmaker, "William Glackens's Beach Scenes at Bellport," *Smithsonian Studies in American Art*, 2, Spring, 1988, pp. 75-94.

33. For Walkowitz, see: Sheldon Reich, "Abraham Walkowitz, Pioneer of American Modernism," *American Art Journal*, 3, Spring, 1971, pp. 72- 83; Utah Museum of Fine Arts, University of Utah, *Abraham Walkowitz 1878-1965*, exhibition catalogue, essay by Martica Sawin, Salt Lake City, 1974; University of Cincinnati, *Abraham Walkowitz and the Struggle for an American Modernism*, exhibition catalogue, essay by Theodore Wayne Eversole, Cincinnati, 1976; Long Beach Museum of Art, *Abraham Walkowitz Figuration 1895-1945*, exhibition catalogue, essay by Kent Smith, Long Beach, California, 1982. Smith deals with the bathing pictures on pp. 20-25.

34. See: Priscilla E. Muller, "Sorolla and America," in: Edmund Peel, et al, *The Painter Joaquin Sorolla y Bastida*, Sotheby's Publications, London, 1989, pp. 55-73, esp. p. 60.

35. J. Jonathan Joseph, *Jane Peterson, An American Artist*, Boston, 1981.

36. Arlene Jacobowitz, "Edward Henry Potthast," *Brooklyn Museum Annual*, 9, 1967-68, pp. 113-128.

37. For Moran's work in Florida, see: Horace H. F. Jayne, "TM (monograph), and his 'Florida Landscape'", *Pharos*, Summer, 1964, n.p.; Thurman Wilkins, *Thomas Moran Artist of the Mountains*, Norman, Oklahoma, 1966, pp. 108-115. Moran's illustrations appeared in Julia E. Doge, "An Island of the Sea," *Scribner's Monthly*, 14, September, 1877, pp. 652-661.

38. Art Institute of Chicago, *Exhibition of Paintings by Frank V. Dudley The Sand Dunes of Indiana and Vicinity*, Chicago, 1918; A. G. Richards, "Lake Michigan's Wonderful Dunes," *Fine Arts Journal*, 36, June, 1918, pp. 19-25; C. J. Bulliet, "Artists of Chicago Past and Present," *Chicago Daily News*, March 28, 1936; Valparaiso Union, *Frank V. Dudley Memorial Exhibition*, essay by J. Howard Euston, Valparaiso, Indiana, 1957.

39. Alfred C. Harrison, Jr., *William Keith The Saint Mary's College Collection*, Moraga, California, 1988, p. 22, with reference to the article, "Art and Artists," *The Californian*, 5, December, 1881, p. 535.

40. Lewis Ferbrache, *Theodore Wores Artist in Search of the Picturesque*, H 57 672 672 1H San Francisco, 1968, p. 50.

41. Jean Stern, *Alson S. Clark*, Los Angeles, 1983.

KATHARINE TIPTON CARTER (b. 1950)

Water's Edge, 1987

acrylic on canvas, 40 x 54
Courtesy of Stein Gallery, Tampa, Florida

Timely Space by the Timeless Sea

Modern Views of the Beach

DONALD B. KUSPIT

There is a rapture on the lonely shore,
There is society, where none intrudes,
By the deep Sea, and music in its roar . . .
Roll on, thou deep and dark blue Ocean—roll!
Ten thousand fleets sweep over thee in vain;
Man marks the earth with ruin—his control
Stops with the shore. . . .

Lord Byron, *Childe Harold's Pilgrimage*

I.

The beach—so familiar, yet so oddly far from daily life—is more difficult to picture than might be imagined, for it is a dramatically ambivalent place. Primitive material forces clash and converge on it: meet, merge, and re-emerge into separateness, in a perpetual play of contraries, seemingly infinite in its combinations, but also obeying an obscure law of rhythm. The beach is an overwhelming scene: water, earth, air (sky), and fire (sunlight)—the ancient elements—co-exist in prelapsarian immediacy. The raw cosmos seems tangible in the space of the beach, evoking the emotionally raw: we readily fall into symbiotic intimacy with the nature of the beach, as alien to the human as it is. Thus, to construct a picture of the beach—to take it seriously as a special visual place, in which special emotions are invested—is to construct an atmosphere fraught with dynamic moods and matter, with spontaneously shifting proportions of the ancient elements, conveying unnamably deep feelings. To go to a beach is to lapse into prehistoricity, to restore an infantile sense of the naturally fated, of what is beyond human control. It is to be unsafe, but also to stay safely on the shore. The beach exists to give us access to the sea, the eternal mother of us all, a regressive refuge, but one necessary for renewal. A beach is also a shore from which we can contemplate the sea without merging with it, a shore which, while close to the sea, is altogether other than it, and so unbridgeably distant from it. The point of going to the beach is not to swim in the ocean and feel vulnerable, but to stay on the shore and feel the ineffable depths one feels watching the sea. The beach is a paradox: a place of reverie and action, of intense introspection and piercing observation—a place where we witness our own delicate inner movement and nature's vigorous outer movement, the one potentially ecstatic, the other potentially violent.

A picture of the beach must be more than matter-of-factly descriptive and expressive—more than a sentimental rendering of natural phenomena—to be truly convincing. It must convey the innocent intensity of our attachment to the beach—the expressive urgency and uncanniness with which it exists in our psyche. A good picture of a beach makes its physiology effortlessly physiognomic. The immediacy with which nature is given at the beach must be made self-evident: the power of nature must be made so declarative that the social use to which the beach is customarily put must seem incidental. Nature's exciting display is incommensurate with the domestic display of society. The line between nature and society is never blurred on the beach, however much they may seem in harmony. A painter who does not put the nature of the beach before all else, or who does not convey how subtly nature conditions the social scene on the beach—how much the human scene is dependent on a fantasy of nature, all-too-human unconscious expectations from it—is missing the emotional point of the beach. People go to the beach because it is as far from civilization as they can go without losing themselves totally in nature. The beach is a part of its infinity made finite in seemingly timeless space. That space

becomes freshly timely through the human presence in it, but its timeless duality, an effect of the rawness of the scene, is in large part what people come to the beach to experience.

Rendering a beach is thus a complicated matter. The beach is not just another novel scene, but a place of ultimates and elemental exhibitionism. The opposites of nature and society come together on the beach, without fully fusing. Many beach scenes offer wonderfully detailed, intimate records of both—for the beach is an indiscreet place, where we strip to meet raw nature half way—but the real indiscreetness of the beach is its subjective flavor. This is inseparable from the sense of the human body in relation to the body of nature—one kind of presence set over against another, stronger kind of presence. The human body seems to projectively identify with the body of nature. Especially does it seek its identity in the sea: the light and air of the beach scene accent the water, which is its raison dêtre. Human relation to the water is the essence of the beach scene, beyond human relation to the elements in general, which is indeterminate and elusive in comparison. We seek something emotionally specific from the water, more than from any other element on the beach. In a sense, in a beach scene, water is the first among peers, in that it seems the most emotionally necessary element. A good picture of the beach must intimate the longing associated with water, the subliminal search for something especially gratifying, if also implicitly terrifying, that water implies. A good artist must be sensitive to the archetypal implications of the beach scene which go beyond issues of the material perception and conception of nature. A beach scene must become a vision of what is beyond the beach but implicit in it. Every pictorial nuance must serve this latent and confusedly felt primitive meaning, which in the last analysis is the source of the lure of the beach. The artist must capture the beachgoer's transferential relation to nature, and especially to the sea. People ostensibly flock to the beach for social and medicinal reasons, but in fact they are drawn to it by blind emotional necessity. They are lemmings drawn to the sea for strange, seemingly unfathomable emotional reasons. The good artist must make this emotional possession by the sea introspectively available: the picture of the beach must be an introspection of its fascination. It must use description to convey the beach's seductiveness.

Ultimately the beach seduces us because it is the mythical place of origination. It thus symbolizes the deepest subjective space. To go to the beach is to return to the place where life originated, the place where one can imagine one's own origination: the beach signals the basic narcissistic fantasy. Face to face with the sea one can dream one's own birth from it. Water is thus the most "mystical" of all the sacred elements at the beach, for it is the most unconsciously personal. Freud has written:

> *Birth is regularly expressed in dreams by some connection with water: one falls into the water or one comes out of the water—one gives birth or one is born. We must not forget that this symbol is able to appeal in two ways to evolutionary truth. Not only are all terrestrial mammals, including man's ancestors, descended from aquatic creatures (this is the more remote of the two facts), but every individual mammal, every human being, spent the first phase of its existence in water—namely as an embryo in the amniotic fluid in its mother's uterus, and came out of that water when it was born. I do not say that the dreamer knows this; on the other hand, I maintain that he need not know it.*[1]

We go to the beach to dream, to commune with our origins, not necessarily in a knowing way. In fact, to know what we are doing emotionally when we go to the beach is to wake from the dream, or to miss the chance to dream, and thus to miss the opportunity for emotional rebirth—for becoming freshly heroic to ourselves. Freud also writes: "in myths about the birth of heroes . . . a predominant part is played by exposure in the water and rescue from the water . . . if one rescues someone from the water in a dream, one is making oneself into his mother, or simply into a mother. In myths a person who rescues a baby from the water is admitting that she is the baby's true mother."[2] In general, says Freud, "a large number of dreams, often accompanied by anxiety and having as their content such subjects as passing through narrow spaces or being in water, are based upon phantasies of intra-uterine life, of existence in the womb and of the act of birth."[3] On the open beach, we can have—uncon-

sciously—the fantasy without the anxiety, and without the claustrophobic sense of passage through a narrow space, threatening to close on us, even with us in it. In the grand, open, unencumbered space of the beach—a compound of the openness of the sky, the expansiveness of the shore, the great distances rays of light cover, the breadth of the sea—we seem to be invited to experience the "oceanic" feeling Freud described. It is "a sensation of eternity," a feeling as of something limitless, unbounded,"[4] in which the boundaries of our self seem to dissolve, painlessly, spontaneously, indeed, in exalted pleasure. This dissolution is psychic merger with the mothering sea. Jung has said that "the maternal significance of water belongs to the clearest symbolism in the realm of mythology,"[5] and going to the beach is a primitive, mythical experience—an experience through which we enter into the realm of mythology. We go to the beach to merge with the mythically mothering sea and be reborn—to recover from the psychic as well as physical fatigue of city life, and emotionally renew ourselves, that is, have unaccustomed, new feelings. At the beach, where we are usually more undressed than dressed, we recover our sense of being-body: the ideality of the state of nakedness, invariably subliminally tied to the sense of being new born. At the same time, we are not entirely submerged in the sea: the beach is shore as well as sea, and the shore is, if not as emotionally primary as the sea, more necessary for our sense of individual identity. For the shore is separate from the sea, and on the shore we are separate from the mother. The beach is a place where we can regulate our relations with the mother— occultly balance symbiotic intimacy and separateness. The beach is as much a place where we re-assert specificity and individuality of self as a place where we willingly lose it. It is a place where we imaginatively re-enact the drama of symbiosis and separation so crucial to childhood, and in general constant through life. Going into the sea is the major event that occurs at the beach, but not the only one: emergence from the sea is an equally great event. Through it we again own our body and self.

II.

Beach scenes thus divide into three groups. There are those in which nature is more predominant than people; those in which the social events on the shore are more predominant than the appearance of nature, which becomes a dramatic accent to them, or simply a backdrop; and those in which an aesthetic effort is made to symbolize the subjective connotations of beachgoing, but also to convey them intuitively through manipulation of the "sensations" of the medium. The conspicuous absence of both objective description of nature and social reporting and observation, correlative with the sense of the beach scene as an abstract fantasy resonant with archetypal implications, signals this mode of representation. Thus, the focus of representation of the beach is nature, society or inwardness. Moreover, it tends to be a utopian nature, society, or inwardness, that is, beach scene representations tend in general to be idealizing, although there are important exceptions. There are important differences within each category, as we will see. Particular kinds of interest give each work its edge. Also, there is not always a hard and fast line between categories; a balance is sometimes struck between competing interests. But initially the works in this encyclopedic exhibition must be sorted out by broad category, with no regard for chronology and style, in order to bring preliminary clarity to the analysis. It is a necessary task, with illuminating results in the end. Works which are by and large descriptive of nature are Frank W. Benson's *Shimmering Sea*, Thomas Birch's *Seascape* (View of Maine Coast), Henry S. Bisbing's *Beach*, Alfred Bricher's *Low Tide, Manomet*, (Soren) Emil Carlsen's *Summer Clouds*, Vija Celmins's *Untitled* (Ocean), William Chadwick's *Griswold Beach, Old Lyme*, Alson Clark's *The Weekend, Mission Beach*, Frank Dudley's *Indiana Dunes*, Childe Hassam's *Fishing Skiffs, Nantucket, Little Good Harbor Beach* and *Seascape—Isle of Shoals*, Winslow Homer's *On the Beach*, William Keith's *The Lone Pine*, John F. Kensett's *the Seashore*, Julian Onderdonk's *Seascape*, William Trost Richards's *On the Coast of New Jersey*, Charles D. Robinson's *The Wet Sand*, Frank Shapleigh's *Nantasket Beach*, Francis A. Silva's *Sunrise: Marine View*, Walter

Stuempfig, *West Wildwood, New Jersey*, John Twachtman's *Beach at Squam*, Abraham Walkowitz's *Bathers on the Rocks*, Frederick J. Waugh's *Green Wave*, Julian Alden Weir's *Shore Scene*, Jane Wilson's *Receding Sea*, Mabel Woodward's *Beach Scene*, and Theodore Wores's *Ocean Shore of San Francisco, Lime Point Seascape*. Works which are by and large social in import—in which the beach scene is an occasion for social description—are Gifford Beal's *Garden Beach*, Alfred Bricher's *Baby is King*, William Burpee's *Doryman at the End of the Day*, Samuel S. Carr's *Beach Scene*, Hilo Chen's *Beach 103*, Philip Evergood's *Love on the Beach*, Eric Fischl's *A Visit to/A Visit from the Island*, Gertrude Fiske's *Ogunquit Beach, Maine*, William Glackenen's *Cape Cod Pier*, Robert Graham's *Beach Party*, Red Grooms's *Girl on Beach*, Childe Hassam's *Beach at Gloucester*, Robert Henri's *Beach at Atlantic City*, Winslow Homer's *On the Beach* and *Woman on the Beach, Marshfield*, Edward Hopper's *Untitled* (House by the Sea), Joel Janowitz's *Greg/Beach*, Jacob Kass's *The Beach*, Max Kuehne's *The Green Hotel, Martha's Vineyard*, Yasuo Kuniyoshi's *The Swimmer*, Alfred Leslie's *Casey Key*, Reginald Marsh's *Coney Island Beach No. 2* and *Lifeguards*, Malcolm Morley's *Beach Scene*, Edward Potthast's *At the Seaside*, *Children at the Beach* and *Beach Scene*, Maurice Prendergast's *Revere Beach*, Alice Schille's *Midsummer Day*, Ben Schonzeit's *Scott Cameron (Bridgehampton)*, Maxwell S. Simpson's *Last Summer*, John Sloan's *South Beach Bathers*, Charles W. Stetson's *Water Play*, Wayne Thiebaud's *Bikini*, Abraham Walkowitz's *Bathers*, and Beatrice Whitney Van Ness's *Summer Sunlight*. Works which seem basically subjective in import are Milton Avery's *The Beach Loungers* and Katharine I. Carter's *Water's Edge*, Louis Eilshemius's *Surf at Easthampton*, Robert Else's *Wave III*, Helen Frankenthaler's *Buzzard's Bay*, John Marin's *Rogue Island Beach, Maine Coast*, Judy Rifka's *Beach III*, Alan Siegel's *Seaside*, and Tom Wesselmann's *Seascape Number 15*.

These lists, as tedious as they are, make certain facts of beach scene representation immediately evident. For one thing, the number of subjectively oriented works seems few in comparison to those that are matter-of-factly descriptive of nature and society, that are, one might say, strongly journalistic. But this is deceptive, for the facts are often handled in a clearly subjective way, or in a way that plays to subjective expectations, however conventional. Thus, the luminosity of the sky in the works of such Luminists as Bricher, Kensett, and Whittredge—and latter day Luminists, as it were, such as Benson and Silva—suggests ecstatic exaltation. This is not simply a matter of Transcendentalist doctrine or quasi-mysticism, as has been said, but rather of the generalized tendency to anthropomorphize nature— ultimately, to project human feeling onto it, making it more expressive, and using it as a device for discharging and articulating feeling. Nature, because of its shifting meteorological appearance—and a good many beach scene representations seem quintessentially meteorological in import—lends itself to the representation of equally shifting, unstable human mood. Thus, a good many of the beach scenes use the cover of meteorological description to explore and intimate human expressivity. A seemingly objective scene is subjectivized, if not made entirely symbolic of subjective reality. A kind of limbo between direct objective and direct subjective expression is established—a space of nature which at first glance looks altogether objective, but slowly unfolds as fraught with subjective resonance.

Sometimes expressive resonance is established more through the aesthetic manipulation of natural shape than through the aestheticization of atmosphere. Birch's picture, in which waves and rocks twist in quasi-Michelangelesque torment, seems a clear instance of this, but in many other works the irregularity of shoreline as well as the surrounding landscapes imply a hallucinatory expressivity. It is as though nature is tipping the subjective hand of obscure fate, without our quite being able to read its import for ourselves. Indeed, many of the works mix rough and smooth textures to uncanny effect, undermining—spoiling—their conventionality. It is unclear whether Dudley means the contrast between the barren sand of the dunes and the grass that grows out of them to have uncanny effect, but he visually exploits the readymade uncanniness generated by the contrast. The contrast of textures between rocks and flowers—also in instant proximity—in Wores's picture has a similar disturbing effect, exploding the descriptive conventionality of the picture. In such objectivist works there is a kind of creeping uncanniness which eventually undermines the artist's neat imitation of nature.

Not all the nature objectivists accomplish this as well as the Luminists and the quasi-expressionists. Nor do they want to make the pathetic fallacy. In fact, they consciously eschew subjective implication.

It seems beside the point of the material intensity of nature at the seashore. They aim at excruciating perceptual accuracy—a realism as piercing as the reality of beach nature itself. These painters—as different as Onderdonk and Schonzeit and Simpson—utilize (wittingly or unwittingly) the landscape *75, 116* formula traditional since the golden age of landscape painting. Sky tends to dominate land in seventeenth-century Netherlandish landscape painting, and sky tends to dominate land in nineteenth- and twentieth-century American beachscape painting. There is usually two thirds of the one and one third of the other. Interestingly, when the formula is not upheld—when there is more land than sea, or when land and sea are equally balanced—a shift to the social scene is indicated. The beach is then a setting for the display of human nature, rather than for the exhibition of nature. In many of these grand beachscape panoramas a social scene—human behavior—is described, but it is implicitly secondary to, even trivialized by, the spatial and atmospheric accents. In Bradford's work the human ele- *50* ment is contained at the bottom of the well of the sky, a dubious, minimum presence in the cosmically vast sweep of the eternal scene. Ever since Altdorfer's *Battle of Alexander and Darius* there has been an effort to capture, if with less scientific pretension, a sense of the illimitable scope of nature, making human activitiy and history seem small and beside the point. There is no doubt fatalism in this, whatever techniques—such as Turner's atmospherics—are used, and the fatalism lingers even in the seemingly innocent panoramic American beachscape. It is in Bierstadt's picture, with its tiny figure marking the limit of the intrusive curve of the sea, shaping the beach; and in Stetson's picture, where the water *71* play is nothing compared to the ominous landscape. The playing figures are in fact absorbed into the landscape, becoming red, yellow, and blue accents—primary colors confirming the dominance of the sky's deep blue. Many other works minimize the figure while exploiting it pictorially and expressively. They reduce it to a measure of scale, and having done this they use it to imply the irrelevance and vulnerability of human presence in pure nature. True landscape, since Patinir's pictures, has wanted to dispense with the figure, but kept it out of necessary social compromise—to lend a touch of conventional "human interest" to the inhuman scene—and, having had to keep it, gave it latently morbid meaning. Already in Patinir the figure of mythology and the Bible was being abandoned in recognition of the mythological and "biblical" character of nature itself. Even in the most conventional objectivist beachscapes of this exhibition, there is more than a hint of this mythologization of the panorama of nature. Indeed, the clouds and waves in many of these pictures have the aura of personages. They are made to echo, in vague recollection, the "titanic" majesty of nature. Keith's *The Lone Pine* perhaps epit- *63* omizes this herocizing of natural phenomena. Nowhere is that dynamic majesty clearer than in Marin's abstract picture of natural forces. *98*

The beach, of course, is also a social scene, and a varied one, as the extensive number of works in the second category indicates. One can further divide this group in terms of activities described, from everyday work, as in Burpee's picture, to holiday bathing, in many more examples. But a more instruc- *67* tive division is that between pictures which show interactive groups of people and those which show individuals, sometimes loosely grouped together but essentially isolated. There is an ulterior motive to these social beachscapes: the observation and articulation of human nature at its most raw, for on the beach people are removed from their everyday settings and reveal themselves more, just as they reveal more of their bodies.

While in many nineteenth-century pictures, such as those of Bricher, Carr, and Henri, the figures *66, 65* are properly clothed, and the trip to the beach was another social, even fashionable, occasion, they *86, 88* are heightened in their particularity by being placed against the horizon between sea and sky. Indeed, that horizon line, along with the line between sea and shore, plays a prominent part in the beachscapes, suggesting different, even hierarchically ordered, realms of being. Setting the figures in one realm or another in part determines their significance, but what most determines their significance is that they are displaced from the urban realm to the natural realm, which they awkwardly inhabit. That awkwardness gives them a kind of edge, conveyed by the fact that most often they exist on the borders between the realms. That is, their figures literally overlap the lines, setting them off as thoroughly displaced persons. Thus, even though Carr's people maintain their everyday activity on the beach, with

adults grouped together and protectively watching children at play, they are oddly isolated from and non-communicative with one another, symptoms of their displacement or dislocation. This odd disorientation of the figures, the sense of them as not belonging at the beach, as utterly alien to it and thus peculiarly melancholy on it, is more intense in the work by Bricher and Henri. Even in Glackens's picture the nonchalantly strolling figures don't belong. Nowhere is this sense of not-belonging, evocative of human loneliness, more intense than in Homer's pictures. The beach is a desolate scene, confirming the inner isolation of the figures, which they helplessly become aware of in the beach situation. Homer's figures have a family resemblance to the withdrawn figures of Caspar David Friedrich, who exist in similarly desolate settings, sometimes also shore scenes. Nature is a scene of absence, bringing out the spiritual absence of human beings, at least those who come to contemplate the beach. It is this raw emptiness, hidden behind the social paraphernalia—the fashionable excuse of taking the fresh seashore air—that many of the nineteenth-century works unexpectedly convey. Even in Beatrice Whitney Van Ness's painting, the sense of human beings withdrawn into themselves remains, for all their physical intimacy. Sometimes the loneliness appears through inanimate structures rather than animate figures, as in Hopper's and Stuempfig's bleak, isolated buildings. Whatever form loneliness takes, it is always a potential of the beach scene.

These works state the existential problem of beachgoing: how to belong to nature, after one discovers that one does not belong to oneself, because one discovers one's loneliness—one's impossibly deep, melancholy need for others. Which raises another existential problem of beachgoing: how to belong to oneself, in a situation in which one is stripped of the usual protective paraphernalia of everyday society—the usual signs of being civilized, socialized. There seem to be two ways; by festive abandonment to the rawness of the beach scene, sometimes quasi-Dionysian in import, as in Marsh's paintings of muscular figures; and by a kind of truculent exhibition of oneself as a specimen of raw humanity, as occurs in Grooms's, Kuniyoshi's and Thiebaud's misogynist images of aggressively isolated females, verging on the coyly caricatural. (It is time that the destructive wit behind Grooms's ostensibly genial humor be acknowledged.) The one involves an extra effort at sociality, the other a kind of truculent retreat into the fortress of oneself—in effect taking a militant stand in oneself.

Socially speaking, the beach is an exhibitionist context, and since it is one on the fringes of everyday society and propriety, what is exhibited tends to be basic emotion—as basic as the body. The works of Evergood, Marsh, and Sloan show the humans in self-adoring folly. Even Morley's Photorealist picture, with the anonymous surface and standardized figures, conveys this narcissistic self-satisfaction, this pleasure in oneself. Indeed, by becoming a place of pleasure rather than insular, melancholy introspection—self-contemplation—the humbling aspects of being thrust into a quasi-cosmic nature are avoided, denied. Thus, even the muted revelry and mild exuberance—the sense of being at some kind of party, sometimes dainty, sometimes casual—of the paintings by Beal, Fiske and Prendergast, buoys the scene, keeping it away from the possible mute despair of some of the nineteenth-century works. One must keep busily playing at the scene, as in several of Potthast's works. There is an air of forced enjoyment to some of these works, as though people are determined to have a good time, which is one way of belonging to the nature of the scene.

The alternative is what I would call the individual case history view, which is what we have in the already-mentioned Grooms and Thiebaud works, and also in the work of Chen and Leslie that depicts sunbathing females. These works have a proto-voyeuristic dimension—although the beach invites voyeurism—but their importance lies in their clinically detached observation of females, a detachment that neutralizes their presumed sex appeal. These works debunk the sex object, showing it simply to be a nominally human object. The beach of course affords a readymade occasion for male artists to mock female subjects—to eliminate their mystery, their presumably enigmatic sex appeal. But in these works the self-containment of the figure seems as crucial to its identity as its "simplicity." That self-containment is at once an intensification of the feeling of loneliness—of being stripped bare—that is a potential of beachgoing, and a way of coping with it. All of these human specimens seem adequate

MILTON AVERY
(1885-1965)
Sails and Beach Umbrella,
1960
oil on canvas, 32 x 42 in.
Courtesy of Grace
Borgenicht Gallery,
New York

in themselves—physiognomies unto themselves. The observation here is not simply social, but psychosocial. This point is made forcefully in Fischl's sensationalist diptych, in which white, would-be Dionysian figures witness an erotically enticing female figure that contrasts with the black, servant figures that witness to a dead figure, washed up by the sea. In both cases the witnessing figures are forced back on themselves—into an opaque interiority—by reason of their helplessness when confronted with the naked, passive figure. The sensational ambivalence of the scene as a whole—the confusion between eros and thanatos—conveys both the Dionysian and lonely potentials of the beach scene. 117

Perhaps the most visually interesting group of works in the exhibition is those that attempt to catalyze and mobilize a subjective, intuitive response to the beach directly. These works, as I have said, are more or less abstract fantasies. Carter, Rifka, Siegel, and Wesselmann provide quirky, witty examples, using figures and abstract signifiers—their abstractness reverberates back on them as emotional commentary—and Avery's and Frankenthaler's works—completely abstract, relying on the "suggestiveness" of formal configuration—are more sober, if equally visually witty, examples. The latter work, by means of a kind of cautious stripping down of the painting to its subtly differentiated surface, creates an elegant yet profoundly evocative "image" of the kind of emotion which being at a beach might articulate. The emotion is not namable, but articulated through a lyric sensibility, which inevitably colors it. In Milton Avery's *Sails and Beach Umbrella* (fig. 2) the strategy of placement of the sails and beach umbrella—the umbrella implying the shore, hinting at what is invisible, out of the picture, and inviting comparison with the sails (it has the curves of one, and the straight lines of the other)—and the strategy of the flowing gestures, with their different tempos, in the Frankenthaler, suggest a discreetly spirited response to the sea, at once ecstatically sober and ecstatically pleased. This is mutedly Dionysian field painting, epitomizing both the melancholy and the pleasure of being on the beach. 40, 113 108 102, 103 105

Finally, it is worth noting that pictures that pursue an extreme—hyperbolic—objectivity that can flip over, as it were, and become subjectively enigmatic. In the works by Celmins and Wilson the sea and the beach scene, by being rendered with a matter-of-fact dryness, become mysterious but have a peculiarly poignant presence. Poignancy is no doubt a tired expressive effect, but in these works it 118

is achieved seemingly without effort. The erratic redundancy of the lines of the sea in the Celmins and the schematic character of the Wilson suggest the hypnotic effect of being on the beach—the strange hallucinatory daze we unknowingly are in when we are at the beach. The hallucinatory effect of these pictures, and the Avery and Frankenthaler—achieved through more or less pure formal means— is the most difficult subjective aspect of beachgoing to convey. Homer's figures staring at the sea must be hypnotized by it, and the "human specimen" figures clinically reported can now be seen to have been turned into sleepwalkers by the sea. Indeed, we are never fully awake on the beach—even when we see it with the same wide-eyed wakefulness of, for example, a Schonzeit picture, and some of the other sharply observant works—but always in a kind of dream state, in which we can expressively be ourselves more completely than usual, if less wittingly.

FOOTNOTES

1. Sigmund Freud, *Standard Edition*, 15, 160.

2. Ibid., 160-61

3. Ibid., 5, 399.

4. Ibid., 21, 64.

5. C. G. Jung, *Psychology of the Unconscious* (New York: Dodd, Mead, 1944). 244.

ILLUSTRATIONS

GEORGE CURTIS (1826-1881)

Clamming on the East Coast, n.d.

oil on canvas, 15 x 26
Collection of Santa Barbara Museum of Art; Gift of Joanna and Henry Travers Newton

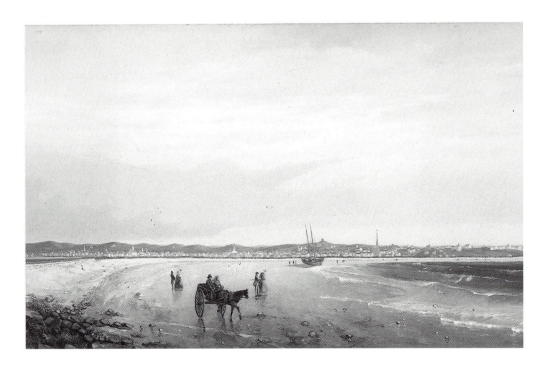

WILLIAM BRADFORD (1823-1892)

Lynn Beach, c. 1855

oil on canvas and aluminum, 13⅝ x 23¾
Collection of Indiana University Art Museum; Gift of Morton C. Bradley, Jr.

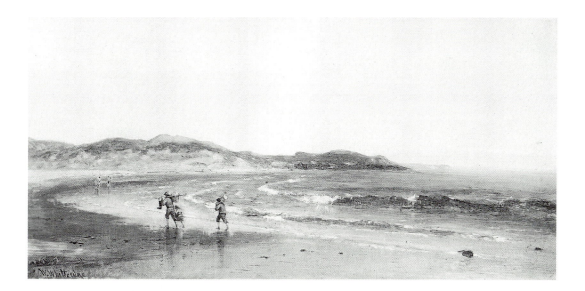

(THOMAS) WORTHINGTON WHITTREDGE (1820-1910)

Scene on Cape Ann, c. 1880

oil on canvas, 11 x 22
Private Collection

(THOMAS) WORTHINGTON WHITTREDGE (1820-1910)

Sunrise at Long Branch, 1883

oil on canvas, 22½ x 32
Private Collection

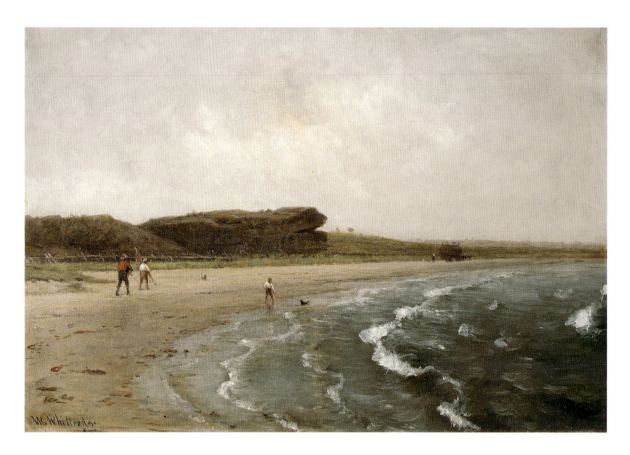

(THOMAS) WORTHINGTON WHITTREDGE (1820-1910)

Second Beach Newport, c. 1900

oil on canvas, 14¾ x 21¾
Collection of Bowdoin College Museum of Art, Brunswick, Maine

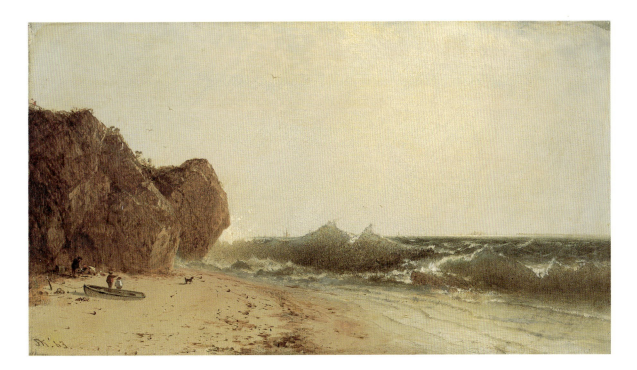

JOHN FREDERICK KENSETT (1816-1872)

The Seashore, 1863

oil on canvas, 10 x 18
Collection of High Museum of Art, Atlanta; Gift of Mr. and Mrs. George E. Missbach

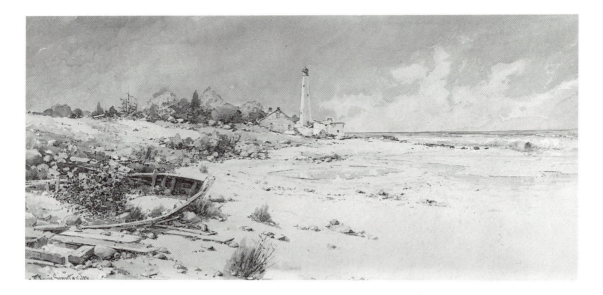

WILLIAM LOUIS SONNTAG, JR. (1822-1900)

The Lighthouse, n.d.

watercolor, 9½ x 20⅝
Mead Art Museum, Amherst College; Gift of William Macbeth, Inc.

JASPER FRANCIS CROPSEY (1823-1900)

Long Beach, 1882

watercolor on paper, 13 x 21½
Collection of Newington-Cropsey Foundation

WILLIAM TROST RICHARDS (1833-1905)

On the Coast of New Jersey, 1883

oil on canvas, 40½ x 72½
Collection of The Corcoran Gallery of Art; Museum purchase, Gallery Fund

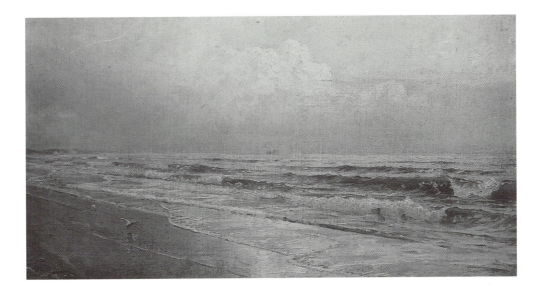

WILLIAM TROST RICHARDS (1833-1905)

New Jersey Seascape—Atlantic City, c. 1880

oil on canvas, 9 x 16½
Collection of George D. and Harriet W. Cornell Fine Arts Museum at Rollins College;
Gift of Samuel and Marion Lawrence in honor of Joan Wavell

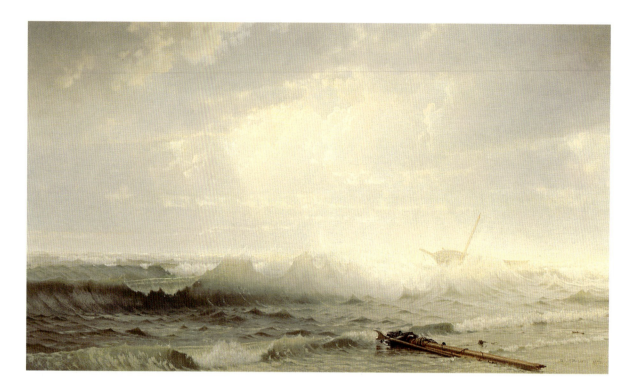

WILLIAM TROST RICHARDS (1833-1905)

Shipwreck, 1872

oil on canvas, 24 x 42
Courtesy of Pennsylvania Academy of the Fine Arts, Philadelphia;
Gift of Henry R. Pemberton

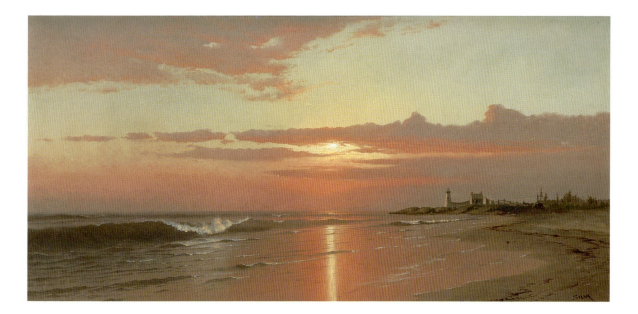

FRANCIS AUGUSTUS SILVA (1835-1886)

Sunrise: Marine View, c. 1870

oil on canvas, 15 x 29⅞
Collection of Munson-Williams-Proctor Institute, Museum of Art, Utica, New York

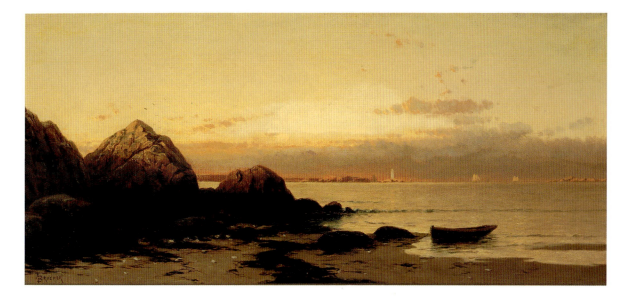

ALFRED THOMPSON BRICHER (1837-1908)

Low Tide, Manomet, Massachusetts, n.d.

oil on canvas, 15 x 33½
Collection of Museum of Fine Arts, St. Petersburg, Florida;
Gift of Margaret Acheson Stuart in memory of Howard Goodrich Acheson

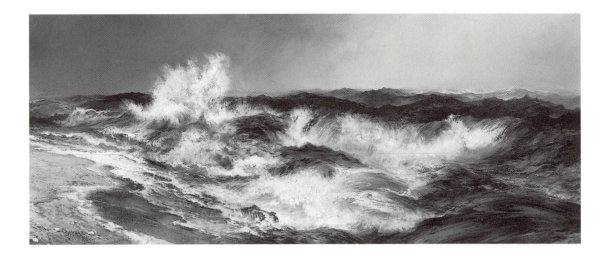

THOMAS MORAN (1837-1926)

The Much Resounding Sea, 1884

oil on canvas, 25 x 62
Collection of National Gallery of Art, Washington, D.C.;
Gift of the Avalon Foundation, 1967.9.1

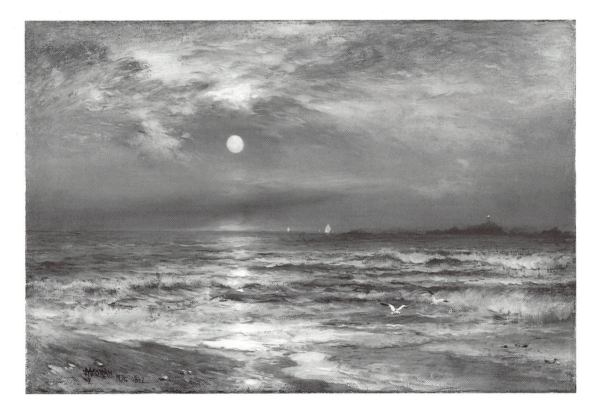

THOMAS MORAN (1837-1926)

Moonlight Seascape, 1892

oil on canvas, 10½ x 16¼
Collection of Samuel B. and Marion W. Lawrence

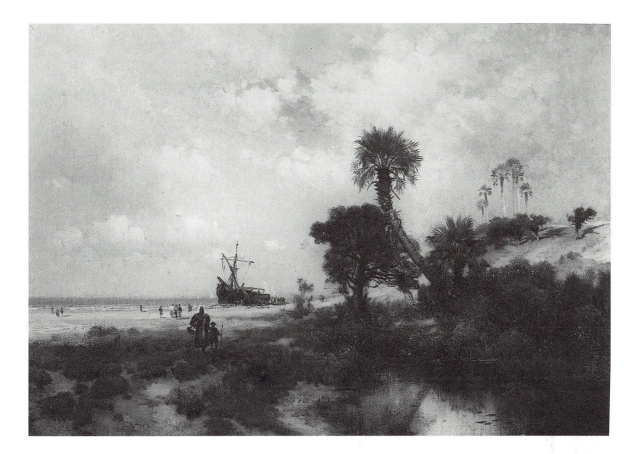

THOMAS MORAN (1837-1926)

Florida Scene, c. 1878

oil on canvas, 10½ x 15½
Collection of Norton Gallery of Art, West Palm Beach, Florida;
Gift of Mr. Will Richeson, Jr.

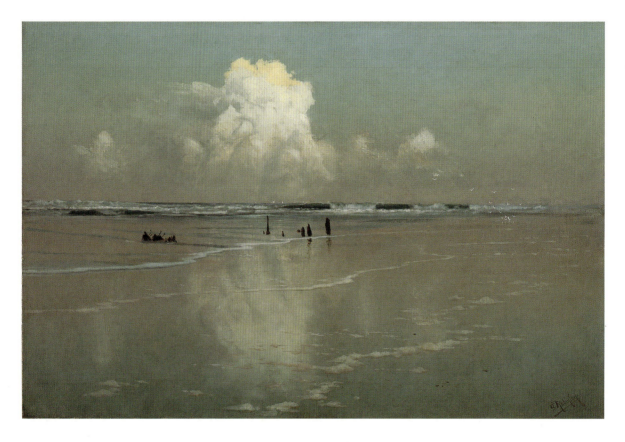

CHARLES DORMAN ROBINSON (1847-1933)

The Wet Sand, c. 1890

oil on canvas, 21½ x 30
Collection of The Oakland Museum; Gift of Doctor William S. Porter

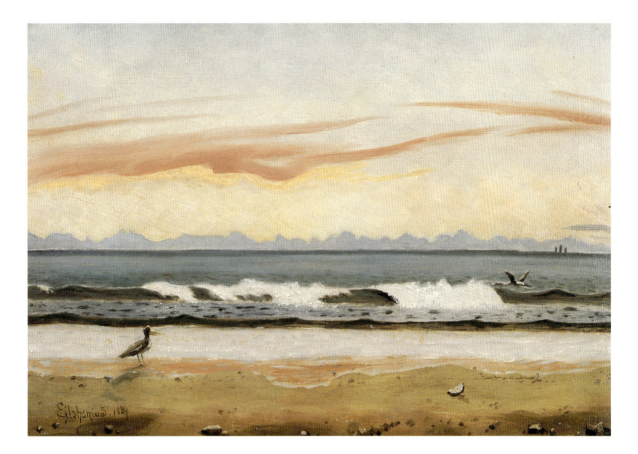

LOUIS MICHEL EILSHEMIUS (1864-1941)

Surf at Easthampton, 1889

oil on canvas, 14½ x 21½
Collection of Mr. and Mrs. Meyer P. Potamkin

LOUIS MICHEL EILSHEMIUS (1864-1941)

Dawn Over the Pacific, Del Mar, California, 1889

oil on canvas, 24⅛ x 37
Collection of The Corcoran Gallery of Art; Gift of Roy R. Neuberger

WILLIAM KEITH (1839-1911)

Stinson Beach, c. 1880

oil on canvas, 8½ x 18½
Collection of Hearst Art Gallery, Saint Mary's College, Morago, California

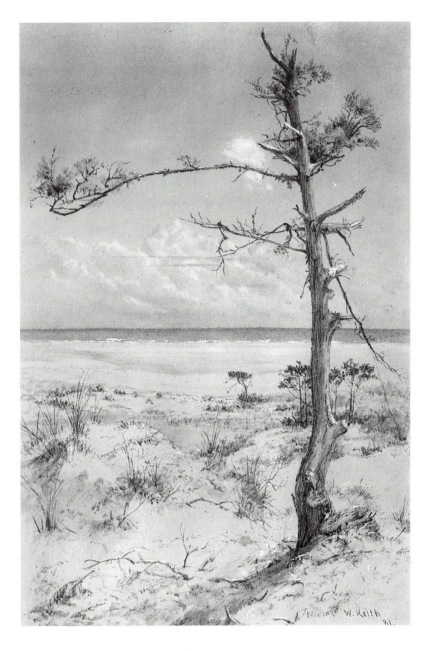

WILLIAM KEITH (1839-1911)

The Lone Pine, 1881

watercolor on paper, 14 x 10
Collection of Museum of Fine Arts, Boston; Gift of Maxim Karolik, 1961

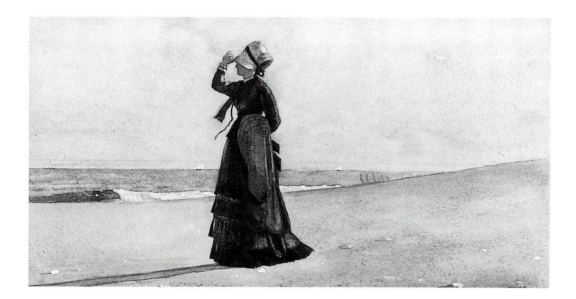

WINSLOW HOMER (1836-1910)

Woman on the Beach, Marshfield, 1874

watercolor, 7 x 13
Collection of Canajoharie Library and Art Gallery, Canajoharie, New York

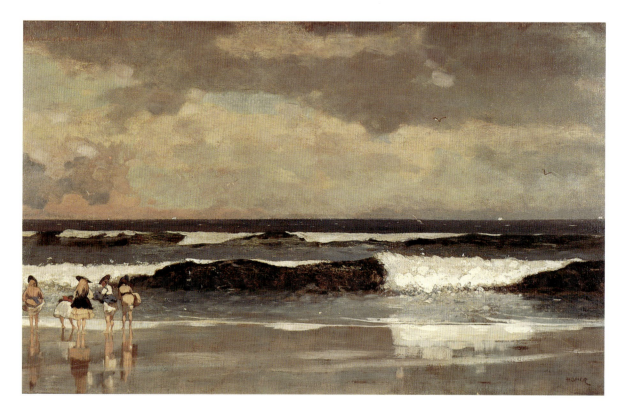

WINSLOW HOMER (1836-1910)

On the Beach, 1870

oil on canvas, 16 x 25
Collection of Canajoharie Library and Art Gallery, Canajoharie, New York

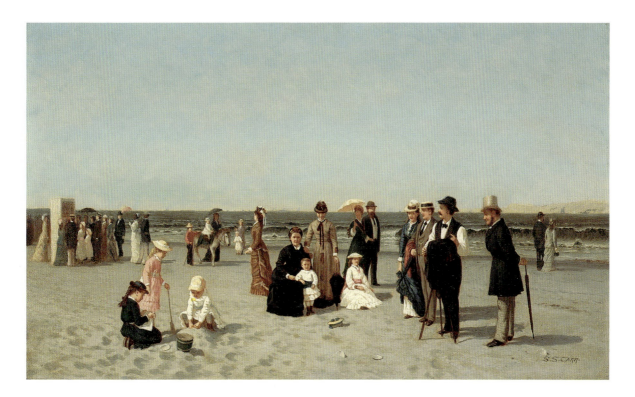

SAMUEL S. CARR (1837-1908)

Beach Scene, c. 1879

oil on canvas, 12 x 20
Collection of Smith College Museum of Art, Northampton, Massachusetts; Bequest of
Mrs. Lewis Larned Coburn, 1934

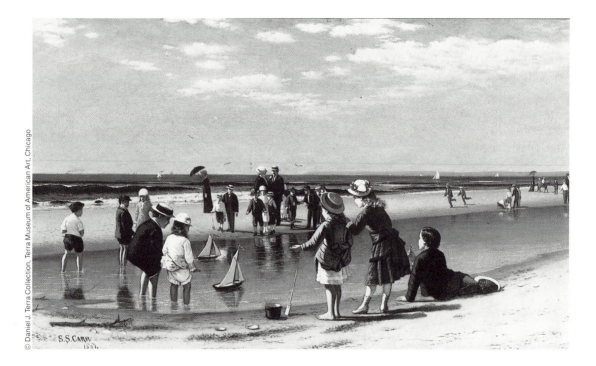

SAMUEL S. CARR (1837-1908)

Small Yacht Racing, 1881

oil on canvas, 14⅛ x 24
Collection of Terra Museum of American Art, Chicago; Daniel J. Terra Collection

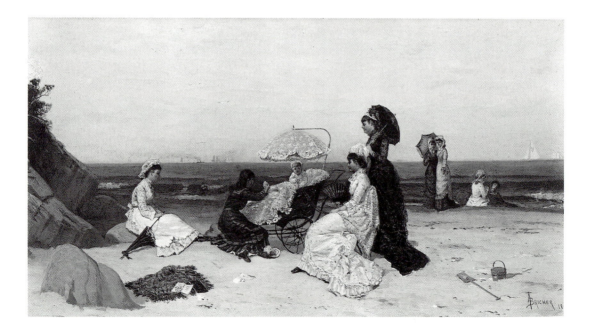

ALFRED THOMPSON BRICHER (1837-1908)

Baby is King, 1880

oil on canvas, 17⅞ x 35⅛
Collection of The Fine Arts Museums of San Francisco;
Mildred Anna Williams Collection

FRANK HENRY SHAPLEIGH (1842-1906)

Nantasket Beach, 1874

oil on board, 15 x 31
Collection of Danforth Museum of Art; Gift of Faith and James Waters

WILLIAM PARTRIDGE BURPEE (1846-1940)

Doryman at the End of the Day, c. 1888

oil on paper on mahogany panel, 7⅞ x 10¾
Courtesy of Childs Gallery, Boston and New York

EDWARD LAWSON HENRY (1841-1919)

East Hampton Beach, 1881

oil on canvas, 23½ x 51½
Collection of The Chrysler Museum, Norfolk, Virginia

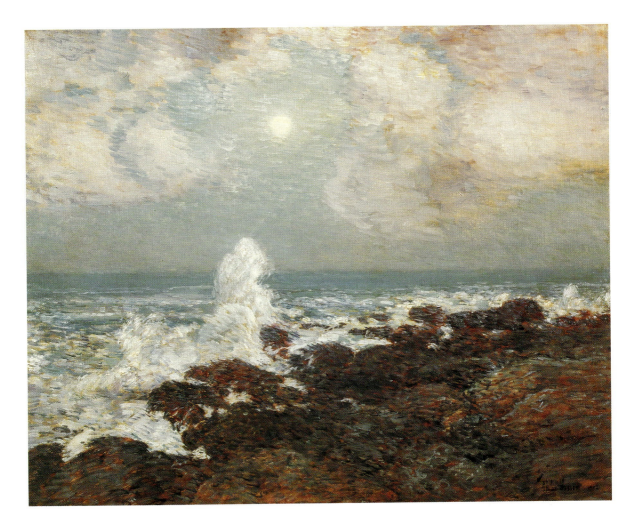

CHILDE FREDERICK HASSAM (1859-1935)

Seascape—Isle of Shoals, 1902

oil on canvas, 29⅛ x 37
Collection of High Museum of Art, Atlanta; Friends of Art Purchase, 37.2

CHILDE FREDERICK HASSAM (1859-1935)

Fishing Skiffs, Nantucket, c. 1882

watercolor on paper, 10 x 16
Collection of Ira and Nancy Koger

CHILDE FREDERICK HASSAM (1859-1935)

Little Good Harbor Beach, 1919

oil on panel, 7 x 10
Collection of Grand Rapids Art Museum; Gift of Emily J. Clark

CHARLES WALTER STETSON (1858-1911)

Water Play, 1895

oil on canvas, 29¾ x 35¾
Collection of Museum of Art, Rhode Island School of Design;
Bequest of Isaac C. Bates, 13.962

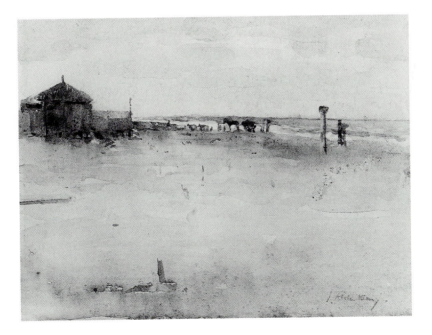

JULIAN ALDEN WEIR (1852-1919)

Shore Scene, n.d.

watercolor on paper, 5¼ x 6⅞
Collection of Williams College Museum of Art, Williamstown, Massachusetts

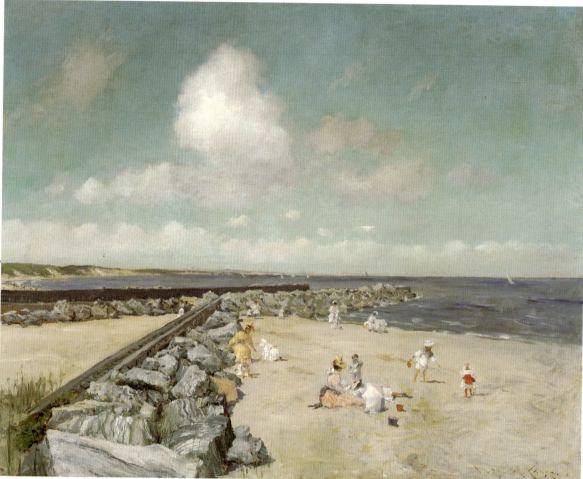

WILLIAM MERRITT CHASE (1849-1916)

Morning at Breakwater, Shinnecock, 1897

oil on canvas, 40 x 50
Collection of Terra Museum of American Art, Chicago; Daniel J. Terra Collection

JOHN HENRY TWACHTMAN (1853-1902)

Sea Scene (Marine, Seascape), 1893

oil on canvas, 28 x 34
Collection of Delaware Art Museum; Special Purchase Fund

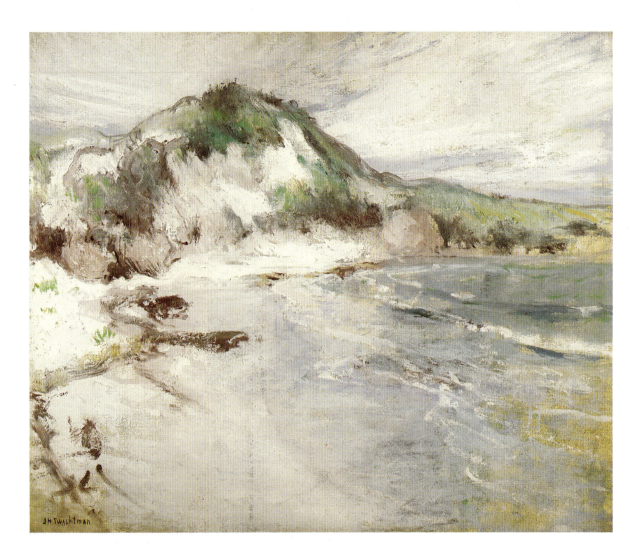

JOHN HENRY TWACHTMAN (1853-1902)

Beach at Squam, c. 1900

oil on canvas, 25 x 30
Collection of Ira and Nancy Koger

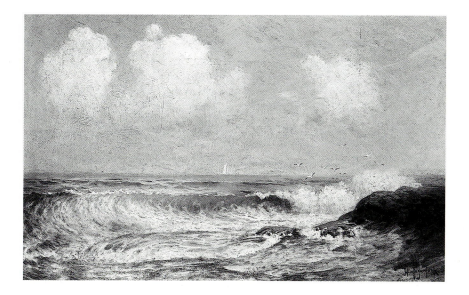

JULIAN ONDERDONK (1882-1922)

Seascape, c. 1901

oil on canvas, 9 x 15⅛
Collection of Marion Koogler McNay Art Museum, San Antonio, Texas;
Gift of Alice C. Simkins in memory of her father, William Stewart Simkins

FRANK WESTON BENSON (1862-1951)

Shimmering Sea, c. 1908

oil on canvas, 37 x 44
Private Collection, Courtesy of Babcock Galleries, New York

CHARLES HERBERT WOODBURY (1864-1940)

Going Up, n.d.

oil on canvas, 12 x 17
Private Collection

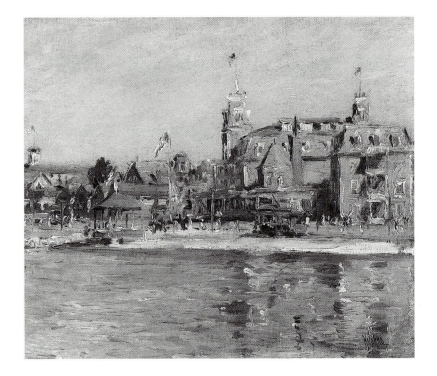

MAX KUEHNE (1880-1968)

The Green Hotel, Martha's Vineyard, 1911

oil on canvas, 15 x 18
Collection of Ira and Nancy Koger

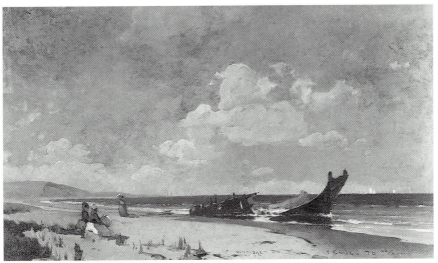

(SOREN) EMIL CARLSEN (1853-1932)

Nantasket Beach, 1876

oil on canvas, 15¼ x 26⅜
Collection of The Art Institute of Chicago; Friends of American Art Collection

(SOREN) EMIL CARLSEN (1853-1932)

Summer Clouds, c. 1912

oil on canvas, 39⅛ x 45
Collection of Pennsylvania Academy of the Fine Arts, Philadelphia;
Joseph E. Temple Fund

EDWARD HENRY POTTHAST (1857-1927)

Beach Scene, c. 1920

oil on canvas, 24 x 30⅛
Collection of Hirshhorn Museum and Sculpture Garden, Smithsonian Institution;
Gift of Joseph H. Hirshhorn, 1966.

EDWARD HENRY POTTHAST (1857-1927)

At the Seaside, c. 1920

oil on board, 30 x 40
Collection of Mr. and Mrs. Merrill J. Gross

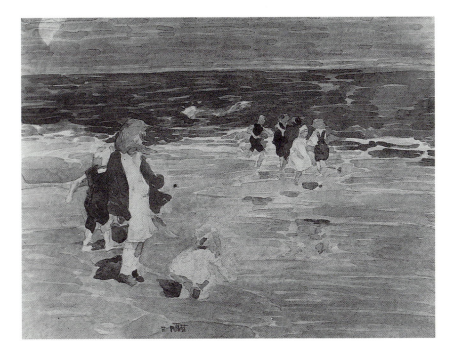

EDWARD HENRY POTTHAST (1857-1927)

Children at the Beach, n.d.

watercolor, 11½ x 15½
Collection of Sordoni Art Gallery, Wilkes College, Wilkes-Barre, Pennsylvania

ALSON SKINNER CLARK (1876-1949)

The Weekend, Mission Beach, 1924

oil on canvas, 24½ x 46
Private Collection, Courtesy of Petersen Galleries, Beverly Hills, California

MABEL MAY WOODWARD (1877-1945)

Beach Scene, n.d.

oil on canvas, 24 x 30
Collection of Danforth Museum of Art; anonymous gift

FRANK VIRGIL DUDLEY (1868-1957)

Indiana Dunes, n.d.

oil on canvas, 27 x 30
Collection of Sheldon Swope Art Museum, Terra Haute, Indiana

THEODORE WORES (1859-1939)

Ocean Shore of San Francisco, Lime Point Seascape, 1927

oil on canvas, 16 x 20
Collection of Drs. Ben and A. Jess Shenson

WILLIAM CHADWICK (1879-1962)

Griswold Beach, Old Lyme, n.d.

oil on board, 14⅓ x 18
Collection of Florence Griswold Museum

FREDERICK JUDD WAUGH (1861-1940)

Incoming Tide, 1931

oil on canvas, 25 x 30½
The Arkansas Arts Center Foundation Collection

FREDERICK JUDD WAUGH (1861-1940)

Green Wave, 1935

oil on pressed wood, 24 x 32
Collection of The Montclair Art Museum; Gift of Mr. and Mrs. Solomon Wright, Jr.

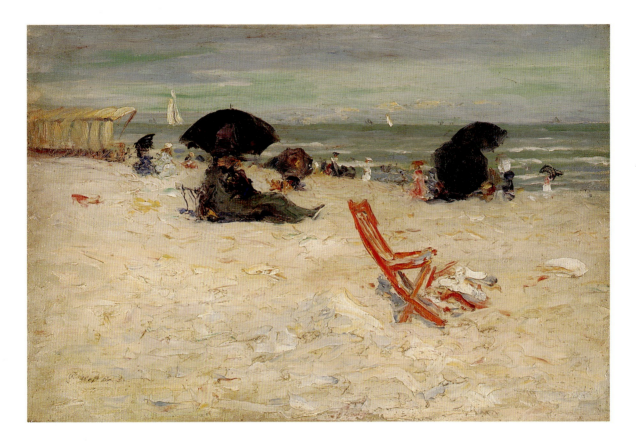

ROBERT HENRI (1865-1929)

Beach at Atlantic City, 1893

oil on canvas, 13¾ x 18
Collection of Phoenix Art Museum; Gift of Mr. and Mrs. James Beattie

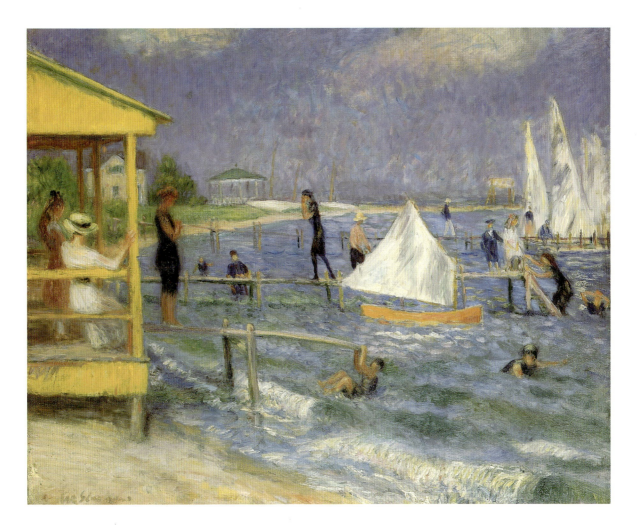

WILLIAM JAMES GLACKENS (1870-1938)

Summer Day, Bellport, Long Island, 1912

oil on canvas, 26 x 32
Collection of Mitchell Museum, Mt. Vernon, Illinois

ROBERT HENRI (1865-1929)

Seascape, 1887

oil on canvas, 10 x 14
Collection of Weatherspoon Art Gallery; Gift of Mr. and Mrs. Edward Rosenberg

WILLIAM JAMES GLACKENS (1870-1938)

Jetties at Bellport, 1912

oil on canvas, 25 x 30
Collection of Albright-Knox Art Gallery, Buffalo, New York;
Evelyn Rumsey Cary Fund, 1935

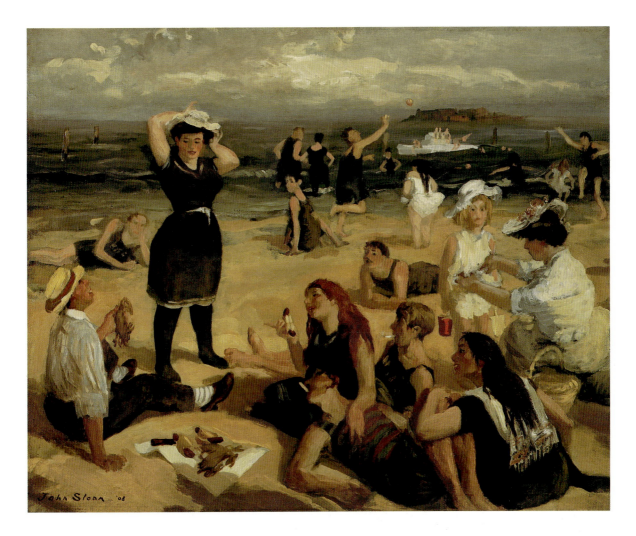

JOHN SLOAN (1871-1951)

South Beach Bathers, 1908

oil on canvas, 26 x 31¾
Collection of Walker Art Center, Minneapolis; Gift of the T. B. Walker Foundation,
Gilbert M. Walter Fund, 1948

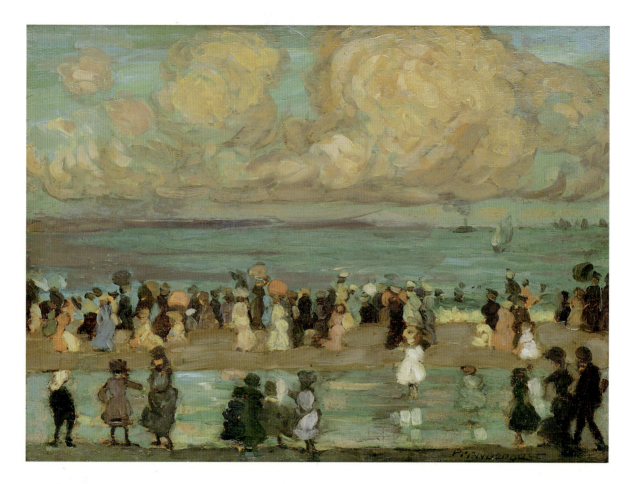

MAURICE BRAZIL PRENDERGAST (1859-1924)

By the Seashore, 1905-06

oil on panel, 11¾ x 16
Collection of Mitchell Museum, Mt. Vernon, Illinois

MAURICE BRAZIL PRENDERGAST (1859-1924)

Bathers in a Cove, c. 1910

oil on canvas, 15½ x 22½
Collection of Williams College Museum of Art; Gift of Mrs. Charles Prendergast, 1986

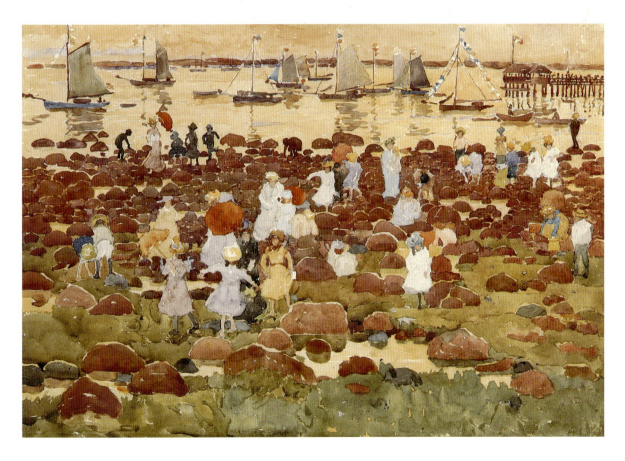

MAURICE BRAZIL PRENDERGAST (1859-1924)

Revere Beach, n.d.

watercolor, 13 x 19
Collection of Canajoharie Library and Art Gallery, Canajoharie, New York

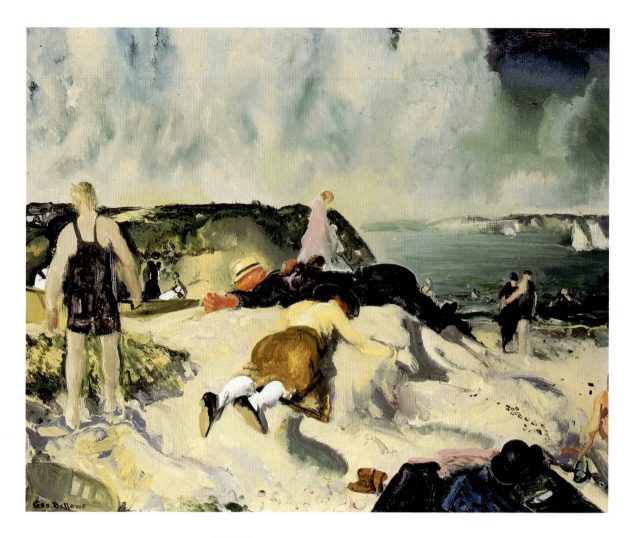

GEORGE WESLEY BELLOWS (1882-1925)

The Beach, Newport, c. 1919

oil on panel, 26 x 32
Collection of Mrs. Miriam Sterling

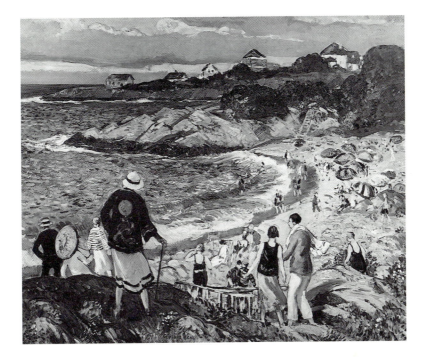

GIFFORD BEAL (1879-1956)

Garden Beach, n.d.

oil on canvas, 40 x 50
Anonymous loan

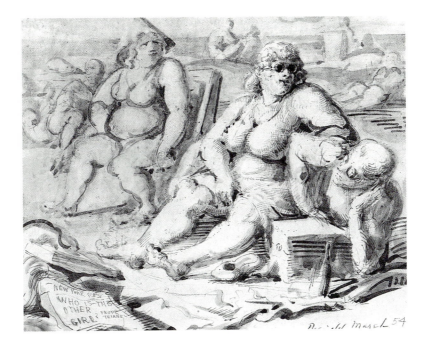

REGINALD MARSH (1898-1954)

Fat Lady on the Beach, 1954

egg tempera and ink on panel, 7½ x 10½
The Arkansas Arts Center Foundation Collection

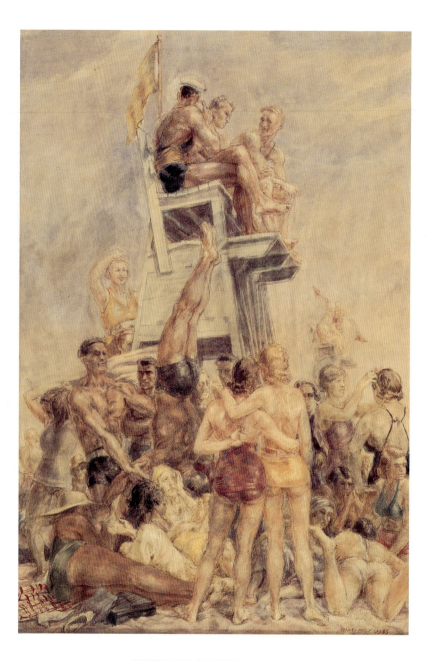

REGINALD MARSH (1898-1954)

Lifeguards, 1933

tempera on gessoed masonite panel, 36 x 24
Collection of Georgia Museum of Art, The University of Georgia; Museum Purchase

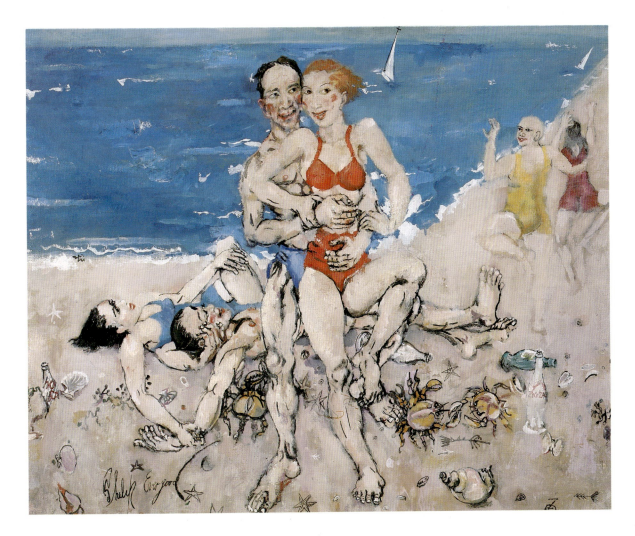

PHILIP EVERGOOD (1901-1973)

Love on the Beach, 1937

oil on canvas, 30½ x 37½
Collection of Hunter Museum of Art, Chattanooga, Tennessee;
Gift of the Benwood Foundation

YASUO KUNIYOSHI (1893-1953)

The Swimmer, 1924

ink on paper, 14¾ x 17⅞
Collection of Whitney Museum of American Art, New York;
Gift of Mr. and Mrs. Charles J. Liebman

ROCKWELL KENT (1882-1971)

Headlands, Monhegan, 1909

oil on canvas, 34⅛ x 41¾
Collection of Sheldon Memorial Art Gallery, University of Nebraska-Lincoln;
NAA-Nelle Cochrane Woods Memorial Collection

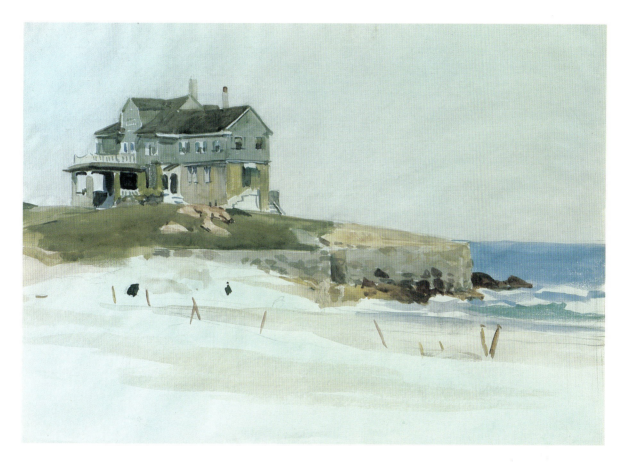

EDWARD HOPPER (1882-1967)

Untitled (House by the Sea), 1923 or 1924

watercolor and pencil on paper, 14 x 20
Collection of Whitney Museum of American Art, New York,
Bequest of Josephine N. Hopper

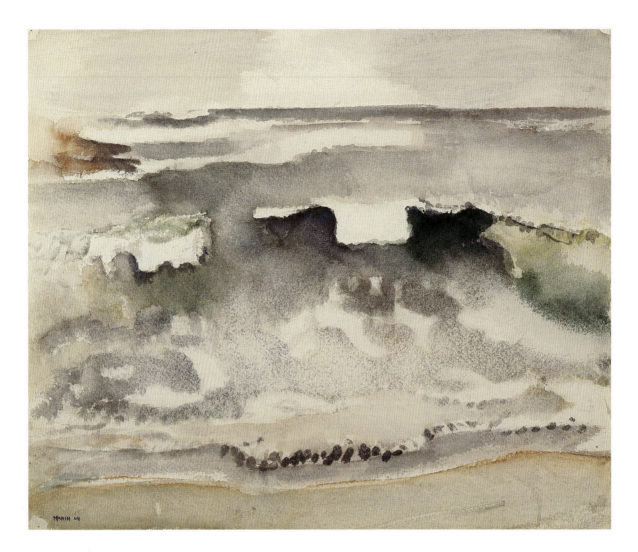

JOHN MARIN (1870-1953)

Waves, 1914

watercolor, 15¾ x 18¾
Collection of The Art Museum, Princeton University; The Laura P. Hall Memorial Collection, Bequest of Clifton R. Hall

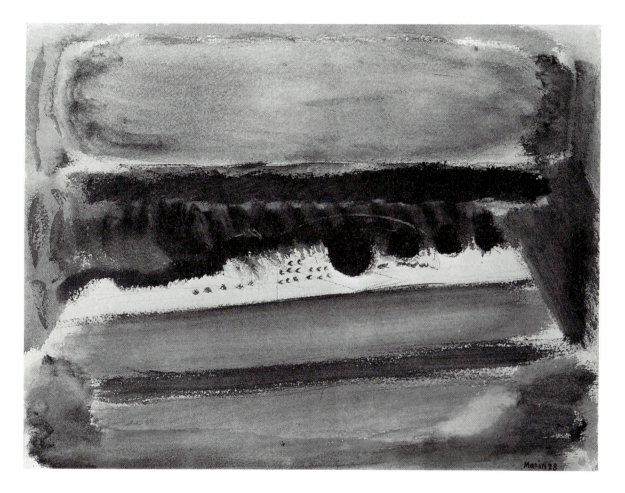

JOHN MARIN (1870-1953)

Popham Beach, Small Point, Maine (Series No. 1), 1928

watercolor and chalk, 17⅛ x 22⅜
Courtesy of the Metropolitan Museum of Art; Alfred Stieglitz Collection, 1949

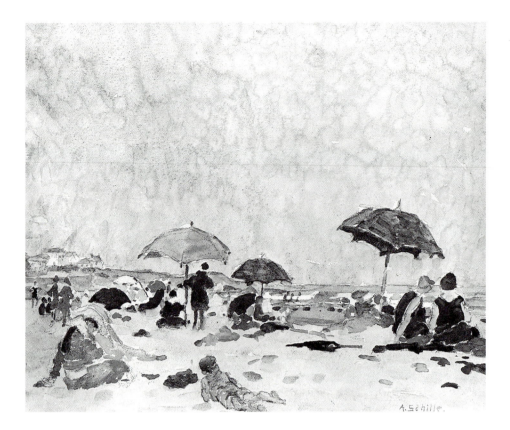

ALICE SCHILLE (1869-1955)

Midsummer Day, c. 1916

watercolor, gouache and conte crayon, 11½ x 13⅝
Collection of Columbus Museum of Art, Ohio; Gift of Ferdinand Howald

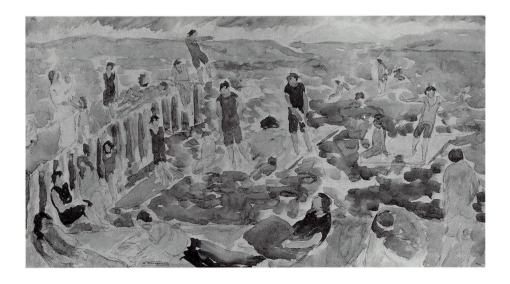

ABRAHAM WALKOWITZ (1880-1965)

Bathers, 1919

watercolor, 15½ x 29
Collection of Columbus Museum of Art; Gift of Ferdinand Howald

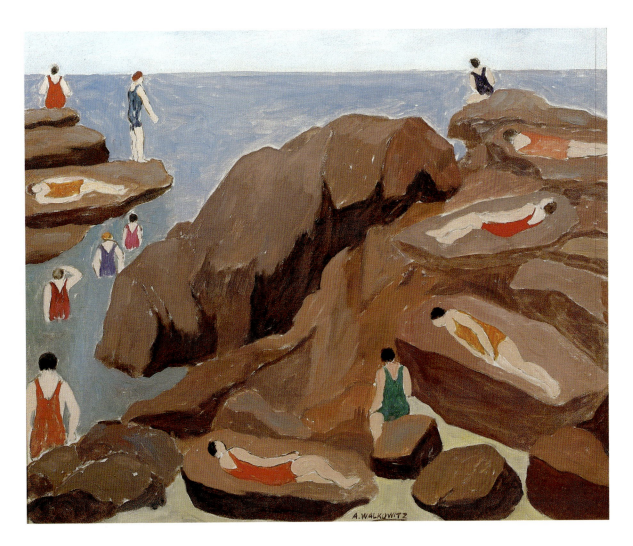

ABRAHAM WALKOWITZ (1880-1965)

Bathers on the Rocks, c. 1935

oil on canvas, 25 x 30
Collection of Tampa Museum of Art, Museum purchase

MILTON AVERY (1885-1965)

Sea and Rocks — Ten Pound Island, 1956

oil on canvas, 38 x 60
Courtesy of Grace Borgenicht Gallery, New York

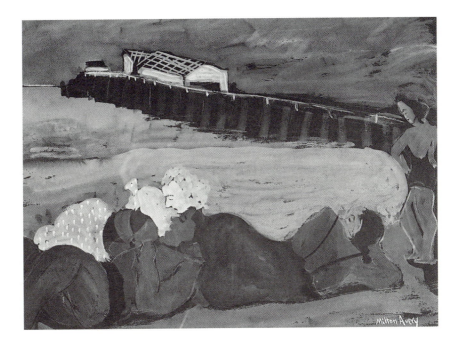

MILTON AVERY (1885-1965)

The Beach Loungers, 1932

gouache on black paper, 18 x 24
Collection of Orlando Museum of Art, Orlando, Florida; Gift of the Acquisition Trust

DORIS EMRICK LEE (1905-1983)

Bathers, n.d.

oil on canvas, 40 x 52
Collection of The Cleveland Museum of Art; Bequest of Doris E. Lee

MORRIS GRAVES, (b. 1910)

Wounded Gull, 1943

gouache on paper, 26⅝ x 30½
The Phillips Collection, Washington, D.C.

DAVID PARK (1911-1960)

Bathers, 1954

oil on canvas, 42 x 54½
Collection of San Francisco Museum of Modern Art; Gift of the Women's Board

HELEN FRANKENTHALER (b. 1928)

Buzzards Bay, 1959

oil stained canvas, 59⅝ x 45
Collection of Seattle Art Museum; Gift of the Sidney and Anne Gerber Collection

FAIRFIELD PORTER (1907-1975)

Beach in Morning #2, 1972

oil on masonite, 11¾ x 14
Collection of The Currier Gallery of Art, Manchester, New Hampshire;
Gift of Neil Welliver, 1982-13

ROY LICHTENSTEIN (b. 1923)

Landscape, 1974

oil and magna on canvas, 30 x 36
Private Collection

TOM WESSELMANN (b. 1931)

Seascape Number 15, 1967

synthetic polymer on molded plexiglass, 65 x 44½ x 3
Collection of Whitney Museum of American Art, New York; Purchase with funds from
the Howard and Jean Lipman Foundation, Inc., 68.29

ALFRED LESLIE, (b. 1927)

Casey Key, 1983

oil on canvas, 72 x 108
Courtesy of the Artist and Oil & Steel Gallery, New York

RED GROOMS (b. 1937)

Girl on Beach, 1970

craypas on paper, 35 x 23
Collection of Weatherspoon Art Gallery

HILO CHEN (b. 1942)

Beach 103, 1983

watercolor, 26 x 39
Courtesy of Louis K. Meisel Gallery, New York

RICHARD BOSMAN (b. 1944)

Aftermath, 1987

oil on canvas, 66 x 84
Collection of Frederick K. W. Day, Chicago

WAYNE THIEBAUD (b. 1920)

Bikini, 1964

oil on canvas, 72 x 35⅞
Collection of The Nelson-Atkins Museum of Art, Kansas City, Missouri;
Gift of Mr. and Mrs. Louis Sosland

PAUL STAIGER (b. 1941)

Santa Cruz, 1974

acrylic on canvas, 60⅛ x 89½
Collection of San Francisco Museum of Modern Art;
T. B. Walker Foundation Fund Purchase

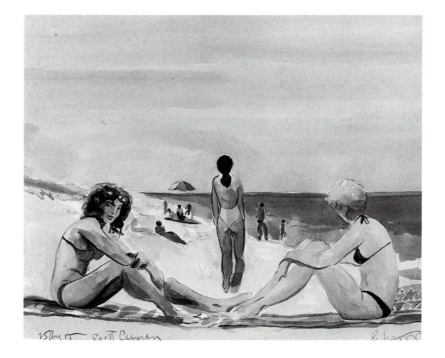

BEN SCHONZEIT (b. 1942)

Scott Cameron (Bridgehampton), 1985

watercolor, 11½ x 30
Courtesy of Louis K. Meisel Gallery, New York

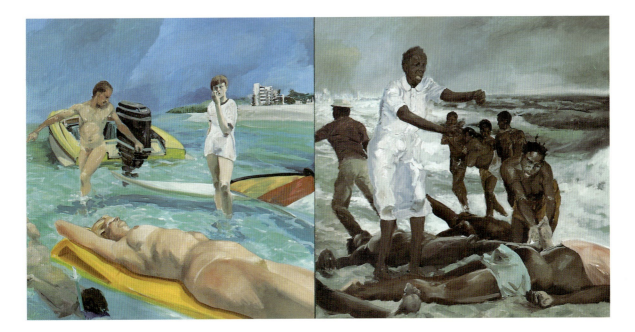

ERIC FISCHL (b. 1948)

A Visit to/A Visit From the Island, 1983

oil on canvas, 84 x 84 each
Collection of Whitney Museum of American Art, New York; Purchase, with funds from
the Louis and Bessie Adler Foundation, Inc., Seymour M. Klein, President

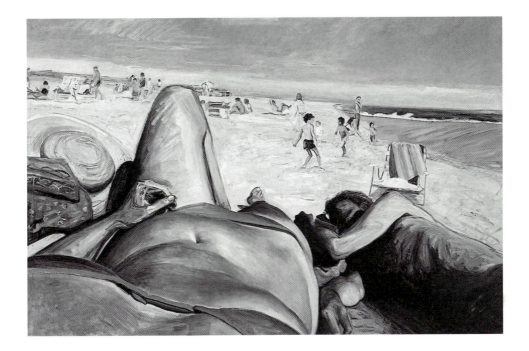

JOAN SEMMEL (b. 1932)

Amagansett Afternoon, 1985

oil on canvas, 78 x 120
Collection of the Artist

JANE WILSON (b. 1924)

Receding Sea, 1987

oil on linen, 80 x 74
Courtesy of Fischbach Gallery, New York

ROBERT BORDO (b. 1949)

Oceanfront, 1987

oil and powdered pigment on gessoed panel, 32 x 36
Collection of S. David Deitcher, New York

DON EDDY (b. 1944)

Clearing, 1989

acrylic on canvas, 30 x 44
Courtesy of Nancy Hoffman Gallery, New York

List of Works

All dimensions are in inches, height preceding width
*Indicates works which will not appear at all venues

MILTON AVERY (1885-1965)

The Beach Loungers, 1932
gouache on black paper, 18 x 24
Collection of Orlando Museum of Art, Orlando, Florida;
Gift of the Acquisition Trust

Siesta, 1945
watercolor, 30 x 22 (sight)
Collection of Colby College Museum of Art;
Gift of Mr. and Mrs. Norman Hirschl

Sea and Rocks—Ten Pound Island, 1956
oil on canvas, 38 x 60
Courtesy of Grace Borgenicht Gallery, New York

GIFFORD BEAL (1879-1956)

* *Garden Beach*, n.d.
oil on canvas, 40 x 50
Anonymous loan

GEORGE WESLEY BELLOWS (1882-1925)

The Beach, Newport, c. 1919
oil on panel, 26 x 32
Collection of Mrs. Miriam Sterling

FRANK WESTON BENSON (1862-1951)

* *Shimmering Sea*, c. 1908
oil on canvas, 37 x 44
Private Collection, Courtesy of Babcock Galleries, New York

ALBERT BIERSTADT (1830-1902)

Cove with Beach, n.d.
oil on paper, 13⅞ x 19½
Collection of Mr. and Mrs. William duPont III

THOMAS BIRCH (1779-1851)

* *Seascape* (View of Maine Coast), 1826
oil on canvas, 30½ x 40
Collection of Ackland Art Museum, The University of
North Carolina at Chapel Hill; the W. W. Fuller Collection
(bequest of Dr. Frederick M. Hanes) and the gift of
Katherine Pendleton Arrington, by exchange.

HENRY SINGLEWOOD BISBING (1849-1933)

Beach, n.d.
oil, 22¾ x 38¼
Collection of Weatherspoon Art Gallery;
Gift of Mr. and Mrs. Leonard Schoonman

ROBERT BORDO (b. 1949)

* *Oceanfront*, 1987
oil and powdered pigment on gessoed panel, 32 x 36
Collection of S. David Deitcher, New York

RICHARD BOSMAN (b. 1944)

Ashore, 1984
stencil, ed. 9/25, 28 x 23½
Collection of BP America, Inc., Cleveland

Aftermath, 1987
oil on canvas, 66 x 84
Collection of Frederick K. W. Day, Chicago

WILLIAM BRADFORD (1823-1892)

Lynn Beach, c. 1855
oil on canvas and aluminum, 13⅝ x 23¾
Collection of Indiana University Art Museum;
Gift of Morton C. Bradley, Jr.

ALFRED THOMPSON BRICHER (1837-1908)

Low Tide, Manomet, Massachusetts, n.d.
oil on canvas, 15 x 33½
Collection of Museum of Fine Arts, St. Petersburg, Florida;
Gift of Margaret Acheson Stuart in memory of Howard
Goodrich Acheson

Baby is King, 1880
oil on canvas, 17⅞ x 35⅛
Collection of The Fine Arts Museums of San Francisco;
Mildred Anna Williams Collection

WILLIAM PARTRIDGE BURPEE (1846-1940)

Doryman at the End of the Day, c. 1888
oil on paper on mahogany panel, 7⅞ x 10¾
Courtesy of Childs Gallery, Boston and New York

PAUL CADMUS (b. 1904)

Coney Island, 1935
etching, 9⅛ x 10⅛
Courtesy of Midtown Galleries, New York

(SOREN) EMIL CARLSEN (1853-1932)

* *Nantasket Beach*, 1876
oil on canvas, 15¼ x 26⅜
Collection of The Art Institute of Chicago;
Friends of American Art Collection

* *Summer Clouds*, c. 1912
oil on canvas, 39⅛ x 45
Collection of Pennsylvania Academy of the Fine Arts,
Philadelphia; Joseph E. Temple Fund

SAMUEL S. CARR (1837-1908)

Beach Scene, c. 1879
oil on canvas, 12 x 20
Collection of Smith College Museum of Art, Northampton,
Massachusetts; Bequest of Mrs. Lewis Larned Coburn, 1934

* *Small Yacht Racing*, 1881
oil on canvas, 14⅛ x 24
Collection of Terra Museum of American Art, Chicago;
Daniel J. Terra Collection

KATHARINE TIPTON CARTER (b. 1950)

Water's Edge, 1987
acrylic on canvas, 40 x 54
Courtesy of Stein Gallery, Tampa, Florida

VIJA CELMINS (b. 1939)

Untitled (Ocean), 1975
lithograph, 19 x 23
Collection of The Museum of Contemporary Art,
Los Angeles; Gift of Wells Fargo Bank, Los Angeles

WILLIAM CHADWICK (1879-1962)

Griswold Beach, Old Lyme, n.d.
oil on board, 14⅓ x 18
Collection of Florence Griswold Museum

WILLIAM MERRITT CHASE (1849-1916)

By the Shore, c. 1886
oil on canvas, 21¼ x 34¼
The Pfeil Collection

* *Morning at Breakwater, Shinnecock*, 1897
oil on canvas, 40 x 50
Collection of Terra Museum of American Art, Chicago;
Daniel J. Terra Collection

HILO CHEN (b. 1942)

Beach 103, 1983
watercolor, 26 x 39
Courtesy of Louis K. Meisel Gallery, New York

ALSON SKINNER CLARK (1876-1949)

The Weekend, Mission Beach, 1924
oil on canvas, 24½ x 46
Private Collection, Courtesy of Petersen Galleries,
Beverly Hills, California

JASPER FRANCIS CROPSEY (1823-1900)

Long Beach, 1882
watercolor on paper, 13 x 21½
Collection of Newington-Cropsey Foundation

GEORGE CURTIS (1826-1881)

Clamming on the East Coast, n.d.
oil on canvas, 15 x 26
Collection of Santa Barbara Museum of Art;
Gift of Joanna and Henry Travers Newton

FRANK VIRGIL DUDLEY (1868-1957)

Indiana Dunes, n.d.
oil on canvas, 27 x 30
Collection of Sheldon Swope Art Museum,
Terre Haute, Indiana

DON EDDY (b. 1944)

Clearing, 1989
acrylic on canvas, 30 x 44
Courtesy of Nancy Hoffman Gallery, New York

LOUIS MICHEL EILSHEMIUS (1864-1941)

* *Surf at Easthampton*, 1889
oil on canvas, 14½ x 21½
Collection of Mr. and Mrs. Meyer P. Potamkin

Dawn Over the Pacific, Del Mar, California, 1889
oil on canvas, 24⅛ x 37
Collection of The Corcoran Gallery of Art;
Gift of Roy R. Neuberger

ROBERT ELSE, (b. 1918)

Wave III, 1972
acrylic on canvas, 42 x 46
Collection of Crocker Art Museum, Sacramento, California;
Gift of the Crocker Art Gallery Association

PHILIP EVERGOOD (1901-1973)

Beach Scene, n.d.
oil on canvas, 13½ x 17½
Courtesy of Midtown Galleries, New York

Love on the Beach, 1937
oil on canvas, 30½ x 37½
Collection of Hunter Museum of Art, Chattanooga,
Tennessee; Gift of the Benwood Foundation

ERIC FISCHL (b. 1948)

* *A Visit to/A Visit From the Island*, 1983
oil on canvas, 84 x 84 each
Collection of Whitney Museum of American Art, New York;
Purchase, with funds from the Louis and Bessie Adler
Foundation, Inc., Seymour M. Klein, President

GERTRUDE FISKE (1879-1961)

Ogunquit Beach, Maine, 1924
oil on canvas, 25 x 30
Collection of Colby College Museum of Art;
Gift of Mr. and Mrs. Ellerton M. Jette

HELEN FRANKENTHALER (b. 1928)

Buzzards Bay, 1959
oil stained canvas, 59⅝ x 45
Collection of Seattle Art Museum;
Gift of the Sidney and Anne Gerber Collection

CHRISTOPHER GERLACH (b. 1952)

Summer Beach and Tennis Club, La Jolla, 1987
oil on canvas, 30 x 40
Collection of Chuck Klein, C. Klein Co. Corp.

WILLIAM JAMES GLACKENS (1870-1938)

* *Cape Cod Pier*, 1908
oil on canvas, 22¼ x 32
Collection of Museum of Art, Fort Lauderdale, Florida;
Anonymous gift

* *Jetties at Bellport*, 1912
oil on canvas, 25 x 30
Collection of Albright-Knox Art Gallery, Buffalo, New York;
Evelyn Rumsey Cary Fund, 1935

Summer Day, Bellport, Long Island, c. 1916
oil on canvas, 26 x 32
Collection of Mitchell Museum, Mt. Vernon, Illinois

ROBERT GRAHAM (b. 1938)

Beach Party, 1966
colored wax, foam rubber, metal, wood and plastic
8 x 21½ x 21½
Collection of Whitney Museum of American Art, New York;
Gift of Howard and Jean Lipman

MORRIS GRAVES, (b. 1910)

Wounded Gull, 1943
gouache on paper, 26⅝ x 30½
The Phillips Collection, Washington, D.C.

EDMUND WILLIAM GREACEN (1876-1949)

Beach Scene at Watch Hill, 1914
oil on canvas, 26 x 35½
Collection of Lyman Allyn Art Museum

RED GROOMS (b. 1937)

Girl on Beach, 1970
craypas on paper, 35 x 23
Collection of Weatherspoon Art Gallery

CHILDE FREDERICK HASSAM (1859-1935)

Fishing Skiffs, Nantucket, c. 1882
watercolor on paper, 10 x 16
Collection of Ira and Nancy Koger

Seascape—Isle of Shoals, 1902
oil on canvas, 29⅛ x 37
Collection of High Museum of Art, Atlanta;
Friends of Art Purchase, 37.2

Little Good Harbor Beach, 1919
oil on panel, 7 x 10
Collection of Grand Rapids Art Museum;
Gift of Emily J. Clark

ROBERT HENRI (1865-1929)

Seascape, 1887
oil on canvas, 10 x 14
Collection of Weatherspoon Art Gallery;
Gift of Mr. and Mrs. Edward Rosenberg

Beach at Atlantic City, 1893
oil on canvas, 13¾ x 18
Collection of Phoenix Art Museum;
Gift of Mr. and Mrs. James Beattie

EDWARD LAWSON HENRY (1841-1919)

East Hampton Beach, 1881
oil on canvas, 23½ x 51½
Collection of The Chrysler Museum, Norfolk, Virginia

WINSLOW HOMER (1836-1910)

On the Beach, 1870
oil on canvas, 16 x 25
Collection of Canajoharie Library and Art Gallery,
Canajoharie, New York

The Bathers
(Cover illustration for "Harper's Weekly"), August 2, 1873,
engraved by Redding
wood engraving, 13¾ x 9
Collection of the Eva and William Gruman Family,
Tampa, Florida

On the Beach at Long Branch—The Children's Hour,
(Cover illustration for "Harper's Weekly"), August 15, 1874,
engraved by J. L. Langridge
wood engraving, 9 x 13½
Collection of the Eva and William Gruman Family,
Tampa, Florida

Woman on the Beach, Marshfield, 1874
watercolor, 7 x 13
Collection of Canajoharie Library and Art Gallery,
Canajoharie, New York

EDWARD HOPPER (1882-1967)

Untitled (House by the Sea), 1923 or 1924
watercolor and pencil on paper, 14 x 20
Collection of Whitney Museum of American Art, New York;
Bequest of Josephine N. Hopper

JOEL JANOWITZ (b. 1945)

Greg/Beach, 1979
oil on canvas, 50 x 84
Collection of Herbert W. Plimpton Foundation; on
extended loan to the Rose Art Museum, Brandeis University,
Waltham, Massachusetts

JACOB KASS (b. 1910)

The Beach, 1989
magna acrylic and oil on saw, 5 x 29½ x 1
Courtesy of Stein Gallery, Tampa, Florida

WILLIAM KEITH (1839-1911)

Stinson Beach, c. 1880
oil on canvas, 8½ x 18½
Collection of Hearst Art Gallery, Saint Mary's College,
Morago, California

* *The Lone Pine*, 1881
watercolor on paper, 14 x 10
Collection of Museum of Fine Arts, Boston;
Gift of Maxim Karolik, 1961

JOHN FREDERICK KENSETT (1816-1872)

The Seashore, 1863
oil on canvas, 10 x 18
Collection of High Museum of Art, Atlanta;
Gift of Mr. and Mrs. George E. Missbach

ROCKWELL KENT (1882-1971)

Headlands, Monhegan, 1909
oil on canvas, 34⅛ x 41¾
Collection of Sheldon Memorial Art Gallery,
University of Nebraska-Lincoln;
NAA-Nelle Cochrane Woods Memorial Collection

GREGORY KONDOS (b. 1923)

Life Guard, Santa Monica, 1987
oil on canvas, 18 x 24
Courtesy of O. K. Harris Works of Art, New York, New York

MAX KUEHNE (1880-1968)

The Green Hotel, Martha's Vineyard, 1911
oil on canvas, 15 x 18
Collection of Ira and Nancy Koger

WALT KUHN (1880-1949)

Coney Island, 1936
oil on board, 7¾ x 9¾
Courtesy of Midtown Galleries, New York

YASUO KUNIYOSHI (1893-1953)

The Swimmer, 1924
ink on paper, 14¾ x 17⅞
Collection of Whitney Museum of American Art, New York;
Gift of Mr. and Mrs. Charles J. Liebman

DORIS EMRICK LEE (1905-1983)

Bathers, n.d.
oil on canvas, 40 x 52
Collection of The Cleveland Museum of Art;
Bequest of Doris E. Lee

HUGHIE LEE-SMITH (b. 1915)

The Beach, 1962
oil on canvas, 35¾ x 48⅛
Collection of Cedar Rapids Museum of Art;
Henry W. Ranger Fund

ALFRED LESLIE, (b. 1927)

Casey Key, 1983
oil on canvas, 72 x 108
Courtesy of the Artist and Oil & Steel Gallery, New York

ROY LICHTENSTEIN (b. 1923)

Landscape, 1974
oil and magna on canvas, 30 x 36
Private Collection

JOHN MARIN (1870-1953)

* *Waves*, 1914
watercolor, 15¾ x 18¾
Collection of The Art Museum, Princeton University; The
Laura P. Hall Memorial Collection, Bequest of Clifton R. Hall

* *Popham Beach, Small Point, Maine* (Series No. 1), 1928
watercolor and chalk, 17⅛ x 22⅜
Courtesy of The Metropolitan Museum of Art;
Alfred Stieglitz Collection, 1949

* *Roque Island Beach, Maine Coast*, 1933
watercolor, 15½ x 21½
Courtesy of Kennedy Galleries, Inc., New York

Sea from Flint Island, 1934
watercolor and pencil on paper, 15½ x 20½
Collection of New Jersey State Museum;
Gift of Mr. and Mrs. L. B. Wescott, FA 1972.148

REGINALD MARSH (1898-1954)

Lifeguards, 1933
tempera on gessoed masonite panel, 36 x 24
Collection of Georgia Museum of Art,
The University of Georgia; Museum Purchase

Coney Island Beach #2, 1938
tempera on composition board, 29⅜ x 39½
Collection of Rose Art Museum, Brandeis University,
Waltham, Massachusetts; Gift of the Honorable William
Benton, New York

Fat Lady on the Beach, 1954
egg tempera and ink on panel, 7½ x 10½
The Arkansas Arts Center Foundation Collection

THOMAS MORAN (1837-1926)

Fort George Island, 1878
oil on canvas, 11 x 16
Collection of Mrs. George Walter Johnson

Florida Scene, c. 1878
oil on canvas, 10½ x 15½
Collection of Norton Gallery of Art, West Palm Beach,
Florida; Gift of Mr. Will Richeson, Jr.

* *The Much Resounding Sea*, 1884
oil on canvas, 25 x 62
Collection of National Gallery of Art, Washington, D.C.;
Gift of the Avalon Foundation, 1967.9.1

Moonlight Seascape, 1892
oil on canvas, 10½ x 16¼
Collection of Samuel B. and Marion W. Lawrence

MALCOLM MORLEY (b. 1931)

Beach Scene, 1969
screenprint with varnish overprint, ed. 59/60, 30 x 22
Courtesy of Brooke Alexander, New York

JULIAN ONDERDONK (1882-1922)

Seascape, c. 1901
oil on canvas, 9 x 15⅛
Collection of Marion Koogler McNay Art Museum, San
Antonio, Texas; Gift of Alice C. Simkins in memory of her
father, William Stewart Simkins

DAVID PARK (1911-1960)

Bathers, 1954
oil on canvas, 42 x 54½
Collection of San Francisco Museum of Modern Art;
Gift of the Women's Board

JANE PETERSON (1876-1965)

Beach at Spring Lake, n.d.
oil on board, 12 x 15⅞
Collection of The William Benton Museum of Art, The
University of Connecticut, Connecticut's State Art Museum

SCOTT PONEMONE (b. 1949)

Frieze, 1986
watercolor, 33 x 32
Courtesy of Littlejohn-Smith Gallery, New York

FAIRFIELD PORTER (1907-1975)

Beach in Morning #2, 1972
oil on masonite, 11¾ x 14
Collection of The Currier Gallery of Art, Manchester,
New Hampshire; Gift of Neil Welliver, 1982-13

EDWARD HENRY POTTHAST (1857-1927)

Children at the Beach, n.d.
watercolor, 11½ x 15½
Collection of Sordoni Art Gallery, Wilkes College,
Wilkes-Barre, Pennsylvania

* *Circle of Friends*, n.d.
oil on board, 16 x 20
Collection of Samuel B. and Marion W. Lawrence

At the Seaside, c. 1920
oil on board, 30 x 40
Collection of Mr. and Mrs. Merrill J. Gross

Beach Scene, c. 1920
oil on canvas, 24 x 30⅛
Collection of Hirshhorn Museum and Sculpture Garden,
Smithsonian Institution; Gift of Joseph H. Hirshhorn, 1966.

MAURICE BRAZIL PRENDERGAST (1859-1924)

Revere Beach, n.d.
watercolor, 13 x 19
Collection of Canajoharie Library and Art Gallery,
Canajoharie, New York

By the Seashore, 1905-06
oil on panel, 11¾ x 16
Collection of Mitchell Museum, Mt. Vernon, Illinois

Bathers in a Cove, c. 1910
oil on canvas, 15½ x 22½
Collection of Williams College Museum of Art;
Gift of Mrs. Charles Prendergast, 1986

WILLIAM TROST RICHARDS (1833-1905)

Shipwreck, 1872
oil on canvas, 24 x 42
Courtesy of Pennsylvania Academy of the Fine Arts,
Philadelphia; Gift of Henry R. Pemberton

New Jersey Seascape—Atlantic City, c. 1880
oil on canvas, 9 x 16½
Collection of George D. and Harriet W. Cornell Fine Arts
Museum at Rollins College; Gift of Samuel and Marion
Lawrence in honor of Joan Wavell (acc. no. 88-2-P)

* *On the Coast of New Jersey*, 1883
oil on canvas, 40½ x 72½
Collection of The Corcoran Gallery of Art;
Museum purchase, Gallery Fund

JUDY RIFKA (b. 1945)

Beach III, 1984
oil, linen on wood, 74½ x 102
Courtesy of Brooke Alexander, New York

CAROLINE E. RIXFORD (1873-1954)

At the Beach, San Francisco, n.d.
oil on board, 11 x 14
Collection of Mr. and Mrs. R. A. Langley, San Francisco,
California; Courtesy of Maxwell Galleries, Ltd.

CHARLES DORMAN ROBINSON (1847-1933)

The Wet Sand, c. 1890
oil on canvas, 21½ x 30
Collection of The Oakland Museum;
Gift of Doctor William S. Porter

ALICE SCHILLE (1869-1955)

Midsummer Day, c. 1916
watercolor, gouache and conte crayon, 11½ x 13⅝
Collection of Columbus Museum of Art, Ohio;
Gift of Ferdinand Howald

BEN SCHONZEIT (b. 1942)

Scott Cameron (Bridgehampton), 1985
watercolor, 11½ x 30
Courtesy of Louis K. Meisel Gallery, New York

JOAN SEMMEL (b. 1932)

Amagansett Afternoon, 1985
oil on canvas, 78 x 120
Collection of the Artist

FRANK HENRY SHAPLEIGH (1842-1906)

Nantasket Beach, 1874
oil on board, 15 x 31
Collection of Danforth Museum of Art;
Gift of Faith and James Waters

ALAN SIEGEL (b. 1938)

Seaside, 1986
painted wood, 63 x 57 x 25
Courtesy of Nancy Hoffman Gallery, New York

FRANCIS AUGUSTUS SILVA (1835-1886)

Sunrise: Marine View, c. 1870
oil on canvas, 15 x 29⅞
Collection of Munson-Williams-Proctor Institute,
Museum of Art, Utica, New York

MAXWELL STEWART SIMPSON (b. 1896)

Last Summer, 1962
oil on canvas, 28 x 32
Collection of The Montclair Art Museum; Museum purchase

JOHN SLOAN (1871-1951)

* *South Beach Bathers*, 1908
oil on canvas, 26 x 31¾
Collection of Walker Art Center, Minneapolis; Gift of the T.
B. Walker Foundation, Gilbert M. Walter Fund, 1948

WILLIAM LOUIS SONNTAG, JR. (1822-1900)

The Lighthouse, n.d.
watercolor, 9½ x 20⅝
Mead Art Museum, Amherst College;
Gift of William Macbeth, Inc.

PAUL STAIGER (b. 1941)

Santa Cruz, 1974
acrylic on canvas, 60⅛ x 89½
Collection of San Francisco Museum of Modern Art;
T. B. Walker Foundation Fund Purchase

CHARLES WALTER STETSON (1858-1911)

Water Play, 1895
oil on canvas, 29¾ x 35¾
Collection of Museum of Art, Rhode Island School of
Design; Bequest of Isaac C. Bates, 13.962

WALTER STUEMPFIG (1914-1970)

* *West Wildwood, New Jersey*, 1946
oil on canvas, 30½ x 40½
Collection of The Fine Arts Museums of San Francisco;
Mildred Anna Williams Collection

WAYNE THIEBAUD (b. 1920)

* *Bikini*, 1964
oil on canvas, 72 x 35⅞
Collection of The Nelson-Atkins Museum of Art, Kansas
City, Missouri; Gift of Mr. and Mrs. Louis Sosland

Baker Beach, San Francisco, 1973
oil on canvas, 10 x 12 in.
Collection of Matthew L. Bult, California

JOHN HENRY TWACHTMAN (1853-1902)

Sea Scene (Marine, Seascape), 1893
oil on canvas, 28 x 34
Collection of Delaware Art Museum; Special Purchase Fund

Beach at Squam, c. 1900
oil on canvas, 25 x 30
Collection of Ira and Nancy Koger

BEATRICE WHITNEY VAN NESS (1888-1981)

* *Summer Sunlight* c. 1936
oil on canvas, 39 x 49
Collection of The National Museum of Women in the Arts;
Gift of Wallace and Wilhelmina Holladay

ABRAHAM WALKOWITZ (1880-1965)

Bathers, 1919
watercolor, 15½ x 29
Collection of Columbus Museum of Art;
Gift of Ferdinand Howald

Bathers on the Rocks, c. 1935
oil on canvas, 25 x 30
Collection of Tampa Museum of Art, Museum purchase

FREDERICK JUDD WAUGH (1861-1940)

Incoming Tide, 1931
oil on canvas, 25 x 30½
The Arkansas Arts Center Foundation Collection

Green Wave, 1935
oil on pressed wood, 24 x 32
Collection of The Montclair Art Museum;
Gift of Mr. and Mrs. Solomon Wright, Jr.

JULIAN ALDEN WEIR (1852-1919)

Shore Scene, n.d.
watercolor on paper, 5¼ x 6⅞
Collection of Williams College Museum of Art,
Williamstown, Massachusetts

TOM WESSELMANN (b. 1931)

Seascape Number 15, 1967
synthetic polymer on molded plexiglass,
65 x 44½ x 3
Collection of Whitney Museum of American Art, New York;
Purchase with funds from the Howard and Jean Lipman
Foundation, Inc., 68.29

(THOMAS) WORTHINGTON WHITTREDGE
(1820-1910)

Scene on Cape Ann, c. 1880
oil on canvas, 11 x 22
Private Collection

Sunrise at Long Branch, 1883
oil on canvas, 22½ x 32
Private Collection

* *Second Beach Newport*, c. 1900
oil on canvas, 14¾ x 21¾
Collection of Bowdoin College Museum of Art,
Brunswick, Maine

JANE WILSON (b. 1924)

Receding Sea, 1987
oil on linen, 80 x 74
Courtesy of Fischbach Gallery, New York

CHARLES HERBERT WOODBURY (1864-1940)

Going Up, n.d.
oil on canvas, 12 x 17
Private Collection

MABEL MAY WOODWARD (1877-1945)

Beach Scene, n.d.
oil on canvas, 24 x 30
Collection of Danforth Museum of Art; anonymous gift

THEODORE WORES (1859-1939)

Ocean Shore of San Francisco, Lime Point Seascape, 1927
oil on canvas, 16 x 20
Collection of Drs. Ben and A. Jess Shenson

Artists' Biographies

MILTON AVERY

Born 1885, Altmar, New York; died 1965, Bronx, New York

Remaining unchanged by criticism or fashion, Avery was an outstanding colorist and a bridge to later Abstractionists. After brief studies at the Connecticut League of Art Students, he married illustrator Sally Michel and they settled in New York. He sketched directly from his subjects, and then composed his paintings in his studio, flattening space and using color to define form. *Beach Loungers* (1932), *Siesta* (1945), and *Sea and Rocks—Ten Pound Island* (1956) show increasing degrees of abstraction and changes of palette, but the overall effect is uniquely Avery—a lyrical quality of motionlessness and peace.

GIFFORD BEAL

Born 1879, New York, New York; died 1956, New York, New York

Beal studied at the Art Students League, the New York School of Art and Chase's Shinnecock Summer School, and graduated from Princeton in 1900. He was associated with the Ashcan School of New York realists, although he never formally allied himself with any movement. He chose elements of Impressionism which interested him, consistently exploring various permutations of light and color in a variety of subjects. *Garden Beach* is straightforward, bright and painterly. It does not address social concerns like the work of many of Beal's contemporaries.

GEORGE WESLEY BELLOWS

Born 1882, Columbus, Ohio; died 1925, New York, New York

An athletic man best known for his depictions of boxing matches, Bellows personified the American realism of the Ashcan School. In fact, he was one of the few artists of his time who never studied in Europe. He studied with Henri, but did not participate in exhibitions of The Eight. He also worked for Sloan as a newspaper illustrator, was an accomplished lithographer, portraitist, and landscape painter. *The Beach* is one of Bellows's few seaside subjects, but its dynamism and bravura brushstrokes catch the same drama and excitement as his other scenes of active life. It was painted as a result of the summers he spent at Middletown, near Newport, in 1918 and 1919.

FRANK WESTON BENSON

Born 1862, Salem, Massachusetts; died 1951, Salem, Massachusetts

Benson attended the School of the Museum of Fine Arts, Boston, then studied at the Académie Julien in Paris. He returned to Salem and taught throughout his career, including at his alma mater in Boston. In 1898, he founded, along with his friend Edmund Tarbell and other American Impressionists, a group known as The Ten. In contrast to Tarbell's subdued interiors, Benson painted women and children at play in cheerful, brightly colored outdoor settings. *Shimmering Sea* contains no figures, but does reflect Benson's sustained interest in sunlight.

ALBERT BIERSTADT

Born 1830, Solingen, Germany; died 1902, New York, New York

Bierstadt's family emigrated to America and settled in New Bedford, Massachusetts when he was two. He returned to Germany to study at the Düsseldorf Academy, then studied in Rome alongside Whittredge. He returned to New Bedford, and in 1859 embarked on his first expedition through uncharted western territories, sketching throughout the journey. His monumental, stunning and romantic panoramas, based on the sketches from his many travels, earned Bierstadt the highest international critical acclaim and placed his paintings in high demand. *Cove with Beach* was probably painted directly from the landscape and conveys, on a small scale, Bierstadt's deep reverence for nature.

THOMAS BIRCH

Born 1779, England; died 1851, Philadelphia, Pennsylvania

Coming from England in 1794 with his father, an engraver and miniaturist, Birch worked initially in the same techniques until marine subjects and landscapes became his primary interests. Birch's *Seascape* (View of Maine Coast) is the earliest work in this exhibition. In its portrayal of the wildness of sea and shore, the painting embodies the English Romantic tradition which Birch brought to America. Because the figures are subordinated to the landscape, the painting also suggests the nineteenth-century American view of nature's dominance over man.

HENRY SINGLEWOOD BISBING

Born 1849, Philadelphia, Pennsylvania; died 1933, Gales Ferry, Connecticut

Bisbing studied at the Pennsylvania Academy of the Fine Arts, the Munich Royal Academy, and with J. H. L. de Haas in Holland before he settled in Paris in 1884. He remained in Paris until the outbreak of World War I when he returned to the United States and settled in Gales Ferry, Connecticut. There he spent the remainder of his years painting the New England landscape, such as the richly textured, quiet *Beach*.

ROBERT BORDO

Born 1949, Montreal, Canada; resides New Jersey

Bordo attended McGill University and studied at the New York Studio School from 1972 to 1975. His work belongs to New Abstraction, a current trend which looks back to gestural abstractions from the 1950s. His works are generally large-scale and, as *Oceanfront* suggests, evocative of landscapes.

RICHARD BOSMAN

Born 1944, Madras, India; resides New York, New York

Bosman, who works extensively in the graphic arts as well as in painting, studied in London before attending the New York Studio School where he worked with Alex Katz, whose influence is seen in Bosman's simplified forms. He also attended the Skowhegan School of Painting and Sculpture and the School of Visual Arts. He brings unusual fluidity to the rough line of the woodcut, one of his principal mediums. He portrays his subjects, drawn from comic books, popular fiction and literature, in an expressionistic style with broad dramatic line and pervasive color. Although events are ambiguous to the viewer, there is always an underlying narrative in Bosman's work, as even the title of *Aftermath* implies.

WILLIAM BRADFORD

Born 1823, Fairhaven, Massachusetts; died 1892, New York, New York

Bradford worked as a shopkeeper before he turned to painting in 1854. His early work consisted of ship portraits and harbor scenes of the New Bedford area. In 1855 he met the Dutch marine painter Albert Van Beest (1820-1860), with whom he studied and collaborated. In the 1860s he travelled to Labrador and the Arctic in search of more dramatic coastal landscapes, and became well-known for his paintings of icebergs. *Lynn Beach*, depicting

a shoreline just north of Boston, is an early work in which the broad expanse of beach converges upon a fishing vessel, placed in the distance on a low horizon.

ALFRED THOMPSON BRICHER

Born 1837, Portsmouth, New Hampshire; died 1908, Staten Island, New York

Bricher was a Boston businessman before he began studying art in 1851 and became a well-recognized marine and landscape painter. He concentrated on coastal views from Maine to New Jersey, and his fascination with the effects of light and atmospheric conditions place him in the Luminist tradition. His facility in capturing the movement of water and atmospheric color is evident in *Low Tide, Manomet*. The figures of the anecdotal *Baby is King* exhibit Bricher's linear style and could be compared to those of Homer.

WILLIAM PARTRIDGE BURPEE

Born 1846, Rockland, Maine; died 1940 Rockland, Maine

Through his association with Bradford, his first teacher, Burpee began painting along the Massachusetts coast. He shared a studio with Joseph DeCamp, and through him came into contact with the Boston School artists. Burpee toured Europe from 1896 to 1900, and the light effects, loose brushwork, and bright palette in his work reflect the influence of the Impressionists. *Doryman at the End of the Day* is an intimate scene in which Burpee has used soft, gradating colors to create a luminous evening scene. It was painted on Lynn Beach, just north of Boston, where Burpee often worked. From 1923 on, Burpee divided his time between Rockland, Maine and East Orange, New Jersey, continuing to paint the beach and the sea.

PAUL CADMUS

Born 1904, New York, New York; resides Weston, Connecticut

This artist's father was a lithographer and watercolorist, his mother an illustrator. He studied at the National Academy of Design and the Art Students League, then studied the European masters and began to paint social satires while living on the island of Mallorca. On his return to this country he painted murals for the WPA and received instant national notoriety when one of his satires depicting drunken American sailors on leave was destroyed following protests by a U.S. admiral. Cadmus continued to produce Depression-era satires of American manners in oil, egg tempera and etching. Crowded scenes of men and women in raucous behavior are set in a Renaissance perspective and composition. His approach is evident in *Coney Island*, an etching which corresponds to his painting of the same subject.

(SOREN) EMIL CARLSEN

Born 1853, Copenhagen, Denmark; died 1932, New York, New York

After studying architecture in Copenhagen, Carlsen emigrated to America in 1872 and shortly thereafter turned to painting. By 1884 he had established a reputation for his masterterful treatment of still lifes in the tradition of Chardin. Visits to Paris and residency in California, where he was Director of the California School of Design, produced a lighter palette and an interest in landscape. He returned to the East Coast and spent the rest of his career in New York and Connecticut, associating with prominent American Impressionists. *Nantasket Beach* exemplifies the combination of traditional representational art and impressionistic color and light for which Carlsen was well recognized.

SAMUEL S. CARR

Born 1837, England; died 1908, Brooklyn, New York

Carr emigrated to America and settled in Brooklyn in the 1860s. Although it is believed he had completed his education by that time, he is known to have taken a mechanical drawing course at Cooper Union Art School. He was a skillful painter of children, seashore life and pastoral subjects. *Beach Scene* and *Small Yacht Racing* are typical of his beach subjects, most of which depict

Coney Island and were painted between 1879 and 1881. Certain figure shapes are used repeatedly, reversed or turned in different directions. Many of the figures are not looking at each other; the photographer in *Beach Scene* does not even address his posed subjects. Carr creates an unusual effect by doing this, giving the paintings an eerie stillness.

KATHARINE TIPTON CARTER

Born 1950, Tampa, Florida; resides Oceanport, New Jersey

Carter graduated from the University of Florida and received her MFA from the University of South Florida. Her introspection and autobiographical explorations fuel her use of symbolic imagery. The bottle shape seen in many of the works represents the artist's self, while the beachscape refers to her surroundings—she now lives near a beach in New Jersey. In *Water's Edge*, from her recent series of whimsical, playful beach-inspired works, the bottle shape suggests bathers on the beach; it is clearly separated from the "ocean" of scallop patterns.

VIJA CELMINS

Born 1939, Riga, Latvia; resides New York

Celmins settled in Indianapolis, Indiana in 1949. She graduated from the Herron School of Art in 1962 and received an MFA from the University of California at Los Angeles in 1965 before moving to New York in 1981. Her work deals with the physical world, although metaphysical aspects are implied by her unpeopled landscapes of ocean, desert, and galaxy. Her exacting technique is based on acute observation, often aided by photographs, and distracts from the subject at times. In *Untitled* (Ocean), the focal point is over the ocean's horizon, viewed from the beach, with an endless expanse of water reinforcing the concept of infinite space.

WILLIAM CHADWICK

Born 1879, Yorkshire, England; died 1962, Old Lyme, Connecticut

Chadwick grew up in Holyoke, Massachusetts. Through a classmate at the Art Students League in New York he was introduced to the artists' colonies of Old Lyme and Cos Cob in Connecticut. In 1915 he purchased a house in Old Lyme, and, like earlier Impressionists, divided his time between Old Lyme and New York City. He travelled and painted throughout New England, but focused on the Connecticut landscape. *Griswold Beach*, painted near Chadwick's home, exhibits the artist's characteristically bright and harmonious palette.

WILLIAM MERRITT CHASE

Born 1849, Williamsburg, Indiana; died 1916, New York, New York

Chase studied at the National Academy of Design in New York and later at the Royal Bavarian Academy in Munich, where he came into contact with the expatriates Twachtman and Duveneck. In 1878 he returned to America and became an extremely influential teacher. He taught at various prestigious art schools and at his summer home in Shinnecock, Long Island. A versatile master of many techniques and styles, Chase combines in *Morning at Breakwater, Shinnecock*, an impressionistic approach and a strong receeding diagonal, which creates an unusual perspective.

HILO CHEN

Born 1942, Taiwan, China; resides New York, New York

Chen received a degree in architecture in the Republic of China. After a year in Paris, he moved to New York in 1968, when Photorealism was an important new art movement. *Beach 103* exemplifies Chen's bold, super-realistic images. The painting is part of a large series inspired by Chen's visit to Jones Beach, New York, in 1974.

ALSON SKINNER CLARK

Born 1876, Chicago, Illinois; died 1949, Pasadena, California

Clark began his art studies at the School of the Art Institute of Chicago but left to study in New York, where he profited most

from his studies with Chase. He was also influenced by his frequent travels in Europe, particularly France. He settled in California in 1919 and soon began to use bold, sparkling colors. *The Weekend, Mission Beach* records the scrubby terrain leading to a beach near San Diego. Typical of Clark's landscapes, it is timeless and painterly, and captures the essence of the place.

JASPER FRANCIS CROPSEY

Born 1823, Staten Island, New York; died 1900,
Hastings-on-Hudson, New York

Cropsey's training in architecture provided a foundation for the precise detail of his paintings. He worked principally along the Hudson River Valley, and became most well known for his brilliantly colored autumn landscapes. *Long Beach* was painted just as that area of Long Island was becoming known as a retreat from New York. In *Long Beach*, a summer scene, Cropsey uses a subdued, delicate palette, but the work shares with his romantic autumn scenes the feeling for man's subordination to nature.

GEORGE CURTIS

Born 1826; died 1881

Curtis exhibited in the Boston area, including at the Athenaeum, from the late 1840s through the 1860s. Most of his works are marine scenes with ships as their main subject. *Clamming on the East Coast* is a departure from this work, as it concentrates on shore activity rather than on sailing vessels. The unusual subject is skillfully handled, and the glow of reflected light on the wet sand displays Luminist qualities.

FRANK VIRGIL DUDLEY

Born 1868, Delavan, Wisconsin; died 1957, Chicago, Illinois

Indiana Dunes is one of many views Dudley painted of these dunes along Lake Michigan. Dudley is recognized not only as an artist but also as a citizen for his successful efforts to preserve the dunes. After studying at the School of the Art Institute of Chicago, he painted in and around Illinois and Indiana. From 1921 until his death, he lived in a cottage on the dunes for nine months of the year. In 1923 his environmental efforts resulted in the creation of Dunes State Park, now the Dunes National Lakeshore.

DON EDDY

Born 1944, Long Beach, California; resides New York, New York

Eddy received his BFA and MFA from the University of Hawaii and did post-graduate work at the University of California at Santa Barbara. He works in a style associated with New Realism, employing photography for the imagery of his art. He seeks in his work a tension between the illusion of three-dimensional space and the flatness of the painting's actual surface. In *Clearing*, the landscape and the fruits and flowers of the border refer to traditional realism. Eddy's particular combination of these elements with two dimensional patterns, however, deals with contemporary issues of visual perception.

LOUIS MICHEL EILSHEMIUS

Born 1864, Arlington, New Jersey; died 1941, New York,
New York

Eilshemius was educated in Geneva and Dresden before enrolling at Cornell to study agriculture. He stayed for two years, but his interest in art led him to the Art Students League, the Académie Julien in Paris, and landscape studies in Antwerp. His visionary paintings of eccentric subjects were drawn from dreams and nightmares. His personal isolation and feelings of failure eventually left him embittered. *Surf at Easthampton* dates from the period in his career between 1882 and 1920 when he turned out hundreds of paintings in a primitivistic new style. He gave up painting in 1921 and spent the rest of his life as a recluse.

ROBERT ELSE

Born 1918, Wayne, Pennsylvania; resides Sacramento, California

An art educator as well as painter, Else did both graduate and undergraduate work at Columbia University in New York. He

is now Professor Emeritus at California State University at Sacramento, where he has taught since 1950. Although he has worked in various styles, beach themes have always been important to him. *Wave III* is from a series of works based on visits to northern California beaches, which examine the interrelationship of sea and shoreline. The painting presents a purely formal approach to the forms and textures of waves and sand.

PHILIP EVERGOOD

Born 1901, New York, New York; died 1973, New York, New York

Evergood was raised and educated in London, where he attended Cambridge University and the Slade School of Art. He studied for a year in New York City at the Art Students League with George Luks, and at Stanley Hayter's graphic arts school. He spent time in Paris and studied at the Académie Julien, but returned to America in 1931, during the throes of the Depression. He became a political activist and was known for paintings which combined fantasy with social realism and criticism. *Love on the Beach* exemplifies Evergood's deliberately awkward form and arrangement. The painting also has the sense of joy, humor and energy which prevail even in Evergood's works of strong social protest.

ERIC FISCHL

Born 1948, New York, New York; resides New York

Fischl received his BFA from the California Institute of Arts, Valencia. *A Visit to/A Visit From the Island* is typical of his large-scale figurative work, executed in a broad painterly style. It is emotionally charged, effectively using the diptych and implying a mysterious narrative. Because of the detachment Fischl maintains while presenting his subjects in unsettling or intimate situations, his work contains strong elements of voyeurism.

GERTRUDE FISKE

Born 1879, Boston, Massachusetts; died 1961,
Weston, Massachusetts

Fiske studied with a number of well-known painters, including Tarbell and Benson at the School of the Museum of Fine Arts, Boston, and Woodbury at his summer school in Ogunquit, Maine. She was a founding member of the Artists Guild of Boston, organized the Ogunquit Art Association, and was a member of the National Academy of Design. *Ogunquit Beach, Maine*, painted in 1924, places figures in a bright, cheerful, sunny setting akin to traditional Impressionist works, but its abstractions, especially in the sky, sea and waves, seem modern for the time.

HELEN FRANKENTHALER

Born 1928, New York, New York; resides New York, New York

Daughter of a New York Supreme Court Justice, Frankenthaler studied at exclusive schools. Rufino Tamayo was her teacher at the Dalton School, and she learned Cubism from Paul Feeley at Bennington College, but she was always attracted to the art of Kandinsky and Miro. After seeing some black paint that Pollock had soaked into unprimed canvas, she pioneered a new movement in modern art with a form of Abstraction called "stain painting." *Buzzards Bay* (inspired by an area on Cape Cod) shows her technique of diluting paints so that they soak into the canvas, allowing areas of color in varying densities to play off against one another. She sketched numerous mountains and coastlines, and her lyrical abstractions evoke these subjects. Color-field artists of the 1960s, including Morris Louis and Kenneth Noland, followed her lead.

CHRISTOPHER GERLACH

Born 1952, Wareham, Massachusetts; resides San Diego,
California

Gerlach received an MA at San Diego State College, then studied at Oxford University's Ruskin School of Drawing and Fine Art, and as an artist-in-residence at Monet's studio in Giverny,

France. He works in a realistic style, producing paintings such as *Summer Beach and Tennis Club, La Jolla*, which depict his California surroundings.

WILLIAM JAMES GLACKENS

Born 1870, Philadelphia, Pennsylvania; died 1938, Westport, Connecticut

Glackens worked as an illustrator while he studied at the Pennsylvania Academy of the Fine Arts. There he met Henri, who urged him to paint. Glackens married Chase's daughter and lived in Greenwich Village. Like other members of The Eight and the Ashcan School who congregated around Henri, Glackens painted urban realism, but his subjects were usually well-dressed people enjoying the pleasures of the city. After a trip to France in 1905, Glackens adopted bright colors and shimmering brushstrokes, and turned to summer landscapes and seaside paintings. These qualities are evident in *Jetties at Bellport* and *Summer Day, Bellport*, which he produced while spending summers with his family at Bellport, Long Island from 1911 to 1916. *Cape Cod Pier* presents an unusual view of promenading gentry.

ROBERT GRAHAM

Born 1938, Mexico City, Mexico; resides Venice, California

After finishing his studies at San Jose State College and the San Francisco Art Institute, Graham settled in Los Angeles and began to make small figures in wax. The psychological tensions of his later work are already present in this early sculpture. Although the figures are very detailed and accessible, they are covered with plexiglass and thus untouchable and remote. His bronzes are usually larger in scale and painted with oils, though they retain a psychological distance. *Beach Party*, one of his early wax sculpture "sets," is an example of his narrative style in which the interaction of figures implies a scenario.

MORRIS (COLE) GRAVES

Born 1910, Fox Valley, Oregon; resides Redwoods, California

Graves was first exposed to Eastern culture as a seaman, and later, when he became a self-taught artist, he was influenced by Mark Tobey's calligraphy. He helped establish a Northwest School, but is now a recluse living on the northwest coast. His work exhibits his interest in Zen and Oriental philosophy and is highly symbolic. Birds appear frequently, often blind or wounded. *Wounded Gull* is a symbol of Transcendentalism.

EDMUND WILLIAM GREACEN

Born 1876, New York, New York; died 1949, White Plains, New York

Greacen studied with Chase and DuMond before spending two years at Monet's studio in Giverny, France with other American expatriates. Returning to America, he divided his time between New York City and the artists' colony at Old Lyme, Connecticut, where he worked with other American Impressionists. Greacen's pale palette and staccato brushstrokes can be seen in *Beach Scene at Watch Hill*, depicting a beach in Rhode Island.

RED GROOMS

Born 1937, Nashville, Tennessee; resides New York

A pioneer of Happenings, Grooms studied at Peabody College, Nashville; the New School for Social Research, New York; the Art Institute of Chicago and the Hans Hofmann School on Cape Cod. Through his choice of themes, he is related to the Pop Art movement. His images of modern life, quickly painted, often contain elements of fantasy, humor and satire. *Girl on Beach* is a caricature of a bathing beauty done in Grooms's exaggerated, cartoon style.

(FREDERICK) CHILDE HASSAM

Born 1859, Dorchester, Massachusetts; died 1935, East Hampton, New York

Hassam apprenticed with a Boston wood engraver, and while studying art privately did illustrations for publications such as *Harper's* and *Scribner's*. He travelled and studied in Europe several times, working with Gustave Boulanger and Jules Lefebvre, exhibiting at the Salon and absorbing the Impressionists' technique. Hassam returned to New York City, became a founding member of The Ten, and is now considered one of America's foremost Impressionists, and the one with the closest affinity to Monet. Although his sparkling light is French-inspired, he maintains a stronger sense of form than French artists, remaining truly American. This is particularly evident in the peaceful New England beach of *Fishing Skiffs, Nantucket*. The Isles of Shoals, off the coast of New Hampshire, inspired some of his best work in oil and watercolor, including *Seascape*. *Little Good Harbor Beach* dates from a later period when his work began to show the effects of Post-Impressionism.

ROBERT HENRI

Born 1865, Cincinnati, Ohio; died 1929, New York, New York

Henri's importance to the development of American Realism cannot be overstated. Firmly rooted in the culture of this country, he brought great vigor to early twentieth-century American art. After living and studying in New York and Paris, Henri settled in New York to begin a long career as a magnetic and influential teacher at the New York School Art. He played a major role in bringing an objective realism—portrayals of ordinary people rather than the social elite—into the mainstream of American art. His paintings of city streets and urban slums helped inaugurate the modern era. As a leader of The Eight and the Ashcan School, he is best known for his portraits and cityscapes. He also painted landscapes; *Seascape* and *Beach at Atlantic City*, show his ability to capture the light and mood of the outdoors.

EDWARD LAMSON HENRY

Born 1841, Charleston, South Carolina; died 1919, Ellenville, New York

Henry studied at the Pennsylvania Academy of the Fine Arts before making the Grand Tour of Europe where he studied with the noted teachers Gustav Courbet and Marc Gabriel Charles Gleyre. Although he continued to travel frequently in Europe, his style is uniquely American. Henry's work is characterized by detailed genre studies which often include a horse and carriage, figures and a cottage. His meticulously accurate scenes, such as *East Hampton Beach*, are important records of his era and document styles in architecture, dress and travel.

WINSLOW HOMER

Born 1836, Boston, Massachusetts; died 1910, Prout's Neck, Maine

Aside from classes at the National Academy of Design and a few private lessons, America's leading nineteenth-century painter of naturalist landscapes was essentially self-taught. He began as an illustrator, producing superb woodblock illustrations, such as the ones from *Harper's Weekly* in this exhibition. He made a trip to Paris, but French art had little influence on him. He lived alternately in New York City and various New England summer retreats. Homer began working with watercolor in 1873 and raised that medium to a new level of excellence. He painted many works of the sea, the shore, and the men and women who struggled against the sea. He settled on a remote point in Maine, Prout's Neck, where he built a studio overlooking the sea, and became reclusive in his later years although he continued to work prodigiously. *On the Beach* shows Homer's depth of color and atmosphere in oils, and *Woman on the Beach, Marshfield* reveals his facility in watercolor.

EDWARD HOPPER

Born 1882, Nyack, New York; died 1967, New York, New York

Hopper, one of the pioneers of American Realism, studied at the New York School of Art with Kenneth Hayes Miller and with Henri, whose urban realism Hopper considered critical to his development. A starkness and a sense of loneliness and detachment set Hopper's works apart from those of his contemporary realists. He supported himself as a commercial artist for more

than a decade until his paintings began to sell. Hopper first experimented with watercolor in 1923 when he summered in Gloucester, Massachusetts. *Untitled* (House by the Sea), from this time, shows his early fluency with the medium. As in much of his work, strong sunlight defines both the landscape and the structure of the composition, and feelings of isolation and barrenness prevail.

JOEL JANOWITZ

Born 1945, Newark, New Jersey; resides New York, New York

After graduating from Brandeis University, Janowitz received an MFA from the University of California at Santa Barbara. For several years he has taught at Brown University, and has received many awards for his work. His early work was abstract, but his style has shifted toward realism. His work is rooted in observation. He catches his subjects at an unusual moment or from an awkward perspective. *Greg/Beach* illustrates Janowitz's accomplishment as a realist.

JACOB KASS

Born 1910, East New York, New York; resides Largo, Florida and Vermont

Kass has been painting on handsaws since 1977. He has no formal art training, but worked for his father's paint shop, which specialized in the design and lettering of logos on commercial vehicles. He began to paint on various found objects and eventually came to favor handsaws, on which he paints panoramic landscapes which fit the shape of the saws. Kass spends summers in Vermont and winters in Florida. Painted in his naive style, *The Beach* captures the essence of Clearwater Beach near his home.

WILLIAM KEITH

Born 1839, Aberdeen, Scotland; died 1911, Berkeley, California

After training in Germany, Keith settled in California in 1858. Initially a wood engraver, he recorded nature in exact detail. His style became looser and more expressionistic as he painted broad panoramas of the California landscape, influenced by the visit of George Inness in 1891. *The Lone Pine* is representative of Keith's more literal style. *Stinson Beach*, painted just north of San Francisco, is a moody scene, with a misty haze and glowing light.

JOHN FREDERICK KENSETT

Born 1816, Cheshire, Connecticut; died 1872, New York, New York

Kensett was a leading painter of the second generation of the Hudson River School. He was also a founder and later a trustee of the Metropolitan Museum of Art. He received his first art training in his father's engraving firm but was also influenced by his Grand Tour of Europe and by his colleagues at the National Academy of Design. On a small scale, the Luminist work *The Seashore* exhibits elements of the powerful style of Kensett's panoramas—sharp detail, sensitivity to atmospheric conditions, and water, rocks, and sky which reflect infinite depth and peace.

ROCKWELL KENT

Born 1882, Tarrytown, New York; died 1971, Plattsburgh, New York

An accomplished illustrator and engraver who enjoyed rugged outdoor life, Kent is also known for his stark paintings of the northeastern coast and Alaska. He studied at the New York School of Art with Henri, Chase and Miller. At the suggestion of Henri, Kent visited Monhegan Island on the Maine coast and was captivated by the monumental proportions of the coastal landscape. *Headlands, Monhegan*, treats the theme of nature's power in Kent's typically bold style, with his striking use of broad black masses and sharp contrasts of tone.

GREGORY KONDOS

Born 1923, Lynn, Massachusetts; resides Sacramento, California

Kondos studied in California, earning his BA and MA from Sacramento State College. He has worked in California since the 1950s, teaching at Sacramento City College and painting. His works, such as *Life Guards, Santa Monica*, relate to the school of California Realism.

MAX KUEHNE

Born 1880, Halle, Germany; died 1968, New York, New York

Kuehne grew up in the Hudson River area and studied at the Chase School and with Henri. He travelled frequently in Europe, and was influenced by the techniques of Monet and Seurat and the color of Bonnard. He joined a group of artists who spent summers painting in Rockport, Massachusetts and drew the inspiration for his open-air paintings from New England harbors and fishing villages. *The Green Hotel, Martha's Vineyard* typifies his interest in the color and light of the coastal landscape.

WALT KUHN

Born 1880, Brooklyn, New York; died 1949, New York, New York

Kuhn is best known for his powerful portraits of clowns and theater performers, but he devoted much of his time to a variety of other pursuits. He designed theater sets and costumes and interiors for railway cars; advised prominent collectors on buying paintings; owned a bike shop and barnstormed as a bike racer; and made a living as a cartoonist for *Life, Puck*, and other popular magazines. He studied in Paris and Munich, and from these years, Cézanne's black outlines and planar form, as seen in *Coney Island*, had the most lasting effect on his work. These qualities, combined with strident Fauve color and German expressionism, give Kuhn the characteristic vigorous style for which his contemporary critics so admired him. In his later years, Kuhn became increasingly eccentric and died in a mental institution.

YASUO KUNIYOSHI

Born 1893, Okayama, Japan; died 1953, New York, New York

Kuniyoshi's work melds Eastern sensibilities with Western sensuousness. He studied in Los Angeles for a few years and then settled in New York in 1916 where he continued his studies at the Art Students League. He was most influenced by Kuhn and the Frenchman Jules Pascin. *The Swimmer* dates from the years he rendered humorous fantasies with a deliberate primitivism. Women were one of his favorite subjects, and he regarded their exaggerated distortions as essentially oriental in tradition.

DORIS EMRICK LEE

Born 1905, Aledo, Illinois; died 1983, Clearwater, Florida

Lee graduated from Rockford College and then studied with Ernest Lawson at the Kansas City Art Institute. After visiting Europe, she attended the California School of Fine Arts where she learned to paint from nature. She moved to Woodstock, New York in 1931 and became a well known figure in the artists' colony there, working with Yasuo Kuniyoshi, Peggy Bacon and Leon Kroll. In 1935 one of her whimsical, anecdotal paintings of American life won the Logan Medal at the Art Institute of Chicago. The Institute's acquisition of that work established Lee's reputation and encouraged important commissions and acquisitions by other major institutions. *Bathers* shows a debt to Avery and is an important modernist work of the time.

HUGHIE LEE-SMITH

Born 1915, Eustis, Florida; resides Hightstown, New Jersey

Smith grew up in Atlanta, then moved with his family to Cleveland. He won a scholarship to the Art School at the Detroit Society of Arts and Crafts, then studied at the Cleveland School of Art. He worked for the WPA in Ohio and served in the Navy before moving to New York City in the late 1950s. His mature style, as seen in *The Beach*, fuses realism with visionary elements: isolated figures occupy desolate landscapes which, though seemingly ordinary, have an eerie stillness that conveys a sense of the surreal. The sense of alienation in his work is similar in feeling to paintings by artists he admires, such as Evergood,

Hopper, Stuempfig and Giorgio de Chirico. Lee-Smith's themes of isolation and alienation are sometimes viewed as metaphors for the state of race relations in this country.

ALFRED LESLIE

Born 1927, Bronx, New York; resides South Amherst, Massachusetts

Initially a film-maker, Leslie became a painter who started with Abstract Expressionism, progressed through a geometric style, and then became—and still is—a Realist. He has been inspired by the chiaroscuro of the Italian Baroque master Caravaggio and his studies with William Baziotes and Tony Smith at New York University. His paintings are usually large close-ups of figures who confront the viewer. *Casey Key*, painted on the West Coast of Florida, is one of Leslie's few outdoor scenes. The sun bather is characteristically Leslie, though, in her hard and precise description.

ROY LICHTENSTEIN

Born 1923, New York, New York; resides New York, New York

Lichtenstein received a BFA and MFA from Ohio State University. His work has been through many phases. In the 1950s his figurative canvases of the Old West recalled Remington, but soon his work was Abstract Expressionist. By 1961 his style was distinctly his own, derived from comic strips and using strident colors and techniques borrowed from the printing industry. The elements were all enlarged to emphasize design and rhythm and to portray the trivialization of culture in modern America. His choice of everyday objects associated him with the Pop Art movement, and he is credited with the return to realism which followed Abstract Expressionism. *Landscape* is an example of Lichtenstein's typical style in which the subject is reduced to its simplest elements: sand dunes and sky.

JOHN MARIN

Born 1870, Rutherford, New Jersey; died 1953, Cape Split, Maine

Although Marin started painting when he was eighteen, he was an architect first and had no formal training until he entered the Pennsylvania Academy of the Fine Arts in 1899. He briefly attended the Art Students League, then travelled and painted in Europe and met Alfred Stieglitz in Paris. Stieglitz promoted Marin's work at his progressive Gallery 291 in New York and encouraged Marin to develop the increasingly abstract style in which he portrayed the crowded architecture of the Manhattan skyline. With Arthur Dove, Georgia O'Keeffe, and other 291 artists, Marin brought Modernism into the mainstream of American art. Marin's paintings in this exhibition were inspired by the Maine coast where he often spent his summers. They share with his dynamic city scapes such Modernist techniques as sight lines, contrasting weights, and rapid brushwork used to represent the flux and collision of natural elements such as rocks and waves.

REGINALD MARSH

Born 1898, Paris, France; died 1954, Dorset, Vermont

A prominent second-generation Ashcan School artist, Marsh is best known for his Depression-era portrayals of New York City life. Both of his parents were artists, and he studied in New York at the Art Students League with Sloan and Luks as well as in Paris. His subjects included the Bowery, dance halls, subways, burlesque theaters and amusement parks. The beach and boardwalk at Coney Island inspired *Lifeguards* and *Coney Island Beach #2*. They are hallmarks of Marsh's style—views of writhing bodies entwined yet emotionally remote.

THOMAS MORAN

Born 1837, Bolton, England; died 1926, Santa Barbara, California

Moran arrived in Philadelphia in 1844 and worked for a wood engraver from 1853 to 1856. He was greatly impressed by the landscapes of J. M. W. Turner and Claude Lorrain. Moran's panoramic landscapes were rooted in America, however, and he is best known for his romantic paintings which capture the spirit and magnitude of the western wilderness. Moran also travelled to other parts of the United States including Florida. Most of his Florida scenes, such as the two works in this exhibition, were inspired by the surroundings of Fort George Island and the St. Johns River. The paintings were completed back in his Long Island studio, so he continued to produce Florida scenes for many years after his visit. Even in these smaller landscapes, Moran's interest in subtle qualities of light and air and the idealization of nature are strikingly apparent.

MALCOLM MORLEY

Born 1931, London, England; resides New York

Morley was educated at London's Royal College of Art and moved to New York in 1958. He has taught at several universities and had a studio in Tampa, Florida in the 1970s. He has produced a consistently changing, assertively independent body of work, ranging from the abstract to the representational. He initially gained recognition as a Photorealist in the Sixties, and *Beach Scene* comes from this period. It captures the reality of the camera with its sharp highlights and flattening of form, and allows the viewer to glimpse a "snapshot" of the all-American family of the Sixties on holiday at the beach.

JULIAN ONDERDONK

Born 1882, San Antonio, Texas; died 1922, San Antonio, Texas

Onderdonk studied first with his father, the artist Robert Jenkins Onderdonk, then in New York with Chase, Henri and Frank duMond. Onderdonk divided his time between New York and Texas, where he was active in the San Antonio area. He is best known for his naturalistic depictions of the Texas landscape, scenes laden with bluebonnets, which are the state flower. His spontaneous brushwork and pleasing sense of color are evident in *Seascape*, although the choice of subject is unusual for him.

DAVID PARK

Born 1911, Boston, Massachusetts: died 1960, Berkley, California

Park and his family moved to California before he was twenty. He ended his formal training early and settled in the San Francisco Bay area, where he became a leader of the California School of Figure Painters. Others in the group included Elmer Bischoff, Richard Diebenkorn, Paul Wonner and Nathan Oliveira. Park was one of the first to break from Abstract Expressionism and return to recognizable figurative imagery, although he merely suggests facial features and his figures are not wholly naturalistic. He characteristically mixes colors with black or white, and his surfaces are thick with pigment. *Bathers* exemplifies this bold, innovative style.

JANE PETERSON

Born 1876, Elgin, Illinois; died 1965, Kansas City, Missouri

Peterson graduated from Brooklyn's Pratt Institute in 1901, then studied at the Art Students League and abroad, where she was influenced by Impressionism, Expressionism, and Fauvism. An inveterate traveller, she visited Egypt, Algeria, Turkey, Canada and Alaska before settling in Ipswich, Massachusetts, following her marriage in 1925 to a less adventurous soul. She concentrated on floral still lifes, but also painted New England scenes. *Beach at Spring Lake* depicts a popular New Jersey beach and illustrates her vibrant style, which provided a vital link between the Impressionist and Expressionist movements in American art.

SCOTT PONEMONE

Born 1949, Baltimore, Maryland; resides Baltimore, Maryland

Ponemone attended Amherst College and received an MA from the Maryland Institute College of Art. Although his early work depicted architectural and street scenes, Ponemone's interest in social commentary eventually found its way into his choice of figurative subjects. From 1985 to 1987, he executed an extensive series of beach scenes, including *Frieze*, a scene inspired by a visit to Ocean City, New Jersey. The artist's images are derived from black and white photographs but he alters the scene as he works.

FAIRFIELD PORTER

Born 1907, Winnetka, Illinois; died 1975, Southampton, New York

Porter graduated from Harvard University with a degree in Art History before studying art at the Art Students League with Thomas Hart Benton among others. In 1939 he saw Vuillard's work in an exhibition at the Art Institute of Chicago; this reinforced his tendency toward realism combined with a patterned surface composition. His subjects are scenes from everyday life, often richly painted, sunlit views of interiors and landscapes. Porter has been called a modernized American Impressionist, and *Beach in Morning #2* fits this description. It shows his sensitivity to nature's light, a serene mood and a soft palette, but also a broad brushstroke and large planes of color which define the compositional design as much as they do real form.

EDWARD HENRY POTTHAST

Born 1857, Covington, Kentucky; died 1927, New York, New York

Potthast is one of a number of significant American artists to emerge from Cincinnati during the nineteenth century. He studied art in his native city, then a burgeoning art center, and established a career as a lithographer and illustrator. After three years of study in Germany and Paris, he moved to New York City in 1896. Potthast is best known for his many sundrenched beach scenes, filled with the life and movement of children playing in the sand, which he began painting around 1910. The paintings in this exhibition show how beach subjects enabled him to combine vigorous brushwork with impressionistic luminescence.

MAURICE BRAZIL PRENDERGAST

Born 1859, St. Johns, Newfoundland; died 1924, New York, New York

Raised in Boston and a commercial artist by trade, Prendergast studied at the Académie Colarossi and the Académie Julien in Paris and immersed himself in the art of the time. He was influenced by those movements to express himself with flat, bold areas of color in combination with a compression of perspective and scale. Although he was a member of The Eight, his style placed him apart. His later work focuses on the Massachusetts coast where he spent many summers. The paintings in this exhibition show Prendergast's range of color and style. They are rendered in the unique mosaic-like style which distinguishes Prendergast's work.

WILLIAM TROST RICHARDS

Born 1833, Philadelphia, Pennsylvania; died 1905, Newport, Rhode Island

Richards studied art under the German Paul Weber, and learned from travels through Florence, Rome and Paris. He met Bierstadt in Europe, and he returned to America in 1856 with high regard for the uplifting works of native American landscape artists such as Kensett and Church. His own landscapes are a combination of various influences: the technique of the Düsseldorf School, the Pre-Raphaelite interest in the minutiae of nature, and the grandeur, light and atmosphere of the American Romantics. Richards began to concentrate on the beach after his first summer at the New Jersey shore in 1859, and is now best known for his coastal seascapes. *On the Coast of New Jersey*, commissioned by the Corcoran Gallery of Art, was one of his largest works, and it reconciles his love of meticulous detail and the large scale.

JUDY RIFKA

Born 1945, New York, New York; resides New York

Rifka studied at Hunter College, the New York Studio School, and the Skowhegan School of Painting and Sculpture in Maine. *Beach III* is from a series of beach-inspired works executed in mixed media. The relief work adds a third dimension to the painting, and Rifka's bold expressive lines and dynamic presentation give the work an unusual power.

CAROLINE E. RIXFORD

Born 1873, San Francisco, California; died 1954, California (?)

Rixford studied at the Mark Hopkins Institute of Art under Arthur Mathews and in Paris at the Académie Julien under J. T. Whistler. She was primarily recognized as a portrait painter and was active in the San Francisco area, consistently exhibiting in regional shows. *At the Beach, San Francisco*, although an unusual subject for the artist, shows a strong regional influence of California Impressionism.

CHARLES DORMAN ROBINSON

Born 1847, East Monmouth, Maine; died 1933, San Raphael, California

Robinson grew up in San Francisco sketching ships in the harbor, but received most of his instruction after his family moved to Vermont in 1861. He learned from the Hudson River School artists, especially Bierstadt, Cropsey, and James Hamilton. He went back to California in 1874 and applied the romantic, panoramic landscape style to views of Yosemite Valley and marine subjects. *The Wet Sand* masterfully captures the light and atmosphere of a luminous California beach.

ALICE SCHILLE

Born 1869, Columbus, Ohio; died 1955, Columbus, Ohio

After studying at the Columbus School of Art, at the Art Students League in New York with Chase, and at the Pennsylvania Academy of the Fine Arts, Schille travelled in Europe where she was particularly influenced by Modernist art movements. She returned to Columbus and taught at the art school there, becoming recognized for her own Modernist watercolors. *Midsummer Day* reflects Schille's adept ability to reduce forms to simple but recognizable shapes and to express the subject with bright colors and dappled brushstrokes.

BEN SCHONZEIT

Born 1942, Brooklyn, New York; resides New York, New York

Schonzeit, a Photorealist, received his BFA from Cooper Union. He often uses photography in the conception of a work, projecting slides onto the canvas to aid in the realistic rendering of the work. For a time during the 1970s Schonzeit worked in black and white, but he has returned to using color. His recent watercolor *Scott Cameron (Bridgehampton)* has a casual, spontaneous, loose quality unlike the severe clarity of his early work.

JOAN SEMMEL

Born 1932, New York, New York; resides New York

Semmel received her BA and MFA from Brooklyn's Pratt Institute, and also studied at Cooper Union and the Art Students League in New York. Originally known for her nudes, she has begun to portray the beach with a painterly realism. She summers on the Long Island shore and draws her inspiration there. Her highly charged pigmentation, with its unusual color contrasts, lends an emotionalism to the scenes, as seen in *Amagansett Afternoon*. The unexpected and intimate vantage point presented on such a large scale has a strong impact on the viewer.

FRANK HENRY SHAPLEIGH

Born 1842, Boston, Massachusetts; died 1906, Jackson, New Hampshire

Although he began as a portraitist, Shapleigh's primary interest was landscape painting. He studied at the Lowell Institute in Boston and in Paris with the Barbizon painter Emile Lambinet, whose influence can be seen in the subtle tonalities of Shapleigh's works. He was a successful resident-artist of fashionable resorts, and had a summer studio in the White Mountains of New Hampshire, and one in St. Augustine, Florida for spring and fall. He wintered in Boston. His personal contentment is translated into the calm serenity seen in his coastal landscapes such as *Nantasket Beach*, which depicts a beach on Boston's South Shore.

ALAN SIEGEL

Born 1938, New York, New York; resides New York

After studying at Brandeis, Stanford and Columbia, Siegel began to paint and sculpt. In the mid-1960s he started to make chairs which take flight as anthropomorphic fancies but remain recognizable and usable. He unifies craft and fine art with these functional but imaginative works. His *Seaside* chair, with its brash colors and shapes, displays a sophisticated treatment of space and perspective.

FRANCES AUGUSTUS SILVA

Born 1835, New York, New York; died 1886, New York, New York

A self-taught artist, Silva was a contemporary of Bricher and Richards and shared their fascination with northeastern landscapes and beach scenes. *Sunrise: Marine View* is an early, tentative work, but it shows how Silva exaggerated and intensified natural effects of light and air for poetic purposes. It typifies his skillful manipulation of atmospheric qualities and detailed view of nature.

MAXWELL STEWART SIMPSON

Born 1896, Elizabeth, New Jersey; resides Scotch Plains, New Jersey

Stewart, an accomplished painter, etcher and lithographer, studied at the National Academy of Design, the Art Students League, and in Europe. Active during the 1940s and 50s, he exhibited extensively in New York and New Jersey. *Last Summer*, though impressionistic in brushwork, depicts the somber atmosphere of an unkempt area on a Staten Island beach.

JOHN SLOAN

Born 1871, Lock Haven, Pennsylvania; died 1951, Hanover, New Hampshire

Beginning as a newspaper illustrator for the Philadelphia *Inquirer*, Sloan entered the Pennsylvania Academy of the Fine Arts in 1892. The same year he met and was captivated by Henri and the new realism, and thereafter began painting scenes of city life using the dark, warm, almost monochromatic color scheme that was characteristic of the Ashcan School artists. The most politically active of The Eight, Sloan loved ordinary people. He painted and sketched hundreds of them in the rhythms of everyday life, such as the bathers in *South Beach Bathers*. The painting captures the mood of the beach, with its heat, gritty sand, noise and motion. Sloan said that, because it had fewer visitors than Coney Island, this Staten Island resort, which he first visited in 1907, offered a better opportunity for observation of individual behavior.

WILLIAM LOUIS SONNTAG, JR.

Born 1822, East Liberty, Pennsylvania; died 1900, New York, New York

Sonntag studied at the Cincinnati Academy of Fine Arts and made regular painting trips around the mountains and valleys of Ohio, Kentucky and West Virginia. In 1855 he studied in Florence and returned to settle in New York City. He is best known for his romantic landscapes of the American wilderness and his idealized visions of Classical Italian ruins. Although not typical of his panoramas, his watercolor sketch *The Lighthouse*, typical of his meticulous style, shows his talent for fine drawing and his feeling for nature.

PAUL STAIGER

Born 1941, Portland, Oregon; resides San Jose, California and Boulder Creek, Colorado

Staiger received his BA from Northwestern University, his MFA from the California College of Arts and Crafts and did graduate work at the University of Chicago. He is now an art professor at San Jose State University. Staiger's work has been associated with the California School of Photorealism since he began

working in that style during the 1970s. In *Santa Cruz*, the realistic interest in various people and objects is concentrated in a narrow horizontal "strip" across the painting just below the unbroken horizon line. The clearly delineated bands of sand, sea and sky create an overall composition which, especially in a painting on such a large scale, is strikingly abstract.

CHARLES WALTER STETSON

Born 1858, Providence, Rhode Island; died 1911, Rome, Italy

A self-taught artist, Stetson travelled extensively in Europe and the United States. He attained recognition for his work despite its distance from the artistic mainstream. *Water Play* was painted after Stetson moved to California from Providence in 1895, and it was most likely inspired by the Pasadena Beach. The work has a haunting sky and a poetic, visionary quality that is typical of Stetson's unique style.

WALTER STUEMPFIG

Born 1914, Germantown, Pennsylvania; died 1970, Oceanport, New Jersey

Stuempfig studied architecture at the University of Pennsylvania for a year, then enrolled in the Pennsylvania Academy of the Fine Arts, where he joined the faculty in 1949 and became a respected teacher and critic. He admired the work of Eakins, Degas, and Caravaggio, and worked in the tradition of American Realism. He was known for his landscapes of the Philadelphia area and the New Jersey shore. *West Wildwood, New Jersey* shows the sense of isolation he conveyed in many of his works.

WAYNE THIEBAUD

Born 1920, Mesa, Arizona; resides Sacramento, California

Until the mid-1950s Thiebaud was active in many phases of the theater, as a student, a set designer, and a teacher at Sacramento City College. When he began painting he saw in this art form issues of light and space similar to those of the stage. His choice of everyday objects linked him to the Pop Art movement, but it was the process of painting, not the subject matter, that interested him the most. His figures, such as *Bikini*, were done from direct observation and have a harsh illumination. His richly textured landscapes of San Francisco, such as *Baker Beach*, were influenced by Diebenkorn.

JOHN HENRY TWACHTMAN

Born 1853, Cincinnati, Ohio; died 1902, Gloucester, Massachusetts

A founding member of The Ten, Twachtman studied with Frank Duveneck in Cincinnati and then in Munich at the Royal Academy. His work had a dark tonality until 1883 when he went to Paris and attended the Académie Julien. Two years later he settled on a farm in Cos Cob, Connecticut, which served as an inspiration for many of his landscapes. His paintings of the 1890s are light and delicate, showing not only the influence of the French Impressionists, but also of Whistler and Japanese painting. *Sea Scene* is most likely a filmy, impressionistic portrayal of the Newport, Rhode Island coast. *Beach at Squam*, a more spiritual work, shows Twachtman's emphasis on poetic atmosphere rather than objective rendering.

BEATRICE WHITNEY VAN NESS

Born 1888, Chelsea, Massachusetts; died 1981, Brookline, Massachusetts

One of the foremost educators of her day as well as a noted artist, Van Ness studied with Benson and Tarbell at the School of the Museum of Fine Arts, Boston, then in Maine at Woodbury's art school. She taught at Beaver Country Day School near Boston from 1921 to 1949, but spent most of her summers in Maine, where she and her husband settled in 1927. Working outdoors in direct sunlight, often with her neighbor Benson, she captured the atmosphere of the Maine summer with highly-saturated colors, as seen in *Summer Sunlight*.

ABRAHAM WALKOWITZ

Born 1880, Siberia, Russia; died 1965, Brooklyn, New York

After his family emigrated to America in 1889, Walkowitz studied at the National Academy of Design and became a skilled draughtsman. He taught art and studied briefly at the Académie Julien in Paris. Through his classmate Max Weber, Walkowitz was introduced to Leo and Gertrude Stein and the art of Rodin, Cézanne, Matisse, Rousseau and Picasso. Walkowitz was an influential pioneer of American Modernism. With other artists associated with Stieglitz and his progressive Gallery 291, he experimented with an abstract, pictorial art, and was among the first American artists to incorporate Fauve color in his work. *Bathers on the Rocks*, an important Modernist work, illustrates his simplicity: broadly conceived, flattened figures in a stylized, rhythmic setting, marked by bright colors. Given Walkowitz's feeling for humanity, however, the painting most likely addressed non-pictorial interests as well—the large brown rocks suggest the power of nature and dwarf the individual bathers.

FREDERICK JUDD WAUGH

Born 1861, Bordentown, New Jersey; died 1940, Provincetown, Massachusetts

Waugh's father was the portrait and landscape painter Samuel Bell Waugh, and his mother was a miniaturist. Waugh studied at the Pennsylvania Academy of the Fine Arts with Eakins and at the Académie Julien with Bouguereau. He returned to Philadelphia upon the death of his father and worked as a commercial artist. He married and returned to Europe, where he painted on the Island of Sark and at St.Ives, Cornwall, and gained success as a marine painter. In 1907 he set up studios in Montclair, New Jersey and Provincetown, Massachusetts and painted realistic, panoramic seascapes. *Incoming Tide* and *The Green Wave* are examples of Waugh's later portrayals of smaller areas of sea, rocks and sky. They exhibit his skill at rendering waves breaking on the shore at close range.

JULIAN ALDEN WEIR

Born 1852, West Point, New York; died 1919, New York, New York

Weir and his brother and fellow-artist, J. Ferguson Weir, received instruction from their father Robert Weir. J. Alden Weir also studied at the National Academy of Design and with Gérôme in Paris at the Ecole des Beaux-Arts. He always experimented with technique, and admired Manet and Whistler. Along with Twachtman, Hassam and Robinson, he pioneered Impressionism in America, and he was one of the founders of The Ten. In 1892 he settled in Cos Cob, Connecticut, where he painted quiet landscapes and taught with his friend Twachtman. *Shore Scene* is perhaps the only beach scene painted by Weir.

TOM WESSELMANN

Born 1931, Cincinnati, Ohio; resides New York

Wesselmann received a degree in psychology from the University of Cincinnati before studying art at the Art Academy of Cincinnati and at Cooper Union in New York City. Although his use of everyday objects for subject matter aligned him with the Pop Art movement in the 1960s, his work places greater emphasis on formal relationship than did that of Pop artists. His early works were collages in which the reality of actual objects was contrasted with a flat, painted image, usually a nude female. In later works during the 1960s, Wesselman isolated details of the human figure. The painting shows the artist's preference for a large-scale, his hard-edged, flatly colored forms, the irony which pervades his work and his increasingly erotic themes.

(THOMAS) WORTHINGTON WHITTREDGE

Born 1820 near Springfield, Ohio; died 1910 Summit, New Jersey

Whittredge received little formal education and began as a portrait painter before devoting himself to landscapes after 1843. He studied for five years in Düsseldorf, saw Barbizon landscapes in Paris and Switzerland, and then spent five more years in Rome, where he was part of an artists' colony that included romantic artists and writers such as Church and Hawthorne. His mature style, seen in the paintings in this exhibition, reflects his European influences but more clearly celebrates the spaciousness, light and serenity of the American landscape painters.

JANE WILSON

Born 1924, Seymour, Iowa; resides New York, New York

Wilson received her BA and MA in art history from the University of Iowa. She has taught at Pratt Institute and Parsons School of Design and presently teaches at Columbia University. She rarely includes figures in her thinly painted landscapes, featuring instead grand spaces defined by a low horizon and saturated with light. Wilson attributes her atmospheric sensitivities to the immense expanses of land she saw while growing up in Iowa. She consciously avoids the stylistic parameters of contemporary art movements, and concentrates solely on producing dramatic yet quiet landscapes such as *Receding Sea*.

CHARLES HERBERT WOODBURY

Born 1864, Lynn, Massachusetts; died 1940, Jamaica Plains, Massachusetts

Woodbury graduated with a degree in engineering from Massachusetts Institute of Technology in 1886, but soon began his career as a marine painter. In 1888 he settled in Ogunquit, Maine and established an artists' colony. Many of his students, including Mabel Woodward and Gertrude Fiske, became successful artists. A respected lecturer and educator, he was virtually self-taught except for brief study at the Académie Julien in Paris. His fascination with motion is seen in *Going Up*, an unusual depiction of a plane taking off from a beach.

MABEL MAY WOODWARD

Born 1877, Providence, Rhode Island; died 1945, North Providence, Rhode Island

After graduating from the Rhode Island School of Design, Woodward studied with Chase, Duveneck, Cox, DuMond and Hawthorne. She taught at the Rhode Island School of Design for twenty-five years, living in Providence during the school year and spending her summers painting at Ogunquit, Maine where she studied with Woodbury. *Beach Scene* is one of the colorful impressionistic scenes for which she is best recognized.

THEODORE WORES

Born 1859, San Francisco, California; died 1939, San Francisco, California

Wores began his artistic studies at the School of Design of the San Francisco Museum, then joined other San Francisco artists who were studying at the Royal Academy in Munich. After his return, he taught at the Art Students League and was appointed Dean at the California School of Design. His extensive travels provided subjects for his works, as did the California hills and coastline. Like many of his contemporaries, Wores abandoned his dark tonality and academic style for the short, broken brushstrokes and vibrant color typical of the California Impressionists. *Ocean Shore of San Francisco, Lime Point* depicts a well-known spot near the Golden Gate Bridge.

Selected Bibliography

GENERAL SOURCES

Battock, Gregory, ed. *Super Realism: A Critical Anthology*. New York: E. P. Dutton, 1975.

Boyle, Richard J. *American Impressionism*. Boston, Massachusetts: New York Graphic Society and Little, Brown and Company, 1982.

The Brooklyn Museum. *The Coast and the Sea: A Survey of American Marine Painting*. Exhibition catalogue. Brooklyn, New York: The Brooklyn Museum, 1949.

Brown, Milton. *American Painting from the Armory Show to the Depression*. Princeton, New Jersey: Princeton University Press, 1955.

Burke, Doreen Bolger, et al. *American Paintings in the Metropolitan Museum of Art* 3. New York: Metropolitan Museum of Art; Princeton, New Jersey: Princeton University Press, 1980.

Butts, H. Daniel, III. *The American Seascape from John Smibert to John Marin*. Exhibition catalogue. Mansfield, Ohio: The Mansfield Art Center, 1988.

Carlin, John. *Coney Island of the Mind: Images of Coney Island in Art and Popular Culture 1890-1960*. Exhibition catalogue. New York: Whitney Museum of American Art, 1989.

Carson, Gerald. "Once More On to the Beach," *American Heritage*, August, 1971, 58-80.

Davis Galleries. *The Beach Scene: An American Tradition*. Exhibition catalogue. New York: Davis Galleries, 1959.

Fairbrother, Trevor J. *The Bostonians: Painters of an Elegant Age 1870-1930*. Exhibition catalogue. Boston, Massachusetts: Museum of Fine Arts, 1986.

Gerdts, William H. *American Impressionism*. Exhibition catalogue. Seattle, Washington: Henry Art Gallery, University of Washington, 1980.

Gerdts, William H. *American Impressionism*. New York: Abbeville Press, 1984.

Greenberg, Howard and Sandra Berler. *Coney Island*. Exhibition catalogue. New York: Photofind Gallery, 1987.

Hern Anthony. *The Seaside Holiday: The History of the English Seaside Resort*. London: The Cresset Press Ltd., 1967.

Howat, John K., et al. *American Paradise: The World of the Hudson River School*. Exhibition catalogue. New York: Metropolitan Museum of Art and Harry N. Abrams, Inc. Publishers, 1987.

Howell, Sarah. *The Seaside*. London: Studio Vista, Cassell & Collier MacMillan Publishers Ltd., 1974.

Keyes, Donald D. *The Genteel Tradition: Impressionist and Realist American Art from the Ira and Nancy Koger Collection in Celebration of the Centennial of Rollins College*. Exhibition catalogue. Winter Park, Florida: The George D. and Harriet W. Cornell Fine Arts Center, Rollins College, 1985.

Levi, Vicki Gold and Lee Eisenberg. *Atlantic City: 125 Years of Ocean Madness*. New York: Clarkson N. Potter, Inc./Publishers, 1979.

Lippard, Lucy R. *Pop Art*. New York: Praeger Publishers, 1978.

Morrin, Peter, Judith Zilczer, and William C. Agee. *The Advent of Modernism: Post Impressionism and North American Art 1900-1918*. Exhibition catalogue. Atlanta, Georgia: High Museum of Art, 1986.

Museum of Fine Arts, Boston. *A New World: Masterpieces of American Painting 1760-1910*. Exhibition catalogue. Boston, Massachusetts: Museum of Fine Arts, 1983.

National Academy of Design. *Next to Nature: Landscape Paintings from the National Academy of Design*. Exhibition catalogue. New York: National Academy of Design, 1980.

Nelson, Harold B. *Sounding the Depths: 150 Years of American Seascape*. Exhibition catalogue. New York: American Federation of Arts; San Francisco, California: Chronicle Books, 1989.

Novak, Barbara. *Nature and Culture: American Landscape Painting 1825-1875*. New York: Oxford University Press, 1980.

Oakland Museum of Art. *Impressionism: The California View; Paintings 1890-1930*. Exhibition catalogue. Oakland, California: Oakland Museum of Art, 1981.

Perlman, Bennard B. *The Immortal Eight: American Painting from Eakins to the Armory Show (1870-1913)*. New York: Exposition Press, 1962.

Pisano, Ronald G. *Idle Hours: Americans at Leisure 1865-1914*. New York: New York Graphic Society; Boston: Little, Brown and Company, 1988.

Pisano, Ronald G. *Long Island Landscape Painting 1820-1920*. New York: New York Graphic Society; Boston: Little, Brown and Company, 1985.

The Queens Museum. *By the Sea: 20th Century Americans at the Shore*. Exhibition catalogue. Flushing, New York: The Queens Museum, 1979.

The San Antonio Museum Association. *Real, Really Real, Super Real: Directions in Contemporary Realism*. Exhibition catalogue. San Antonio, Texas: The San Antonio Museum Association, 1981.

Sandler, Irving. *The New York School: The Painters & Sculptors of the Fifties*. New York: Harper and Row Publishers, 1978.

Skow, John. "All Washed up at the Beach," *The Saturday Evening Post*, March 1985, 40, 101.

Stein, Roger. *Seascape and the American Imagination*. Exhibition catalogue. New York: Clarkson N. Potter, Inc. and Whitney Museum of American Art, 1975.

Stilgoe, John R. "Bikinis, Beaches & Bombs: Human Nature on the Sand," *Orion Nature Quarterly*, Vol. 3, Summer 1984, 4-15.

Tufts, Eleanor. *American Women Artists 1830-1930*. Exhibition catalogue. Washington, D.C.: International Exhibitions Foundation for the National Museum of Women in the Arts, 1987.

Von Groschwitz, Gustave. *The Seashore: Paintings of the 19th and 20th Centuries*. Exhibition catalogue. Pittsburgh, Pennsylvania: Museum of Art, Carnegie Institute, 1965.

Weber, Bruce and William H. Gerdts. *In Nature's Way: American Landscape Painting of the Late Nineteenth Century*. Exhibition catalogue. West Palm Beach, Florida: Norton Gallery of Art, 1987.

West, Richard V., Fridolf Johnson and Dan Burne Jones. *"An Enkindled Eye" The Paintings of Rockwell Kent: A Retrospective Exhibition*. Exhibition catalogue. Santa Barbara, California: Santa Barbara Museum of Art, 1985.

William Benton Museum of Art, *Connecticut and American Impressionism*. Exhibition catalogue. Storrs, Connecticut: The University of Connecticut, 1980.

Wilmerding, John. *American Marine Painting*. New York: Harry N. Abrams, Inc., Publishers, 1987.

Wilmerding, John et al. *American Light: The Luminist Movement 1850-1875*. Exhibition catalogue. Washington, D.C.: National Gallery of Art, 1980.

Young, Mahonri Sharp. *American Realists: Homer to Hopper*. New York: Watson Guptill Publications, 1977.

MONOGRAPHS

Alloway, Lawrence. *Roy Lichtenstein*. New York: Abbeville Press, 1983.

Art Institute of Chicago. *Exhibition of Paintings by Frank V. Dudley: The Sand Dunes of Indiana and Vicinity*. Exhibition catalogue. Chicago, Illinois: Art Institute of Chicago, 1918.

Atkinson, D. Scott and Nicolai Cikovsky, Jr. *William Merritt Chase: Summers at Shinnecock 1891-1902*. Exhibition catalogue. Washington, D.C.: National Gallery of Art, 1987.

Bedford, Faith Andrews, Susan C. Faxon and Bruce W. Chambers. *Frank W. Benson: A Retrospective*. Exhibition catalogue. New York: Berry-Hill Galleries, Inc., 1989.

Boyle, Richard J. and John Douglass Hale. *John Henry Twachtman 1853-1902: An Exhibition of Paintings and Pastels*. Exhibition catalogue. New York: Ira Spanierman Gallery, 1968.

Center for the Fine Arts, Miami. *Milton Avery: A Singular Vision*. Exhibition catalogue. Essay by Burt Chernow. Miami, Florida, 1987.

Cohen, Marilyn. *Reginald Marsh's New York: Paintings, Drawings, Prints and Photographs*. Exhibition catalogue. New York: Whitney Museum of American Art and Dover Publications, Inc., 1983.

Columbia Museum of Art. *Gertrude Fiske: American Impressionist 1878-1961*. Exhibition catalogue. Columbia, South Carolina: Columbia Museum of Art, 1975.

Columbus Museum of Art. *George Wesley Bellows: Paintings, Drawings and Prints*. Exhibition catalogue. Columbus, Ohio: Columbus Museum of Art, 1979.

Columbus Museum of Art. *Lyrical Colorist Alice Schille 1869-1955*. Essay by Ronald Pisano. Columbus, Ohio: Columbus Museum of Art, 1988.

Cooper, Helen A. *Winslow Homer Watercolors*. Exhibition catalogue. Washington, D.C.: National Gallery of Art; New Haven: Yale University Press, 1986.

Creer, Doris Jean. "Thomas Birch: A Study of the Condition of Painting and the Artist's Position in Federal America," Master's thesis, University of Delaware, 1958.

Cummer Gallery of Art. *Edmund W. Greacen, N.A.: American Impressionist 1876-1949*. Exhibition catalogue. Jacksonville, Florida: Cummer Gallery of Art, 1972.

Delaware Art Museum. *Robert Henri: Painter*. Exhibition catalogue. Wilmington, Delaware: Delaware Art Museum, 1984.

Driscoll, John Paul, and John K. Howat. *John Frederick Kensett: An American Master*. Exhibition catalogue. Worcester, Massachusetts: Worcester Art Museum; New York: Norton, 1985.

Ferber, Linda S. *William Trost Richards: American Landscape and Marine Painter, 1833-1905*. Exhibition catalogue. Brooklyn, New York: The Brooklyn Museum, 1973.

Glen, Constance, W. and Lucinda Barnes, Jane K. Bledsoe, Ed. *Eric Fischl: Scenes Before the Eye*. Exhibition catalogue. Long Beach, California: University Art Museum, California State University, 1985.

Goodrich, Lloyd, Susan Lubowsky and Tom Wolf. *Yasuo Kuniyoshi*. Exhibition catalogue. New York: Whitney Museum of American Art, 1986.

Hale, John Douglass, Richard J. Boyle and William H. Gerdts. *Twachtman in Gloucester: His Last Years, 1900-1902*. Exhibition catalogue. New York: Ira Spanierman Gallery; New York, Universe Books, 1987.

Harrison, Jr., Alfred C. *William Keith: The Saint Mary's College Collection*. Moraga, California: Saint Mary's College, 1988.

Haskell, Barbara. *Milton Avery*. Exhibition catalogue. New York: Whitney Museum of American Art and Harper and Row, 1982.

Homer, William Inness. *Robert Henri and his Circle*. Ithaca, New York, 1969.

Hendricks, Gordon. *The Life and Work of Winslow Homer*. New York: Harry N. Abrams, Inc., Publishers, 1979.

Indianapolis Museum of Art. *Alfred Thompson Bricher 1837-1908*. Exhibition catalogue. Essay by Jeffrey R. Brown. Indianapolis, Indiana: Indianapolis Museum of Art, 1973.

Jacobowitz, Arlene. "Edward Henry Potthast," *Brooklyn Museum Annual 9* (1967-1968).

Janson, Anthony Frederick. *The Paintings of Worthington Whittredge*. Ph.D. dissertation, Cambridge, Massachusetts: Harvard University, 1975.

Jayne, Horace H. F. "TM (Thomas Moran) and his 'Florida Landscape,'" *Pharos*, St. Petersburg, Florida: Museum of Fine Arts. Summer, 1964.

Keny and Johnson Gallery. *Alice Schille: The New England Years 1915-1918*, Exhibition catalogue. Essay by Gary Wells. Columbus, Ohio, 1989.

Kirstein, Lincoln. *Paul Cadmus*. New York: Rizzoli International Publishers, Inc., 1984.

Levin, Gail. *Edward Hopper: The Art and the Artist*. Exhibition catalogue. New York: W. W. Norton and Co. and Whitney Museum of American Art, 1985.

Long Beach Museum of Art. *Abraham Walkowitz Figuration 1895-1945* Exhibition catalogue. Essay by Kent Smith. Long Beach, California: Long Beach Museum of Art, 1982.

Love, Richard H. *William Chadwick 1879-1962: An American Impressionist*. Exhibition catalogue. Chicago, Illinois: R. H. Love Galleries, 1978.

Munson-Williams-Proctor Institute. *Worthington Whittredge 1820-1910: A Retrospective Exhibition of an American Artist*. Exhibition catalogue. Utica, New York: Munson-Williams-Proctor Institute, 1969.

Museum of Fine Arts, Boston. *Fairfield Porter 1907-1975: Realist Painter in an Age of Abstraction*. Exhibition catalogue. Boston, Massachusetts: Museum of Fine Arts, 1982.

National Gallery of Art. *John Sloan 1871-1951*. Exhibition catalogue. Washington, D.C.: National Gallery of Art, 1971.

New Jersey State Museum. *Hughie Lee-Smith: Retrospective Exhibition*. Exhibition catalogue. Trenton, New Jersey: New Jersey State Museum, 1988.

Philadelphia Maritime Museum. *Thomas Birch 1779-1851*. Exhibition catalogue. Essay by William H. Gerdts, Philadelphia, Pennsylvania: Philadelphia Maritime Museum, 1966.

Pisano, Ronald G. *A Leading Spirit in American Art: William Merritt Chase 1849-1916*. Exhibition catalogue. Seattle, Washington: Henry Art Gallery, University of Washington, 1983.

Reich, Sheldon. "Abraham Walkowitz, Pioneer of American Moderism," *American Art Journal* 3 (Spring, 1971).

Sawin, Martica. *Abraham Walkowitz*. Exhibition catalogue. Salt Lake City, Utah: Utah Museum of Fine Arts, University of Utah, 1974.

Smith College Museum of Art. *S. S. Carr (American, 1837-1908)*. Exhibition catalogue. Essay by Deborah Chotner. Northampton, Massachusetts: Smith College Museum of Art, 1976.

Spencer Museum of Art. *Charles Walter Stetson: Color and Fantasy*. Exhibition catalogue. Essay by Charles C. Eldredge. Lawrence, Kansas: Spencer Museum of Art, 1982.

Stahl, Elizabeth. *Beatrice Whitney Van Ness 1888-1981*. Boston, Massachusetts and New York: Childs Gallery, 1987.

Steinfeldt, Cecilia. *The Onderdonks: A Family of Texas Painters*. San Antonio, Texas, 1976.

Stern, Jean. *Alson S. Clark*. Los Angeles: Peterson Publishing Company, 1983.

Stevens, Andrew. *Prints by Richard Bosman: 1978-1988*. Exhibition catalogue. Madison, Wisconsin: Elvehjem Museum of Art, University of Wisconsin, 1989.

Taylor, Kendall. *Philip Evergood: Never Separate from the Heart*. Exhibition catalogue. Lewisburg, Pennsylvania: Bucknell University Press, 1986.

University of Cincinnati, *Abraham Walkowitz and the Struggle for an American Modernism*. Exhibition catalogue. Essay by Theodore Wayne Eversole. Cincinnati, Ohio: University of Cincinnati, 1976.

Valparaiso Union, *Frank V. Dudley Memorial Exhibition*. Exhibition catalogue. Essay by J. Howard Euston, Valparaiso, Indiana: Valparaiso Union, 1957.

Vose Galleries of Boston, Inc. *Gertrude Fiske (1878-1961)*. Exhibition catalogue. Essay by Carol Walker Aten. Boston, Massachusetts: Vose Galleries, 1987.

Vose Galleries of Boston, Inc. *Charles H. Woodbury 1864-1940*. Exhibition catalogue. Boston, Massachusetts: Vose Galleries, 1978.

Wattenmaker, Richard J. "William Glackens's Beach Scenes at Bellport," *Smithsonian Studies in American Art* 2 (Spring, 1988).

Zimmer, William. *Richard Bosman*. New York: Brooke Alexander Gallery, 1987.